Advance

Confessions of a V.

"*Confessions of a Wildlife Filmmaker* reveals the scandalous misrepresentations in many television wildlife films. Since an increasing number of people obtain their information of the natural world from television and videos, it is important that we are able to know truth from deception. Chris Palmer's powerful new book is a must read for all who care about the natural world and the future of our planet."

—TED DANSON, Actor and Environmentalist

"In a world where media holds enormous influence, Chris Palmer's book makes fascinating reading. He tells an alluringly honest and genuinely impactful story, while compassionately revealing the shortcomings of the environmental film industry. His goal—one I heartily support—is to inspire and empower the next generation to embrace ethical filmmaking."

—JEAN-MICHEL COUSTEAU, President, Ocean Futures Society

"It puzzles me how a nation so entranced with its pet cats and dogs tolerates so much cruelty toward and senseless killing of wildlife on its TV programs. Violence is profitable and the tyranny of TV ratings encourages so-called documentaries on *Animal Planet, Discovery,* and others to demonize predators as monsters and promote all sorts of fakery. Chris Palmer exposes this dark side of nature films in his powerful book *Confessions of a Wildlife Filmmaker* with graphic accounts of gross misinformation and brutality on popular shows. After over a quarter century in the business, he is a passionate advocate for ethical films in which animals are not mistreated and the audience is not deceived, inspiring us all to love, respect, and take action to protect wildlife and its habitat."

—GEORGE B. SCHALLER,
Panthera and Wildlife Conservation Society

"Those amazing 'reality' shows and natural history documentaries! Are they fact or fantasy? Real or staged? Sensitive or indifferent to impacts on the animals being filmed and misinformation conveyed to

an unwitting public? Are integrity, truth, and ethics being sacrificed by some to improve ratings? Who can be trusted? These timely issues are explored in this deeply personal saga by award-winning film producer Chris Palmer, who pulls no punches as he challenges the media and viewers alike to demand clarity, compassion, and honesty."

—DR. SYLVIA EARLE, Ocean Scientist and Explorer

"Chris's 'confessions' are an industry's collective confession where a quick study of the natural history line up on television for the week will confirm his findings. While shining a hard light on the wildlife film-making business, Chris's direct approach also reflects light on the path ahead. I hope that broadcasters, students of the craft, and audiences all read this book because the wildlife filmmaking industry is at a turning point as viewing habits change, and we all have the ability to steer it in a better direction. Like all creative industries, this is a revolving door of good ideas and bad ideas. I have almost never found a bad person in the business, but the pressure of chasing ratings forces good people to some-times make bad decisions. Chris's confessions will ease the way for more ethical and good ideas to pass through those doors."

—DERECK JOUBERT, National Geographic Explorer
in Residence, Filmmaker, Conservationist

"Chris's book is important and timely–a call to arms for wildlife film-makers to do better and be better. Read it, and take moral responsibility for how wildlife is portrayed. There has never been a more important time to make challenging, inspiring wildlife films."

—MARK DEEBLE AND VICKY STONE,
Award-Winning Wildlife Filmmakers

"Chris Palmer's *Confessions of a Wildlife Filmmaker* is a remarkably candid, well-crafted story about the ethics and challenges facing those who go to the edge to make nature films. Disney, Discovery and National Geographic may not be happy with this book, but it may be just the shock therapy they need. Palmer reveals that the most dangerous preda-tors in wildlife film-making are rarely those in front of the camera lens. In reading this insider's 'confession' you'll come to appreciate what drew

one man into a remarkable career as a filmmaker and, with this book, a clarion voice for why we need to bring greater humility and respect to our stories of a once wild planet. This fiercely moral book is essential reading if we're to understand and correct the media's failure to inspire our species to end the carnage we're carrying out on all others."

—DAVID HELVARG, Author of
The Golden Shore and Saved by the Sea

"Palmer's honest and self-revealing account of three decades in wildlife film production brings a harsh though much-needed spotlight on the 'toxic techniques' that threaten animals and their well-being, as well as the integrity of wildlife filmmaking. His love for film and his high regard for its potential as an instrument of change are matched by his desire to see it used well and right in the world."

—WAYNE PACELLE, President & CEO,
The Humane Society of the United States

"In a book sure to raise eyebrows and controversy, Chris Palmer offers both his *mea culpa* and his insights. Wildlife filmmaking has reached both new highs and, with a proliferation of trashy shows in a race to the bottom on cable, new lows. My hope is that with this book Mr. Palmer can bring up the bottom half with his ideas for new standards and accountability. Viewers and the animals deserve no less."

—CARL SAFINA, Author of
Beyond Words: What Animals Think and Feel

"Anyone who enjoys watching animal documentaries (and who doesn't?) owes it to themselves to read Chris Palmer's scathing, enthralling and often humorous work — part expose and part confessional autobiography — about what really goes on behind and in front of the camera to produce these beloved shows. It is not always a pretty picture, and you will likely never look at a wildlife documentary the same way again."

—DAVID KIRBY, Author of *Death at SeaWorld – Shamu*
and the *Dark Side of Killer Whales in Captivity*

"So many of us depend on wildlife films to learn about the fascinating and mysterious worlds of nonhuman animals and nature. Chris Palmer's

compelling new book, *Confessions of a Wildlife Filmmaker*, explains how these films are made and uncovers unacceptable and surprising levels of animal abuse and other ethical violations. This is a very important book and deserves a wide readership among professionals and non-professionals alike."

—MARC BEKOFF, University of Colorado,
Author of *Rewilding Our Hearts: Building Pathways of Compassion* and *Coexistence* and many other books

"Chris Palmer has written an important and timely book that tackles the dilemma facing all wildlife film makers, torn between our desire to protect the world's dwindling wild animals, the commercial imperatives of a fiercely competitive media industry, and the need to be transparent with viewers about how films are made. This is a fascinating and insightful book for anyone who makes wildlifefilms—and for everyone who enjoys watching them."

—TIM MARTIN, Executive Producer,
BBC Natural History Unit

"Chris Palmer's *Confessions of a Wildlife Filmmaker* is both humorous and introspective, while being brutally honest about the somewhat dysfunctional state of wildlife filmmaking today. A veteran wildlife film producer who fearlessly exposes his own mistakes over the years, Palmer has emerged as one of the leaders in his field who speaks candidly about the responsibility and power that wildlife filmmakers hold. He acknowledges the remarkable role wildlife filmmakers could potentially play, if directed properly, in actually helping to save some of the world's most endangered and threatened species."

—DR. ALAN RABINOWITZ, CEO of Panthera

4/15/15

Dear Betsy,

CONFESSIONS OF A
WILDLIFE FILMMAKER

Thank you so much for all
your wonderful support of my
conservation + education work.
I deeply appreciate it! You
have been a treasured friend.
I hope you enjoy this book.
Warmest wishes,
Chris

CONFESSIONS OF A

WILDLIFE
FILMMAKER

A Memoir

*The Challenges of Staying Honest
in an Industry Where Ratings Are King*

CHRIS PALMER

AUTHOR OF *Shooting in the Wild*

FOREWORD BY JANE GOODALL

BLUEFIELD
PUBLISHING

First published by Bluefield Publishing

Cover photo from **Hurricane on the Bayou,** *a film for IMAX* *and other giant screen theatres from MacGillivray Freeman Films and the Audubon Nature Institute.*

First Edition

3720 Spruce Street
Suite 426
Philadelphia, PA 19104
Tel: (866) 792-6164
http://style-matters.com/BluefieldPublishing/
Cover & Interior Design: StyleMatters, info@style-matters.com

Library of Congress Control Number: 2015930374
ISBN 978-1-938954-05-4 (paperback) – ISBN 978-1-938954-06-1 (e-book)

I dedicate this book to my grandchildren—Kareena, Neal, and Jackson—and to all of the many honorable wildlife filmmakers who endure deprivation, risk injury, and work diligently to produce entertaining, informative, and ethical wildlife films that create a better world for future generations.

CONTENTS

FOREWORD

CHRIS PALMER HAS WRITTEN a very important book. There is no question but that wild life films have played a major role in raising awareness about the natural world. For many people, watching these films is the only chance they have of glimpsing some of the amazing things that go on in nature. After watching film of elephants playing in a river or a chimpanzee mother gently grooming her infant, viewers will be far more prepared to want to conserve and protect these and other animals and their habitats. Indeed, as Chris says, wildlife films can be a very powerful tool in the effort to sway public opinion, as they can educate and inspire every viewer and encourage them to be more respectful of life on earth.

But sometimes footage, especially of some of the rarer animals, has been obtained at the expense of greatly disturbing—even harming—the animals being filmed. I learned a good deal about the unethical behavior of some film makers when I was working with my first husband, Hugo van Lawick. During this time, we realized not only how often animals are treated with disrespect but also how some films, as a result of clever

editing, can present a distorted picture of what actually happens. Film makers and producers are always striving for good ratings, and only too often this causes them to disregard the well-being of their animal subjects.

Chris wrote passionately about many of these issues in his 2010 book *Shooting in the Wild*. Now he has written this sequel, *Confessions of a Wildlife Filmmaker*. In many ways this is a courageous book, for in order to deepen our understanding of what goes on behind the scenes during the making of some wildlife movies, he not only faces these issues head on but also confesses ways in which he himself has behaved in ways that he now regrets. And now that he has thus criticized his own behavior, he is in a strong position to challenge other film makers to follow the same rigorous guidelines. He is, in fact, striving to move the profession to a higher level.

This will not be easy, as Chris explains in the pages of this book. There are many difficulties involved in producing wildlife films in a truly ethical way. As viewers become more sophisticated, they expect ever more detailed and exciting material. Film makers, producers, and TV channels are all competing for ratings even as budgets are increasingly stringent, and it becomes ever more difficult to afford the long hours that are necessary to obtain really good footage and to capture those rare events that make a film outstanding.

Thus, it is easy to understand why wildlife film making has become increasingly corrupted. Yet Chris is pleading for stringent ethical standards that will move the profession into a new era. An aware public, demanding these high standards of ethical behavior and condemning films that were made possible only by disturbing the animals will certainly help to move things in the right direction.

If you have any interest in the natural world and in animals, I urge

you to read this book and think about the concerns highlighted within its pages. When enough viewers make the right decisions about which wildlife films to watch and which to avoid, we can hope to see the kind of ethical change that is needed.

Jane Goodall, Ph.D., DBE
Founder, the Jane Goodall Institute &
UN Messenger of Peace

PREFACE

HERE IS THE FIRST confession in a book of confessions: I haven't always lived up to my responsibilities as a filmmaker. I've been as guilty of fabricating phony wildlife scenes as those I now criticize. That's just the way it is done in this industry, and I'm ashamed of how long it took me to realize this practice was wrong. Now, as you will see in this book, much worse things are being done in the chase for ratings.

Over thirty years ago, I began producing wildlife films when I realized that film and television are some of the best tools society possesses to protect the environment and encourage conservation. I've spent my career trying to create films that people would want to watch and that will help the environment and wildlife. Sometimes—through the magical combination of funding, incredibly talented colleagues, and luck—I've been successful.

But amid this success, it has gotten harder and harder for me to ignore the dark side of wildlife filmmaking. My first book, *Shooting in the Wild*, published in 2010, looked behind the scenes of wildlife films, exposing an industry undermined by sensationalism, fabrication, and sometimes

even animal abuse. I described how, over the course of producing many films, I became haunted by the measures sometimes taken by broadcasters and filmmakers to capture compelling images. Were filmmakers doing more harm than good by staging "money shots" to capture more dramatic footage and achieve higher ratings at the expense of the animals and truly natural behaviors?

This new book is a memoir about my unusual childhood in England, my stern and demanding father, my emigration to America, my flaws as a dad, the superficial world of television, the foibles of environmental groups, the cruelty of SeaWorld, and the mistakes I made while struggling to excel as a film producer, stand-up comic, and teacher—and how all of these experiences shaped my views on wildlife filmmaking. It's also about how networks like Discovery, Animal Planet, and National Geographic are failing in their responsibility to produce and broadcast programs that are not only entertaining but also consistent with their founding visions. The networks are full of honorable and ethical people who care about wild places and animals, but the business side of television seems to coerce them into behavior that sometimes harms wildlife, spreads misinformation, and coarsens society's appreciation of nature.

Suppose you want to produce a wildlife documentary and you've scraped together some financing. You don't have much time in which to make this film. Of course, you want your film to achieve high audience ratings when it airs. Those high ratings will help get you rehired and give you the income you need to put food on the table and send your kids to college.

As you set out to shoot your film, certain questions will arise in your mind:

- To save time and money, can I stage some shots?
- Will it be easier to film if I rent captive animals?

- How close can I get to wild animals to capture dramatic behavior?
- Can I bait or entice wild animals to get them to act in ways that I want?
- Should I ignore conservation because the average viewer is not that interested in it?

In this book, I tackle these questions and challenge those in the environmental media industry to reconsider their own choices and obligations. I also hope that these behind-the-scenes reports will serve as a wake-up call to viewers who may not fully realize that they are watching unethically made wildlife programs and are thereby encouraging continued exploitation.

I am writing this book to try to change the industry by being open about my own challenges and failings as a human being and as a filmmaker. I want to show the complexities of making wildlife films in an ethical manner. It is not easy to pull back the curtain on the industry's failures—and even harder to reveal my own—but I believe the time has come for wildlife filmmaking to move in a healthier direction. We, as a society, cannot afford the malignant race for ever higher ratings to further corrupt the quality of these programs.

I believe that wildlife filmmakers have at our disposal one of the greatest tools ever conceived to sway public opinion—a tool so powerful that, with its influence, we can actually change the future for all life on this planet. Film gives us the potential opportunity to educate and inspire every single viewer to move closer to nature and to treat the other inhabitants of this planet with more dignity and respect. Let's seize this opportunity.

CONFESSION ONE

I Knew Almost Nothing
about Wildlife
(and Even Less about
Making Films)

CHAPTER ONE

Wildlife Nightmares

ONE OF MY FIRST hints that wildlife filmmaking would not be what I expected and that I would have to first confront my own basic ignorance before even attempting to make a wildlife film came soon after I started working as a lobbyist for the National Audubon Society in 1980. I had come from Capitol Hill and the Environmental Protection Agency—two places where you're more likely to need protection from power-hungry colleagues than from predatory bears. So when I gathered with several hundred other environmentalists in Montana's Glacier National Park for a conservation event, I quickly found myself out of my element.

Rumor had it that two young women had been killed by bears in the area. Although the other attendees, who included bearded Greenpeace organizers as well as well-off land barons from the Nature Conservancy, seemed to be taking this information in stride, I felt anxious. I had recently become a father, and although I wanted to support environmentalism, I also didn't want to be mauled to death by a 500-pound grizzly.

As a dozen or so of us gathered around a park ranger one evening, I

took the opportunity to try to allay my fears. "Is it true that two different bears killed two different women all on the same night?" I asked. I really wanted to hear the details, along with any hints for how to avoid becoming a victim myself. Although my mind suspected otherwise, my body felt sure that bears were lurking beyond every turn in the trails, ready to pounce.

The park ranger smiled gently at me. "Yes, sir, two women. Died, both of them. Nineteen years old. Sad. Very sad."

I needed to hear more. "Were they ganging up on people that night for some reason?" I was still searching for some survival tips I might use to protect myself from a bloody death, some action taken or avoided that would protect me from ursine jaws if I ventured out into the wild.

The ranger shook his head. "No, sir, that's not how bears act. They're just animals trying to survive."

"But there must have been something that each of the women did wrong, or maybe the bears had rabies or something?" I asked.

The ranger smiled again, diplomatically suppressing amusement or maybe even contempt. He was probably used to dealing with the paranoid fears of inexperienced hikers. "Many of us believe that the bears have gotten used to being fed by people and, having lost their natural fear, they become frustrated when there's no food for them. That's why we tell people not to feed wild animals."

I made a mental note to avoid feeding wild animals.

The ranger then turned and addressed the whole group. "Let me keep it simple. Bears don't want to hurt you. Use your common sense—hike in groups of three or more, stay alert at all times, make enough noise so you don't surprise a bear, carry bear spray, and don't run if you encounter a bear—and, of course, never feed a bear. Bear attacks are rare—really rare."[1]

He paused to swat away a fly that was buzzing near his face and then continued, "Enjoy the park. It belongs to you. Don't let fear rob you of the experience."

His sense of calm only partially diminished my fears. What was I, an English lad raised in the genteel Georgian circles of Bath in the west of England, doing in the wild American West, anyway? Why wasn't I back home, drinking tea in someone's parlor before a cricket match? Whatever had brought me here, it was too late now—fear or no fear—and I had caught the bug. I wanted to be here and to make wildlife films, and not even the paranoid fear of a bear attack could stop me.

In addition to learning how to avoid bear attacks, I was introduced to the basic players and principles of environmentalism that weekend. The rest of the crowd was feisty, buoyed by their recent policy accomplishments: Within the previous decade, environmentalists had successfully pushed for the creation of the Environmental Protection Agency, the President's Council on Environmental Quality, the celebration of Earth Day, and the passage of the Clean Air Act and the Clean Water Act. Our cause had been elevated in the public's mind, embraced by schoolchildren and grandmothers alike. We had a lot to celebrate. Even as a latecomer to the party, I felt that sense of optimism and energy.

But the past decade had also seen a meteoric rise in the cost of oil, economic slowdown, runaway inflation, and resolute lobbying by the Chamber of Commerce and other conservative forces determined to protect their profits against sensible regulation. Yes, environmental causes were being advanced, but they were far from unopposed.

Specifically, we environmentalists had gathered in Montana to devise strategies to defeat the virulent antienvironmentalism of the new Reagan administration, whose front man was the new Interior Secretary James

Watt. Watt had become a household name because of his extreme right-wing views. The Conservation Foundation had titled the meeting "The Environmental Decade"—and all of us wondered whether it was named for the decade that had just passed or for the decade ahead.

One of my friends on the trip was Grant Thompson, who worked for the Conservation Foundation. Grant was everything I wasn't: experienced, confident, and knowledgeable. A Westerner by birth, seasoned by stints at Oxford and Yale Law School, his love for the great western parks and vistas was unrivaled. He could be overwhelming with his knowledge and enthusiasm, but his Quaker demeanor brought gentleness to his intensity. And intense he was as he grabbed my arm, swept us around in a circle, and shouted, "Hey, Chris! You are so damned lucky! To be alive *here,* in the midst of God's country!"

"What on Earth could be wrong with surrounding yourself with a million or more acres? Untamed wilderness! Grizzlies! Wolves! Bighorn sheep! Golden eagles! Trees! Mountains! The Earth carpeted with wildflowers! The night sky like Cleopatra's jewel case! Just breathe in, gather your strength, then go home and fight like hell to make sure that we don't let anyone turn this paradise into a slag heap."

Grant went on to assure me that despite the attacks that killed two young women, the chances of getting attacked by a grizzly bear in Glacier National Park were remote. Grant's words supported the unflappable park ranger's assurances I had listened to earlier in the day.

Like the many other environmentalists I was to meet over our days together at the park, Grant urged vigilance. "Glacier won't stay pristine if Watt has his way. He'll rape and pillage the natural world because he thinks God has asked him to."

"Is that really true?" I asked him.

6

"You bet it is. We Quakers have a saying: 'Let your life speak!' And Jim Watt's actions are practically shouting that people come first. I'll give him the benefit of the doubt—I think Watt genuinely believes that nature's gifts are here to be exploited to benefit the current generation. He's the sort of guy who interprets the Biblical language giving man 'dominion over the fish of the sea and over the birds of the heavens and over every living thing that moves on the earth' as God's direction to dig, clear cut, dump, and drain. It's as if we are the final generation of humanity to live on this beautiful planet and dominion means 'take it all for us right now.'"

"Are you serious?" I said. I didn't know a lot about James Watt, but this description of him by Grant sounded harsh. It surprised me coming from my friend, who I knew to be levelheaded, not an extremist.

"You are damn right I'm serious," Grant responded. "Watt favors the development and use of federal lands by logging, ranching, and mining interests. Rivers are for damming and overfishing. He is openly antienvironmental and is doing everything in his power to promote commercial leasing for oil and gas development in wilderness areas."

"Does he see no benefits to conservation at all?"

"It doesn't seem that way. He openly brags about his determination to mine more, drill more, and cut more timber."

"But that doesn't necessarily mean he's opposed to sensible conservation," I insisted.

Grant was firm. "James Watt sees conservation as fundamentally inconsistent with the American way of life. He truly believes that the relentless consumption of resources is good public policy, little more than what the human race deserves. He sees environmentalism as a Machiavellian plot to weaken and subvert America."

My conversation with Grant took place early in the week. To many

of my colleagues in the environmental movement, including Grant, my thinking appeared hopelessly naive. It seemed to me that private industry would want to make money but that it was government's job to make sure that natural resources belonging to all of the country's citizens, including our children and grandchildren and beyond, were not sacrificed for present, private consumption. I was aware of the fact that many Republicans favored development, but I guess I had never understood how fundamental the split between the parties was. I thought that surely everyone agreed that we couldn't just take it all, indifferent to balance in nature. I didn't understand the way bears thought about their world, and I didn't understand how James Watt thought about the environment those bears lived in.

I decided to confront my fears about bears directly and at the same time learn more about how Americans thought about their parks and wild lands. Early in the conference week, I hiked into the hills. Within thirty minutes, I realized I had violated one of the park ranger's rules: I was alone. My fear returned and I found myself gripped by the idea that a bear was tracking my every step, planning a bloody revenge on me for the sins of hunters and trappers. I shortened my hike, terrified by the thought that I might not return to the conference before darkness fell.

At dinner that night, I sought Grant out again, feeling the need for more information. I confessed my certainty that my hike had put me in grave danger. He smiled as I talked. "Chris, it's a lucky thing for you that sitting in Quaker meetings has taught me patience," Grant said. "Let's face your fears together, shall we?" I knew I could trust his knowledge and his genuine concern that I should set aside the terror that might later prevent me from experiencing the natural world.

"Look, it's true," he replied, "In 1805, Meriwether Lewis said he'd rather

fight two Indians than one bear because he knew of grizzlies' formidable strength and aggressiveness. But grizzly bears' normal behavior is to avoid people if they can. Attacks are very rare. Looking back to 1900, there have been only about two attacks a year in the wild this century—and compare that with the fact that there are at least 15 deaths a year from dog attacks."

"Aren't you afraid when you go hiking?" I asked, unconvinced.

"Not at all," Grant replied. "Bears have lots more to fear from us than the other way around. They just want to be allowed to live in peace. If we keep our distance, protect their habitat, and show two ounces of common sense, they'll avoid us."

Grant added scornfully, "Sure, some people are idiots and shouldn't be surprised when they get hurt. I remember once in Oregon watching a tourist at Crater Lake lie down on the ground six feet in front of a black bear, presumably to get a better camera angle. What a fool! Only a ranger stopping that nonsense kept the bear from seeing him as food or an intruder."

"People have to realize," Grant went on, "that when they go to a place like Glacier, there is only an infinitesimal risk of becoming part of the food chain. I'm sorry when people get attacked and hurt, but most of the time, it's their own fault. They got too close while taking photos, or they didn't make enough noise while hiking and surprised a bear, or they got between a mother bear and her cubs."

I tried to make sense of what Grant was saying, but the power of fear still made it hard for me to absorb his message. It was just then that he got to the essence of what he was trying to teach me.

"You can manage and ultimately overcome your fear of grizzlies and other wild animals by learning about them," Grant said. "There's no need to fear them if you know how to behave around them and keep your distance. Believe me, Chris, you will come to love the place they occupy in

nature, and once you move away from fear, through understanding, to love, you'll be as crazed as I am to save space for them to thrive."

A glimmer of understanding began to form in my head.

Grant said, "The way we mistreat and abuse our wildlife is extraordinary. Earlier this week, as I was driving around outside Glacier before arriving at the conference, I could see enormous clearcut areas in the forest. That's bear habitat destroyed by extraction industries that have Watt and his kind as their allies. Snuggled against the boundaries of the park, you'll find strip mines, oil and gas projects, housing, and logging projects. These all threaten and endanger bears."

I was quiet for a moment, turning Grant's words over in my mind.

Grant threw out a final verbal punch. "Bears are symbolic of wildness, and their homeland is being decimated by the explosion of clearcuts, golf courses, ranches, homes, and shopping malls. We need to protect these animals from the onslaught of people. Animals have as much right to exist as we do. We need to learn how to live with them."

I had rarely seen my friend as worked up as he was then, and I began to understand the passion that drove him and so many others who were gathered together that week. His energy helped jumpstart my process of coming to terms with the damage that ignorance inflicted on my connection to the wild places on the planet. I realized that on one level, it made sense to fear a possible bear attack. On another level, I knew that my fears were rooted in ignorance of the natural world.

Much earlier in my life, I had learned that fear has many sources: Even far from wilderness and grizzly bears, the world was a dangerous place.

CHAPTER TWO

A Distressing Introduction to the Natural World

A FRIGID SILENCE GRIPPED THE boarding house and engulfed us; we all knew something awful and violent was about to happen. The sixty-odd occupants of the large baronial house— the master, the seven prefects (senior boys responsible for discipline), and the rest of us boarders (ranging from twelve to eighteen years of age)—became icily still. Several boys were about to be beaten for an infraction of the rules. The silence seemed to tightly wrap each one of us around the chest; adrenaline rushed through our veins, fueled by fear and intimidation.

Of course, for the victims, it was far worse. They stood petrified in their thin pajamas outside of the prefects' room, their hearts thumping hard. A prefect bellowed the surname of the first to be punished into the silence, chilling bone to the marrow. "PALMER!" The prefects ruthlessly asserted their despotic authority. Boarding school was a grim dystopia.

At the age of eleven years, I was sent to boarding school (not an

uncommon occurrence in British middle class homes), where the routine infliction of pain was an accepted feature of daily life. The social culture at boarding school in the 1950s was suffused with a dark sense of foreboding, perpetuated by the autocratic school prefects, whom I feared and loathed.

My experiences with animals were no more comfortable or agreeable than my experiences with prefects. The feral nature of boarding school shaped my initial understanding of the natural world. For the most part, wildlife and nature issues were not on my family's radar, but when they were, the experiences were usually unpleasant.

One afternoon, when I was about seven years old, my father and I were walking on the beach in Portsmouth, where my grandmother lived, on England's southern coast. The sky was a cerulean blue, and the day was balmy with delightful breezes. By chance, we came upon a group of twenty or so teenagers who had caught a very large and beautiful crab with a gorgeous, iridescent shell. "Christopher, look at the huge crab," my father said. But instead of admiring the now helpless creature, the teenagers brutally plunged a large knife through it. I was stunned by their cruelty.

My father held my hand tightly as we stopped for a moment and then, shocked, briskly walked on. Feeling conspicuous, we hurried our pace to get away as quickly and quietly as possible. Although neither of us said a word, I suspect that my father hoped I would soon forget the incident. Nonetheless, I realized, not for the first time in my life, that there was vicious cruelty in the world disguised as mundane and quotidian banality.

Even when people were not involved, cruelty revealed itself. Our pet cat caught birds, mice, and rats, none of which held much meaning for me, apart from giving me a vague sense of disgust and unease. I gave our cat's behavior little attention, except for one day, when I looked out of my bedroom window and saw her playing with—tormenting, really—a

live mouse. I watched as my heart pounded with a dreadful excitement.

Our well-fed cat appeared cruel and malicious as she toyed mercilessly with her catch. I thought that the predator might be wearing down her prey so that the mouse would be too exhausted to injure her with a defensive bite. Yet, after observing the awful process for a few moments (before racing downstairs to save the mouse), I couldn't help but feel that our feline pet actually obtained pleasure from the mouse's suffering, or at least from its pitiful and futile attempts to flee.

Something about the mouse's flight response fascinated and excited the cat and turned it into an egregious tormentor and torturer. I didn't know what to make of all of this, but it gripped and scared me.

Growing up, we rarely could afford fancy vacations, but once we stayed for a week at an inexpensive hotel in Looe, a seaside town in Cornwall on England's south coast. My father's commanding voice jettisoned us out of the hotel each morning with a hearty "Off you go, you boys!" My twin brother, Jon, and I were delighted to be set free to do whatever we liked.

And we knew what we liked: We were drawn to the killing fields at the docks a few blocks away. My parents had chosen to stay in a coastal town that happened to be the headquarters of British shark fishing. I didn't even know sharks swam in the English Channel until I discovered that every day, a fleet of small fishing vessels left Looe Harbour to hunt and kill them.

Jon and I were about ten years old, and during that vacation, we saw sharks lying bloodied and lifeless in the boats after having been caught and killed. Every evening, Jon and I would scout out the shark boats as they returned with their kills. Boats typically carried half a dozen dead sharks, each about ten feet long, and there were scores of boats. Amazed at how many sharks they could find day after day, Jon and I found the whole endeavor morbidly fascinating. Were the sharks killed for sport

or for their fins, meat, or liver oil? Whatever the reason, I was struck by how harmless the sharks seemed to be compared with the violence of their human predators.

Sharks fascinated me, but dolphins intrigued me even more. In the 1930s, my father was a young naval officer researching ship design, focusing particularly on how warship hulls could be shaped to allow them to cut through the water faster. His supervisor had noticed how fast swimming dolphins are, so my father was assigned to go into the English Channel, harpoon a dolphin, bring it back to the dockyard testing tanks, and drag it through the water to see why and how it could swim so fast.

The idea was that ship designers like my father could learn something from dolphins that would enable them to build faster and more agile ships to outmaneuver and outrace Hitler's navy. The Royal Navy supervisor assumed, naively and erroneously, that a dead dolphin and a live dolphin were pretty much identical when it came to the mechanics of their bodies while swimming. Testing in a dockyard tank revealed nothing, but something else my father told me in passing grabbed my attention.

"When the dolphin was harpooned and writhing in agony," he said, "all the other dolphins gathered around it, making what seemed to us like anguished sounds. We were astonished to see this display of sympathy and compassion. The pod looked like it was trying to comfort its wounded and dying family member." This story seeped into my brain and my bones. I had no idea then that later on, dolphins would play a significant role in my professional filmmaking life.

Sensitivity to animal suffering, or lack thereof, also arose in another childhood context. As a boy, I loved gently rubbing my cheek on my mother's luxurious fur coat. Gorgeously smooth, it exuded a visceral comfort that both my mother and I appreciated.

Undeniably soft and warm against the chilly English climate, the fur was also a status symbol. My mother valued her fur not only for its warmth but perhaps even more for how it elevated her socially. None of us in the family ever thought about the pain and suffering involved in its production. We didn't know that animals used for fur are kept in cramped wire cages and go psychotic from stress before being electrocuted, strangled, drowned, or bludgeoned to death.

Despite the fur coat (an extravagance my mother received as a wedding gift), my parents had an admirable habit of thrift, born out of their transformative experiences during World War II as well as my father's deprived, working-class childhood. They both believed they needed to make everything count.

Even though my parents were financially secure and my father had a successful career, my parents didn't think anything justified waste. To leave the tap water running while you brushed your teeth was unacceptable behavior; leaving a light on in a room with no one in it struck my parents as shockingly wasteful.

"Don't waste that!" my father ordered when I looked like I might toss away a plastic bag. Every plastic bag, however shabby, was washed and used over and over again. Growing up, I remember our kitchen being festooned with raggedy, tattered plastic bags drying out over the sink, ready to be used yet again for storing lettuce or other food items in the fridge.

My parents never threw away anything because they believed whatever it was might be useful later on. Everything was reused until it wore out. My father wore clothes until they became threadbare. To do otherwise struck him as just plain wrong. In fact, that threadbare look was a source of pride, not shame. It showed that the person wasn't being wasteful. With four boys in an expensive private school, my parents didn't have

much money left over, so they had practical as well as moral reasons not to be extravagant.

This frugality on my parents' part and the value they placed on not wasting natural resources taught me some of the fundamentals of environmentalism and conservation. Still, my childhood left me ill-prepared for a career as a wildlife filmmaker because I had very little interaction with or understanding of the natural world in those early years.

Perhaps it was the infrequency of my brushes with nature that planted the seeds of my later interest in wildlife. For example, seeing the Pyrenees Mountains between France and Spain when I was twelve years old filled me with awe. For a child who grew up on the relatively flat terrain of southern England, the unbelievable height of such majestic vertical rock faces was a revelation. The magnificent scenery inspired me with wordless joy. For the first time in my life, I felt viscerally thrilled by the sheer beauty of the natural world.

There were other sources of joy, too. An incident when I was about seven or eight years old—before the years of boarding school—played a big role in shaping the person I became. Every day, Jon and I had to walk over a mile to and from school. We invariably felt tired and sluggish at the end of the school day and would allow ourselves to get distracted and delayed on the return trip, which often made the journey take quite a while.

One day, however, Jon and I raced home from school in an astonishingly short time; we had an exciting project at home awaiting us, something we had invented ourselves and were frenetically eager to work on. Our usual fatigue and lassitude vanished as we rushed back, our mood electric.

Once there, we scampered to a secret hole we had been digging, a fortress in the garden that went down into the earth about four feet. It was

magical and thrilling—a secret hiding place that no one else knew about. Jon and I had dug it out with our own hands, and we, on our clandestine adventure, wanted to dig deeper. We also created a cover for it, so it remained hidden.

It was our treasure, our adventure, our accomplishment, and I felt energized every day in school by having something to run home to that seized my imagination and creativity. I had discovered how incredibly fulfilled, and happy it made me feel to have a lucid and focused goal. It was a new experience for me—an epiphany—and I vowed to repeat it.

CHAPTER THREE

Politicians and Other Wild Animals

I **STOOD AT THE BACK** of the room in the Dirksen Senate Office Building waiting for my turn to testify on the nation's solar policy. My papers crinkled in my hand as I glanced down at them, going over my key points. I had prepared answers to the hardest questions I could think of, so that if a hostile senator asked me tough questions, I would not be caught off guard. But today, only two senators attended the hearing and both asked easy, friendly questions. Preparing my testimony took three or four days of work. Was it worth it? I had serious doubts.

Testifying before Congress carries a whiff of glamour, but days spent in diligent preparation usually produce disappointing results. Hearings on Capitol Hill were often sparsely attended. People like me gave impassioned presentations to the few attending congressmen and -women, only to be interrupted by questions from them that made it clear they were barely listening.

I had begun my journey to the Dirksen Senate Office Building about ten years earlier. In the early 1970s, when I first arrived in America, there was a growing consciousness in society about the importance of conserving

the environment. Rachel Carson's pioneering book *Silent Spring*, the fetid Cuyahoga River in Ohio catching fire, and the Santa Barbara oil well blowout had all led to a rapidly rising awareness of how thoroughly people were fouling the Earth and making it unlivable.

The founding of Greenpeace, Friends of the Earth, and the Environmental Defense Fund and the work of luminaries and activists like Barry Commoner, Paul Ehrlich, Farley Mowatt, and Garrett Hardin inspired me. Further, I was disgusted by America's growing air and water pollution and by the loss of wildlife habitat and biodiversity.

I realized that clean air, clean water, renewable energy, and healthy wild land were important and worth fighting to protect. The environment was a cause about which I felt passionate in a way I never had in my previous career.

In my late teens, not knowing what I wanted to do with my life, I meekly followed my father into naval ship design for the Royal Navy. My father's lifelong focus on warships and submarines had propelled him from a working-class background in rural Wales to the top of his profession. His work won him high recognition from the Queen, who bestowed prestigious awards on him.

But the truth was that designing warships didn't interest me. Important as ship design is to military strength and the success of the Navy, I wanted to devote my life to something more inspiring and less militaristic. I yearned to recreate the sense of purpose I experienced as a little boy excavating that secret hole in our backyard. I longed to find an honorable cause to support that would do something to improve the world. My goal was to throw myself into a noble social movement, something far bigger than me.

No great life event triggered my realization that I wanted to dedicate my working life to conservation and protecting the environment. There

was no epiphany or revelation, just a gradual awakening fueled by books, lectures, articles, and films. Vivid images of polar bears, poignant footage of humpback whales singing, and inspirational words (such as Margaret Mead's "Never doubt that a small group of thoughtful, committed citizens can change the world; indeed, it's the only thing that ever has") all spurred me to pursue this line of work. I felt at the deepest part of my being the necessity of protecting the air, water, land, and animals from abuse and exploitation. It was, I sensed, the right thing to do.

Although I craved my father's approval, I realized with increasing clarity that if I devoted my life to warship design, I would never be fulfilled. So I left my work in engineering and searched for ways to break into environmental protection and energy conservation. Admittedly, my interest in these topics was partly driven by a desire to separate myself from my father, but I could have chosen many paths other than this one. To my relief, my father didn't object to me changing careers. A tough disciplinarian when I was young, my father, to his credit, softened as he got older and wanted me to follow my dreams.

Follow my dreams I did. I left the British Navy; earned an advanced degree from the Kennedy School of Government at Harvard; and then worked for the giant consulting firm Booz Allen, for a US senator on Capitol Hill, and at the Environmental Protection Agency as a political appointee for President Jimmy Carter.

After Ronald Reagan defeated Jimmy Carter in 1980, I left the government (the new Republican administration replaced Carter operatives like me) and joined the National Audubon Society as a senior lobbyist. After a year or two, I came to view tasks like testifying on the virtues of energy conservation or solar energy as not having nearly the impact that was needed.

I realized more needed to be done to convince people to take conservation seriously, and I started to look for new ways to win converts to conservation and shape public opinion. I proposed to the board of the National Audubon Society that we create a for-profit company to help homeowners purchase solar panels for their houses, that we create a second company to advise investors on which stocks were clean and worthy of their support, and that we create a third organization to spend serious money on influencing voters. This third company would help elect legislators who supported sustainability and conservation.

Almost as an afterthought, I also recommended that Audubon produce a film on conservation to show on Capitol Hill and on television. I knew nothing about television, so I was in way over my head with this idea.

The Audubon board rejected my ideas one by one as being too risky, too expensive, or too unrelated to Audubon's core mission. As a sop to me and to stop me from feeling resentful of the rejections, they told me that I could work on the film idea.

My thought (which seemed novel at the time) was to invite celebrities to host prime-time, hard-hitting environmental documentaries about conservation policy issues. The point was to combine sugar and spinach. Conservation was important, but people were not going to come home from a hard day's work and plop themselves down in front of the TV to watch educational programming. To get people to watch, our shows had to be leavened with entertainment, hence the inclusion of celebrities and the importance of crafting compelling stories.

I already knew of the power celebrities had to attract attention to the causes they cared about. When I worked on Capitol Hill in the 1970s, I had watched, fascinated, as the legendary actress Liz Taylor arrived for an unannounced visit to the Senate gallery and, in doing so, brought

the work of the Senate to a complete halt as senators gawked at her in stunned admiration.

Soon after I began working on the film idea for Audubon, serendipity struck. I heard that media mogul Ted Turner was looking to form partnerships with environmental organizations to create programs for prime-time television. While other organizations scrambled to develop ideas, I was ready to go—I had been working on television ideas for months. I immediately contacted Turner's key staff. They liked my ideas and introduced me to Ted, and we were off and running.

Well, not quite. As I described in my book *Shooting in the Wild*, the biggest obstacles I had to surmount were the ones from inside Audubon.[1] I spent weeks pitching my proposal to Audubon colleagues, explaining how the organization would benefit from getting into the television business. But antipathy and animus to the proposed partnership between Audubon and Ted Turner stubbornly persisted. Audubon board members worried that I was inexperienced and naive. Three senior vice presidents, concerned that my ideas for television programs were distracting the organization from its historic focus on *Audubon* magazine, tried to get me fired.

Fortunately Russell Peterson, then president of the National Audubon Society, rejected this advice, and Audubon and Ted Turner formed a partnership to produce celebrity-hosted, hard-hitting, prime-time environmental and wildlife shows for TBS Superstation and PBS. In this way, we hoped to reach and influence the people who elected our lawmakers, thus bringing to Capitol Hill the type of legislators who would support conservation in the first place.

I was excited to work with Ted Turner. He embodied everything I loved about Americans, who had always struck me as being people driven

by ambition and audacious goals, reveling in a buoyant optimism and practicality, remaining indifferent to class or heritage, applauding hard work and entrepreneurial zeal, lauding the self-made person, relentlessly pursuing constant self-improvement, and being fearless when it came to new and ennobling challenges.

Ted had a passion for conservation and the natural world, and he operated less on cerebral, logical thinking and more on intuition and instinct. He gave away $1 billion to United Nations causes such as fighting global poverty, not after ponderous strategic thinking but because, he told a reporter, he needed something interesting to say in a speech.[2] At the time, it was the biggest single gift ever made.

Around the time the Turner–Audubon partnership began to flourish, I was boarding a plane in Washington, DC, to fly to Atlanta. As I looked for my seat, I was surprised to see Ted waving and calling me over to sit with him. He was reading Lester Brown's book on the world's environmental challenges, and he told me he had ordered everyone at CNN to read it. Our energetic conversation lasted the entire two-hour plane ride, with him doing most of the talking and me listening. I remember two questions I asked him.

My first question was, "How do you plan your work?" He replied, "I don't plan it. I just do it."

Then I asked him, "Surely you must have a written set of goals?" He replied matter-of-factly, "Nope. I don't need them." Pointing to his head, he added, "They're all up here."

Both answers amazed me, but they were consistent with Ted's seat-of-the-pants operating style.

My new career as a filmmaker amazed me, too. I had an enormous amount to learn. When I started, I knew nothing about the television

business or producing films, but I threw myself into it with fierce determination and hard work, traits I learned from my father.

With Ted Turner's support, I commissioned films on a wide range of topics (from condors to wolves and from climate change to overpopulation) for TBS Superstation and PBS and combined them with aggressive outreach. Ted and I viewed our films not simply as films but as campaigns. We were out to save bears, sharks, wolves, and many other creatures, not to simply show pretty pictures of them.

We faced opposition to some of our films from Audubon board members, many of them hunters, who felt that we cast hunting and trapping in a bad light. But the severest opposition came from the ranching, lumber, and other extractive industries, who unleashed punishing boycotts against Audubon and Ted's networks because our television programs openly criticized them.

Our films forcefully pointed out what was happening to the air, water, land, and wildlife. This stance angered public lands exploiters and all of those, including James Watt, who wanted to remove environmental protections and give priority to economic and commercial interests over conservation. Our message triggered an intense and harsh backlash. I was in television to promote conservation, but I was jarringly reminded that advertisers and sponsors had different motives and were prepared to boycott our shows to get their way.

Now Ted Turner had to choose between his commitment to conservation and his network's interest in ratings and revenue. As I described in my book *Shooting in the Wild*, he chose conservation. Ted refused to kowtow to the demands of our critics, who insisted that our films not be shown on his network. Owing to decisions like these, Ted Turner is the kind of broadcaster that every filmmaker dreams of working with: He is a leader

willing to stand up for something beyond ratings and profits and who is deeply concerned about the social impact of his programs.

It was through my filmmaking work with Ted Turner and the National Audubon Society that I began to come into contact with wild, charismatic, and big animals for the first time. It was at this point in my career that I visited Glacier National Park and talked with Grant Thompson. As I learned more about the natural world from friends and colleagues like Grant, I realized that wild animals like grizzlies, sharks, and wolves have far more to fear from people than people have to fear from them.

Despite my growing understanding of wild animals, I was ill-prepared to survive in the wild, cutthroat industry of television.

CONFESSION TWO

I Put Ratings above Everything Else

CHAPTER FOUR

Dumbing It Down

ONE DAY, I WAS sitting in a lavish meeting room at TBS, struggling to listen to feedback from executives on an early version of a film we were producing on wildlife migrations.

The top executive, a six-foot muscle-bound individual with slicked-back blond hair, turned to my colleagues and me and screamed, "The film has to say why these animals migrate, and I know why they migrate—SO THEY CAN F**K!"

The executive glared at those of us responsible for making the film with bulging, frustrated eyes, as if what he was saying was obvious and we just weren't getting it. I didn't mind the suggestion that the film would be improved if we were to state more clearly why animals migrate, but the way it was delivered was crass and unprofessional. Right or wrong, though, the executive's words shot straight to the heart of what he and his colleagues really cared about: ratings.

Part of me wanted to walk out on this guy because he was arrogant and excruciatingly shallow. On the other hand, he was an experienced television executive, and I realized I might be able to learn something from him.

So I bit my tongue, hoping that listening would be a better strategy than fighting back.

Even before this incident, I had realized that my relationship with the television industry was fraught with tension and lack of understanding. It was not a place where I felt at home. I came from the nonprofit world, in which people were ready to make personal sacrifices to further a noble cause like environmental protection, but I was now inhabiting a world in which commercial transactions were the highest goal and where the commodities exchanged were essentially trivial. I had a serious case of moral haughtiness, a feeling of being ethically superior to the television executives all around me.

Near the beginning of my television career in the early 1980s, I was excited to attend an enormous annual television industry event in Las Vegas called the National Association of Television Programming Executives (NATPE). I didn't know how naïve I was about what really happened at these sales events and how little there was to be excited about.

NATPE is a global television programming trade show where, for the most part, cheap and tasteless television programs, supported by massive marketing and promotional budgets, are bought and sold. It draws over 10,000 television programming executives from all over the world. There are no awards for best series and no pretense that anyone is there to assess artistry or quality in filmmaking. I attended because if my television shows were to succeed, I had to find buyers for them abroad.

I walked around the sales floor feeling self-conscious and absorbing the loud, flashy, cacophonous atmosphere where everyone was selling and buying television programs. Mammoth banners and signage proclaimed the names of popular prime-time shows such as *The A-Team*, *Baywatch*, and *MacGyver*.

Nothing was subdued or subtle, with showmanship and extravagance being endemic and flaunted. As I walked around the sales floor past lavish sales displays reaching high into the air, a vast array of giveaways, freebies, and perks tempted me to visit vendors' stands, with most offering free food and drink. Signs of profligate spending and hyperaggressive promotion were everywhere.

NATPE was all about making money and totally alien compared with my customary work setting, which was focused on saving the environment. There was something melancholy about the garishness of it all; the selling and buying on the sales floor certainly seemed disconnected from the conservation documentaries I was producing. It felt as if I had said I was going to save the oceans and then pursued that goal by sunbathing on an opulent yacht.

I was also (as a new and proud immigrant) mortified to think that the gaudy and flamboyant flashiness that suffused NATPE was the face of America that the rest of the world saw via our television programming. I reflected dolefully on how American television shows, so popular around the globe, portrayed a self-indulgent, decadent way of life.

My interest in television was in nonfiction and documentaries, particularly wildlife and environmental programs. But I soon realized that even in this area, ratings are king. Attending NATPE made me appreciate that if I was going to succeed in television, my programs would have to achieve high ratings. What rating a show or series was likely to achieve was the main issue attendees at the convention wanted to focus on.

While walking the sales floors, I saw a large crowd of men (this was the early 1980s and virtually everyone at NATPE was white and male) and wondered what was going on. Someone told me that the film star Jane Seymour was there to promote her television series *Dr. Quinn, Medicine*

Woman. My wife and daughters loved this series about a doctor on the American frontier in the nineteenth century. A celebrity photo session was being offered, and I lined up eagerly to have my photo taken with Jane Seymour, who was patient and charming.

I collected the photo and took great pleasure in anticipating the amusement it would provide my family, while also realizing that I had participated in an inconsequential trifle. The frisson inspired by meeting Jane Seymour soon evaporated. I was beginning to realize that the world of television was full of empty distractions that, despite my smug self-righteousness, I could easily get sucked into because I was young, eager, and inexperienced.

As the day progressed, I found it mentally draining to keep up a cheerful façade as I ventured around the various booths hour after hour, trying to look as if I belonged there. By the end of the day, I felt like wilted lettuce. The fake smiling, sore feet, and sense of being an outsider brought on a crushing mood of ennui that made me yearn to escape.

CHAPTER FIVE

The Boring Crusader

"**D**OLPHINS HAVE ACTIVE SEX** lives," I told the audience of ad salesmen, who sold TV ad time on TBS Superstation to companies like Budweiser and Honda. The group suddenly came to life with guffaws and sniggers. Our next film was on dolphins and at last I had their attention.

After giving several tepid and poorly received presentations to these tough businessmen (yes, once again, this group mainly consisted of men), I eventually realized that I needed to spice things up if I was going to capture their interest. When I spoke to them, their eyes tended to glaze over, and the looks on their faces reflected only bored indifference. So I tried to make my presentations more interesting by talking about the flashier aspects of our programming, like animal sex, that I knew would grab their attention. I was vaguely ashamed of myself for pandering to the sales team, yet, at the same time, I was proud of myself for successfully connecting with them at last.

Moments like these aside, I often recognized despondently that my identity in the world of hard-nosed TV executives was one of weakness.

Nonprofit organizations, such as the National Audubon Society where I worked, are sporadically useful to television networks because they help to add gravitas to a network's documentary programming, but nonprofits and their representatives are also viewed as naive about the commercially based entertainment world.

The TBS ad sales people viewed the National Audubon Society and its senior leaders (like me) as idealistic and ignorant. Whenever I gave pep talks to the Turner salespeople to tell them about our upcoming shows, I realized that they saw me as some kind of pathetic, unsophisticated naïf, with little understanding of what it takes to grab viewers' attention. I must admit that their opinions were not entirely inaccurate, as I was no expert in popular culture or what appealed to the average Joe watching television. Nonetheless, I hated to be viewed and diminished as such.

In a sanctimonious way, I pitied these sales guys. They sold television ad time (for our series and others) in an arena where nothing mattered except money. To me, their work lives seemed empty and shriveled, whereas my career was meaningful. I felt that I was a moral crusader and they were simply trying to make a buck. I felt that I was saving the environment and working on one of the world's great causes, whereas they were simply after ratings so they could earn higher commissions and bonuses. Yes, I was after ratings too, but my goal was to promote the big, ennobling cause of conservation, not just to put cash in my pocket.

The truth was that I was immature, judgmental, and arrogant. I may have been on the right side of history (putting a higher priority on protecting the natural world and the creatures within it than on making a network profitable), but I was also self-important, failing to fully appreciate how my success depended on theirs. The salespeople—gritty, down-to-earth, and diligent—probably aspired, like me, to accomplish something

worthwhile with their lives and be part of the team that made TBS a highly successful and well-regarded network.

There was one area that TV executives grasped far more profoundly than I did, and that was the importance of ratings. Networks live and die by them. Although the sales guys knew this, I was slow to learn it, despite my attendance at NATPE in Las Vegas. Only in time would I realize that a noble film with an important social message is no better than a trashy film if no one watches it. Without an audience to view a film, all the work and money that goes into making it is wasted.

I was faced with a dilemma in making wildlife documentaries. On the one hand, I wanted to produce films that were scientifically rigorous and responsible. On the other hand, I wanted to attract a large and general audience, and I knew that I would have to entertain them to achieve that goal.

CHAPTER SIX

The Ardent Pursuit of Ratings

WAS EXCITED. MY PARENTS, who lived in Bath, England, were visiting me in America, and I was eager to show them my first film. It was 1984, and I was convinced that television could, if used wisely, inspire people to improve their lives and the planet. I was proud of the work I was doing and the new career I was pursuing, and I looked forward to sharing it with them.

My work was just one small piece of the bigger picture that excited me. I was in awe of wildlife cinematographers, who were tough as Marines and willing to film for days, weeks, or even months just to capture a few minutes of useable footage. David Attenborough's landmark series *Life on Earth* (1979) captivated me; the stories of pioneers like Jacques Cousteau, Hans Hass, and Alan Root enthralled me as well.

In my view, compelling imagery was an effective way to build environmental awareness and engagement. Without wildlife films, many people (especially those living in cities and disconnected from nature) would have little knowledge of the myriad diverse species with whom we share our planet.

I saw film as a powerful tool to alert viewers to environmental threats. In fact, I believed film was the best way for activists like me to reach a large number of people in a short amount of time and awaken consciousness about the need for greater environmental protection.

I believed my time was well spent producing films and videos because media shapes what people think and could ignite citizen action. Movies that glamorized smoking encouraged people to smoke. Why couldn't movies glamorize conservation and make it appealing to a mass audience?

I knew that a single image—for example, a picture of a starving little girl to represent the dreadfulness of famine—could be more effective than reason and statistics in instigating change. Seeing striking images of threatened wildlife and wild habitat was, I smugly assumed, going to help viewers connect personally to conservation issues.

All of this seemed obvious, and I never thought to question it. I was confident my life was at last heading in the right direction.

So when my parents came from the United Kingdom to visit, I was eager to give them an inkling of what my new life was like and how exciting it was. The film I wanted to show them was a documentary I had produced about condors—magnificent birds with over nine-foot wingspans—which was narrated by Hollywood star Robert Redford.

I sat my parents down and started the film, anticipating accolades and approbation. But after a bit, they both got sleepy and dozed off. It failed to keep their attention and engage them, and I felt deflated. My sleeping two-person screening audience showed me that I had to make my films more entertaining if I hoped to attract a wide viewership.

Experiences like that one taught me a dangerous lesson: A good message wasn't enough. Films needed high entertainment value and powerful stories. Ratings became incredibly important to me. I realized that

without high ratings, I would fail and my career as a wildlife film producer would come to an ignominious end. Producing high-quality documentaries on important environmental and conservation issues wasn't enough.

Still, my stated mission was to achieve conservation, not high ratings. I tried to convince myself that if a program got high ratings, it would have a high impact on conservation. I wanted to see ratings and conservation as synonymous. As it turned out, I wasn't all wrong, but I wasn't entirely right, either.

Visiting the National Geographic Society encouraged me to think this way. When I first got into television in the early 1980s, the National Geographic Society had pioneered the use of television to advance its mission. Since the 1960s, the venerable organization had been producing scores of highly esteemed and popular films for TV. It made sense for me to learn all I could from them.

Dennis Kane had headed up National Geographic's television programs since their inception in the 1960s. Urbane, self-confident, and knowledgeable, he knew everyone in the wildlife filmmaking industry. I asked to meet with him to seek his advice.

"Television has had a huge influence on the success of NatGeo," he told me. "Just look at the growth of our programs and membership. Since we got into television, our membership has grown from two million to eleven million. Television is the wave of the future."

As Kane told me more about the influence his highly rated television programs had had on National Geographic's success, the allure of high ratings dazzled me. They became my singular goal.

But not everyone saw a direct correlation between high ratings and a high impact on conservation. One of the people I got to know as I began my career in television was an insightful and erudite academic named

Derek Bousé. In his thoughtful and provocative book *Wildlife Films*, Bousé pointed out that conservation-oriented viewers were predisposed to agree with the conservation messages in a wildlife film and that conservation films tend to be watched by people already sympathetic to conservationist views.[1]

Even though some viewers may claim to have been moved by some film to take action, it is far more likely that they are predisposed in that direction and that the film simply acted as the trigger. Bousé believes that it is likely there are no actual conversions and that no single film can really be life altering or effect some kind of character reversal:

> A media message may act as the *trigger*, and you might say therefore that it was the *proximate* cause, but not the *ultimate* cause. If psychoanalysis has taught us anything it is that we often don't really know or understand what actually motivated us to do (or say) something. Our motives are unclear even to us, so just because someone claims in all sincerity that a film changed their life doesn't mean that this is necessarily true. Predisposition is almost always present in these cases.[2]

Bousé carried his erudition lightly. He disdained trendy academic jargon and disliked academics who assumed a tone of superiority in their filmmaking research—those who wrote from the seclusion of universities without ever learning the challenging mechanics and artistry of filmmaking.

He knew making films was hard because he had tried to do it himself. That experience increased his admiration for those filmmakers who had the competence and capability to take an idea and get it on the screen. Bousé knew that highly touted academic theories often appeared frivolous and pathetic in the harsh light of the real world of filmmaking.

"You do realize, Chris, that your films may not be making any significant impact?" he asked me one day over lunch.

"Excuse me?"

"You may be assuming your films are much more effective than they really are."

"But we receive letters from viewers saying how much they love the movies."

"I'm willing to bet those letters are from viewers who agree with your views on the environment to begin with."

"You're probably right," I mumbled.

"High ratings don't mean your show had a big conservation impact. In fact, you might be better off with your program winning a smaller audience that you really want to reach—say, members of the Senate Finance Committee."

Derek Bousé was undermining everything I had come to believe about television: namely, that the higher the rating, the better I was doing in terms of promoting conservation.

"What if a film you made," he asked me hypothetically, "was made unethically or contains misleading information or irresponsible sensationalism in an attempt to gain higher ratings?"

"That wouldn't be good," I admitted.

"Ratings don't necessarily correlate with conservation impact," Bousé concluded. "They certainly aren't in lockstep."

"So you're saying that the number of eyeballs viewing my programs on prime-time television isn't what I should be focused on?"

"Exactly," he replied.

After Bousé learned of all of the money I had raised to make environmental and wildlife films, he asked me, "How do you know that the money you've raised wouldn't be better spent in on-the-ground programs to conserve species and habitat? In other words," he continued, "what real evidence do you have that all of that money is actually accomplishing anything—other than just attracting more donors?"

I didn't reply, but I realized he had made a good point. The exchange made me brood on the issue.

Bousé also made me realize that programs about wildlife can have unintentional and undesirable effects, such as giving humans the impression that wild animals are safe to approach or that some species, like lions, are constantly in motion when, in fact, they spend most of their time resting. Bousé noted that another possible misconception could involve viewers' perceptions of the population density and vibrancy of some species, because they see so many of them on television so often.

He observed that the important variable in all of this is whether someone is a "heavy viewer" or "light viewer" of television. Heavy viewers are far more likely to believe that social reality is as television depicts it. In theory, then, the heavier viewer who sees more wildlife films may be more likely to believe that the natural world is as it is shown on television—a place of action and dynamism (the essential ingredients of TV).

In his book, Bousé told the story (which he credited to the art critic and novelist John Berger) of London housewife Barbara Carter. Carter won a "grant a wish" charity contest. Her wish was to kiss and cuddle a lion. She was taken to the lions' compound of a safari park in the south of England. As she bent forward to stroke the lioness, Suki, it pounced and dragged her to the ground.

Carter was admitted to the hospital in shock with throat wounds. Wardens said later that they didn't understand what had happened; they regarded Suki as "perfectly safe." Accidents like that are sometimes encouraged by wildlife films on television. Bousé pointed out to me that watching wildlife films can make people want to kiss and cuddle a wild animal like a lion because of the preponderance of close-ups that seem to put the animals in our intimate zone, where we usually encounter people who are close to us. This results, noted Bousé, in what is called a "para-social" relationship, in which we feel an intimacy with the animal, just as we do with human characters on television. A documentary about lions

might be intended to make the animals look fascinating and beautiful and therefore worth saving. But instead, it might carelessly imbue viewers with inane, myopic, and dangerous beliefs.

After talking with Derek Bousé, I realized I was deluding myself by trying to define my impact on conservation in terms of ratings. The issue of creating social change was more complex than I had realized.

Bousé's points sunk in even further one evening as I pulled into my driveway on my way home from work and spied a friendly neighbor. I called out proudly, "We have a show on wolves on PBS tonight at eight o'clock. I hope you can see it!" The information elicited little interest from my neighbor and made me realize that there were plenty of people that my work was not reaching. I was living in a bubble of self-importance; no one except card-carrying environmentalists cared about this stuff. Just as Derek Bousé had suggested, most of the people watching my shows on prime-time television were predisposed to agree with what the films were advocating; everyone else didn't care. Maybe wildlife films weren't as big a deal as I thought they were. If I couldn't convince even my own neighbor to tune in, what chance did I have with the general public?

Soon after this humbling interaction, I sat down on a routine flight to Los Angeles. The year was 1987. As my plane lifted off from Dulles International Airport, I started reading the book *Jaguar* by Dr. Alan Rabinowitz.[3] When I picked it up, I had no idea what impact it was going to have on me, but *Jaguar* held me spellbound as it described Rabinowitz's Indiana Jones–type quest to persuade the leaders of Belize to establish the world's first jaguar preserve. I kept reading, every page making me hungrier for more, until we touched down at LAX six hours later.

Rabinowitz, a wildlife biologist, has devoted his life to saving big cats, like jaguars and leopards, and has worked relentlessly to preserve huge sections of their pristine wilderness habitat. He knew that when top predators are given enough room in which to thrive, conservationists can save whole ecosystems, including other wild animals lower down the food

chain. For years, he has traveled the world as an international diplomat for big cats, working most recently through a nonprofit organization he cofounded called Panthera.

As a child, Rabinowitz had an appalling stutter, and teachers put him in special needs classrooms because they misinterpreted his stutter as a learning disability. He was angry and deeply upset that his teachers couldn't see past his stutter, so he stopped talking in second grade. Yet he still spoke to his pets at home, which led him to realize that they had feelings and, in a way, were exactly like him. His pets weren't inferior or broken in any way, yet people treated them badly because they had no voice and no way to communicate. Rabinowitz realized that animals shared a struggle not unlike his own: If animals had a voice, people would be more respectful and not treat them like disposable trash. His voice came back as he resolved to devote his life to giving big cats a voice and to fight for their protection.

As I turned page after page of Rabinowtiz's book, I marveled at the stories of this intrepid conservationist who lived among the Mayan Indians in the rainforests of Belize, studying jaguars and attempting to establish the world's first jaguar preserve. He battled with drug traffickers, crashed his small plane, and discovered a forgotten Mayan temple. It dawned on me that finding gripping tales and compelling, authentic characters like Rabinowitz could help me achieve high ratings—and satisfy the TBS ad sales guys—while conveying a conservation message at the same time. I began to see a way out of the dilemma between conservation and entertainment. Celebrities could only do so much. Real people and real stories were the answer. Rabinowitz had emotional authenticity and was grittily real and genuine. He was human and flawed and relatable. Even more important, he was driven to succeed, even if it meant breaking rules occasionally.

As I implemented this insight by making films about fascinating people like Rabinowitz, my career in television took off. But other parts of my life were struggling to keep up.

CONFESSION THREE

As I Learned about Filmmaking,
I Was Still a Clueless Dad

CHAPTER SEVEN

Conserving My Home Environment

WORKING DILIGENTLY TO BUILD my career as a wildlife filmmaker meant making certain sacrifices, like spending time away from my family to be on location, attend film festivals, and oversee multiple film productions. At home with my wife, Gail, I wanted to be a capable, loving, and effective father of our three daughters, but when I tried, the girls kept me at a distance. When Gail and I put our daughters to bed one night, I tried to cuddle with each one. All under ten years of age, they loved to wear colorful PJs, and their bedrooms brimmed with dolls, stuffed animals, drawings, and the bric-a-brac of childhood.

"Would you like to snuggle?" I asked my girls, each of them adorable, loving, and beautiful in her own way.

"No," came their answers, one by one, unknowingly inflicting wounds on my heart.

"Can I tickle your back?" I tried again.

"No, I want Mommy to," said one. Another pulled closer to Gail. They would only snuggle with their mom.

It hurt to be left out. Full of self-doubt and certain that I was failing as

a father, I wondered whether my own father had ever felt the same way. I suddenly had a new understanding of what he might have experienced as a parent. I realized just how hard a job being a father really was.

I wanted to be a better father and I wondered if I was devoting sufficient time to parenting. For a month, I kept a log of everything I did during the day and how long it took me. I discovered a massive discrepancy between how I spent my time and what I claimed was important to me. I would glibly tell people that my family was my top priority, but when I analyzed my schedule, I found that I devoted 90 percent of my time to my job. I realized that I was actually a workaholic.

My memories of my own childhood were still vivid: the nights I lay awake in bed, trying to fall asleep as I heard my father shouting angrily at my oldest brother, Jeremy: "Don't be so wet and stupid! How thick can you be, boy? Don't you understand anything?" *Wet* was my father's insulting term for anyone who was obtuse and pathetic. The harsh sounds and the high volume of these arguments kept me awake, my heart pounding with alarm. Would the yelling get louder? Would the anger get worse? Jeremy was the oldest of my father's four sons, and my twin brother and I were the youngest. I craved a household in which we would all live in harmony and shared laughter.

My father castigated and lambasted Jeremy for his shortcomings, baffled by why Jeremy was failing so miserably in his life. Instead of being captain of the cricket and rugby teams in school, my brother had poor exam results, smoked cigarettes, and got into trouble at school. This infuriated my father, and he was not subtle about telling Jeremy how he felt.

Despite all of the benefits of Jeremy's upbringing—privileged compared with the deprived childhood my father had endured—Jeremy was not what my father wanted him to be. My father believed the reason for

this was Jeremy's indolence and lack of ambition, and he was incensed. He had big ambitions for his sons, and his oldest son was struggling and failing. This isn't to say that my father didn't love Jeremy. He did. He just had no idea how to show it.

Everything my father did to try to help Jeremy succeed produced the exact opposite result. Cuffing, belittling, criticizing, censuring, and yelling achieved nothing. My brother detested this treatment and slipped further and further away from any desire to emulate what my father had achieved in his own life: a successful climb up the socioeconomic ladder.

Watching the slow deterioration of the relationship between my father and Jeremy had a significant impact on me and helped to shape the person I became. As a sensitive child in that volatile environment, I learned that I could easily be hurt and that I was vulnerable to forces outside of my control. Observing the widespread damage emanating from my father and Jeremy's failing relationship taught me that healthy relationships were the building blocks for a successful life.

I believe most fathers—even devoted ones—in the 1950s cuffed and clouted their kids to keep them in line, and my father probably used less corporal punishment than most. He was a thoroughly good and decent man who was totally devoted to his family, but he had a hair-trigger temper and little patience, which kept our family life in a state of constant tension. I inherited that irritability from him and had to work hard and exert a lot of self-discipline to get it under control.

Perhaps my father went through a similar process in learning to control his temper. A few years before he died at 87 years of age, he told my brother Tim that he regretted his past behavior. "You know, I often feel bad about how fierce I was with you boys when you were little," he blurted out one day. "I'm very sorry I was like that." Tim was momentarily stunned to hear

49

my father offer this deeply felt apology. My father had never said anything like this before.

It is interesting that my father as a grandfather to my daughters was the model of a warm, loving, and affectionate patriarch. He lavished love on them, playing catch, cracking jokes, letting them sit on his lap and eat his precious tomatoes, and teaching them bridge. He enlivened meals by recalling stories of his youth and heroic (my characterization, not his) service during World War II.

Now that I had a family of my own, I wanted to be a father who wasn't simply an awkward appendage to the nuclear group but a pivotal and integrated member. The feelings of rejection roiling around inside me prompted me to start thinking of innovative things I could do to play a more significant and meaningful role in my daughters' lives. So, over time, I became a serious student of what makes an effective parent. I studied parenting books and audiotapes to learn what other successful fathers had done to demonstrate their love and family devotion.

With Gail's support, I introduced new traditions and rituals to help build a strong family. One of the ideas I came up with was writing letters to my daughters every night I was away. I invested a lot of time and effort in these letters; I saw that my daughters really liked them and got a lot out of them. The letters were a way I could build a meaningful connection with them. I wrote to them about all sorts of things, such as how to give a dinner party, the importance of having a rich vocabulary, and stories about Abraham Lincoln and George Washington.

Despite my renewed efforts to be a good dad, I still occasionally tripped up. I would sometimes act like my father and lose my temper. I remember—to my undying shame—going to the basement one evening with our gentle and shy middle daughter Christina to help her hammer nails into a

piece of wood for a science experiment. She was perhaps six or seven years old—a quiet, reflective, and sensitive child. After she repeatedly missed nail after nail with the hammer, I rashly snatched the hammer from her and finished the project myself.

Later, remorse washed over me as I realized how ugly and toxic my impatience had been. The stress I had been feeling from work challenges was hanging over me and had narrowed my patience to a sliver. Still, that was no excuse for my behavior. I resolved to do better. I *had* to do better if I ever wanted my family to be happy and healthy. My first step was to apologize to Christina. "Sweetie, will you forgive me?" Of course, loving little girl that she was, she said that she did.

Soon after this awful incident, I read one of Stephen Covey's books. One idea in particular hit me like a revelation. He said that one should absolutely never lose one's temper or get irritable. It never does any good. It accomplishes nothing and only sows mistrust and fear. I stared at his words and read them over and over again. "If that is true—and I know it to be true," I said to myself, "why would I ever be irascible, snappish, and ill-tempered again? It makes no sense." After that leap of understanding, I very rarely, if ever, lost my temper and, when I did, never to the same degree. Over time, I could feel the trust growing in everyone around me.

It took me several years of relentless self-discipline and study of self-improvement books to totally rid myself of the temptation to succumb to irritability. I realized from my own experiences as a child that it was a profoundly destructive habit. My impatience achieved nothing, eroded my family's trust in me, and made my daughters feel as though they were walking on eggshells. Because my father had been easily roused to anger, I knew what it was like to live with an impatient person, and I remembered all too well how his temper had fostered tension and anxiety in the rest of

the family. I also learned that the opposite of irritability wasn't meekness or passivity but listening with intention. Listening actively to other people makes losing one's temper impossible.

Mastering my irritability was a tribute to my father. I know he would have wanted me to gain control over my temper. He would have been deeply pleased to know that I had finally let go of my grouchiness, becoming a consistently calm, loving, caring, fun, and attentive presence at family gatherings. My unhappy memories from my own childhood became a motivation to do a better job as a father rather than an excuse to replicate the mistakes of the past. I charted a different course—exactly what my father would have wanted.

As I learned the skills to be a better father, I also learned to apply those same skills to my professional work. This helped me become a better filmmaker because my leadership abilities improved. I kept my promises, made more offers, and spoke more clearly. I was kinder and listened more actively. I became more self-aware and less self-absorbed. All of the qualities that made a good father also made for a good leader. I slowly learned to live more intentionally: to decide what person I wanted to be and to commit to achieving that goal, acknowledging that I will forever be a work in progress.

These positive changes would soon be challenged by what I found in the wildlife filmmaking industry. As I worked on my own issues and chose to model the best possible behavior for my daughters, I became more sensitive to ethical issues. That's when I began to have doubts about the industry that had become my career.

CONFESSION FOUR

I Joined an Industry that
Accepted Animal Abuse

CHAPTER EIGHT

Ethics and Education

W HEN I FIRST GOT into wildlife filmmaking, I took it for granted that wildlife films were intrinsically on the side of what was right and honorable. Then, in the early 1990s, I saw the movie *Cruel Camera*. Canadian investigative reporter Bob McKeown hosted and wrote this 1982 documentary about the brutal treatment of animals in Hollywood films.

But McKeown didn't stop there. He also revealed that fakery, manipulation, cruelty, and the intentional killing of animals were common in wildlife documentaries, on both the big and the small screens. All that deceit was just to create excitement and sensationalism to boost ratings and box office revenues.

As I watched the film, I was shocked. Wildlife filmmaking was the career I had chosen to pursue, but I had not fully realized the extent of its dark side. *Cruel Camera* revealed that the Disney film *White Wilderness*, released in 1958, deliberately promulgated misinformation and lies. The movie is responsible, for example, for the misconception that lemmings commit mass suicide: Disney staged this "phenomenon" by

55

intentionally throwing the hapless rodents off a cliff into the water below.

Cruel Camera showed that the situation had not improved between 1958 and 1982. Wildlife filmmakers captured what looked like amazing footage in their pursuit of dramatic shots of large, charismatic animals. But a significant proportion of it was faked or involved cruelty and mistreatment of the animals. The footage was not educationally driven, science based, or conservation minded, and it placed the welfare of the animals being filmed well below the importance of the scene being shot.

Cruel Camera revealed that wildlife films were heavily contaminated with a litany of toxic techniques: covert animal abuse, manipulated behavior, captive animals, staged predation sequences, game farms, contrived stories, and tethered live bait. Moreover, the films often neglected a conservation message and gave the misleading impression that the world was blessed with an abundance of pristine Edens.

Not all of the information in *Cruel Camera* was a complete surprise to me. Soon after I started work as a wildlife filmmaker, I heard one story of Disney filmmakers smearing stinging Bengay ointment on a beaver's anus to get it to move around and behave in a more active and interesting way. That abhorrent story, which I later confirmed was true, was just the tip of the iceberg.

I had not been producing documentaries for long before I had my first brush with an ethics issue. As I described in my first book, *Shooting in the Wild*, I brought home a film on bears we had just completed to show Gail. She especially liked one scene of a grizzly bear splashing through a stream and she asked me how we got the shot. I told her we filmed it from across a valley using a powerful telescopic lens. Naturally, Gail next wanted to know how we were able to record the sound of water dripping off the grizzly's paws. I replied that my talented sound guy had filled a basin full of

water and recorded the watery drips and splashes he made with his hands and elbows. He then matched the video of the bear walking in the stream with the sounds he had recorded.

Gail was shocked and called me "a big fake." I had made a documentary, which led her to expect authenticity, reality, and truth. Instead I delivered, in her view, fabrication, fakery, and fraudulence.

Questioning the sound effects of an animal interacting with its environment—dripping water, paws clawing the ground, chewing food, scratching a tree trunk, sniffing the air, and so on—is to question the basic parameters of filmmaking itself. Almost all wildlife filmmakers would claim that creating sound effects is simply part of the art of filmmaking. Foley work is an accepted and innocuous facet of filmmaking.

We kept the fake sound effects in our bear film.

Unfortunately, natural history programs have far more serious flaws than fake sound effects, including the heavy emphasis on predation and violence and the neglect of important ecological issues like climate disruption. Footage is often grounded in deception. For example, game farms supply captive animals to filmmakers who then pretend the animals are wild and free-roaming.

After some years producing wildlife films and learning more about what went on behind the camera, I decided to go public with my concerns. In the early 1990s, I seized an opportunity when I was invited to debate the status of nature films at the International Wildlife Film Festival in Missoula, Montana, with a respected wildlife filmmaker who didn't share my skepticism of wildlife films and believed they were an unqualified blessing. The debate took place in a conference room in downtown Missoula in front of an audience of about a hundred wildlife filmmakers.

"If the average viewer were to find out about the techniques we use to

make our wildlife films...they would feel betrayed," I began. "Pretending captive animals are free-roaming, staging predation sequences, exaggerating the dangerousness of predators (like sharks), using computer graphics to manipulate images, and getting too close to wild animals to get a 'money shot' may be common elements of a typical wildlife documentary, but they're unethical."

"These practices are necessary for the greater good," my opponent responded. "Without these common filmmaking techniques, most wildlife films would be prohibitively costly to produce, and those that did get made would be dull and unappealing. Few people would watch them, and if few viewers watch them, then the important role these films play in advancing conservation would be lost."

"Sometimes the ends do justify the means," my opponent explained. "For example, one common criticism of wildlife films is the use of captive animals—such as wolves, bears, and wolverines—from game farms. Some may argue that animals on game farms are kept under stressful conditions. However, using rented captive animals means a film producer doesn't have to disturb and harass wild, free-roaming animals—and that's a good thing. In any case, a few game farm animals suffering a bit is a small price to pay for a film that promotes conservation to a large audience."

I appreciated my opponent's point about the value of not disturbing animals in the wild but felt that this didn't justify harassing other animals that were unlucky enough to find themselves on a game farm. "The suffering of animals on game farms is extensive, protracted, and severe," I argued. "The conditions at these places are often horrendous. Animals are kept in small cages, often close to other animals that they would carefully avoid in the wild and sometimes feel outright hostility toward. Then, to get to desirable photographic locations, the captive animals are trucked

long distances, the cages stacked on top of one another, with foul stenches and noise from traffic battering the animals' senses."

My opponent replied vehemently, "Look, let's focus on this from the point of view of the audience. The audience does not need to know that the pack of wolves they are watching is captive and controlled, or that the footage of a predatory shark and a diver is enhanced to seem more menacing by the use of computer manipulation of the images, or that the sounds viewers hear of a bear preying on an elk is created by a Foley artist in the studio. All movies, by definition, involve manipulation. Wildlife filmmakers should not ruin the mood and atmosphere by interrupting the film to inform viewers that a particular shot, for example, was captured in a zoo and not in the wild. If you told viewers the truth, they would feel disappointed and tricked, and they might turn to another channel. Losing the audience is bad for conservation."

Of course I understood my opponent's perspective. I had struggled with the very same issues in my own films and could easily recall how my film on bears had been tainted for Gail once she knew the sound effects weren't authentic. Yet, having witnessed Gail's very real disappointment in me when the truth emerged, I could no longer just bury wildlife filmmaking techniques like these under the rug. Wildlife TV shows were the main way the increasingly urbanized citizenry was remaining in touch with the natural world; I felt we had an obligation to portray it honestly.

I argued that my opponent's point about not losing the audience was a good one, but audiences should be engaged using ethical means, if for no other reason than corrupt filmmakers would eventually be exposed and audiences would never trust them again. As filmmakers, we had a responsibility to make the best films possible so as not to give a black eye to the cause of conservation.

"Skillful deception is the essence of artful filmmaking," my opponent countered. "And wildlife filmmakers are in the business, first and foremost, of entertainment." My opponent believed, as I once had, that high ratings were synonymous with an effective message.

Ours was not a new conversation. Much of what was debated that day had been brought up for discussion thirty years earlier by an eccentric Englishman named Jeffery Boswall.

Jeffery Boswall was one of a kind. Underneath an occasionally gruff, cranky, and arrogant exterior beat the heart of a kind, funny, compassionate, and loveable person. A devoted secular humanist, he pioneered fresh thinking on the subject of wildlife filmmaking ethics. Boswall refused to be average in any way. He stood out wherever he went because of his outspokenness, humor, and eccentricity. His annual end-of-year letters were famously candid—for example, one discussed how long he was likely to live—and made for delightful reading.

In a 1988 paper called "The Moral Pivots of Wildlife Filmmaking," Boswall opined that when it came to animal welfare versus getting audience-pleasing money shots, morality was subjective. To illustrate his point, he offered his readers a graded series of five moral problems that they had to answer with a simple yes or no:

1. Knowing that spiders do eat flies and therefore there is no problem of scientific integrity, and knowing that you are doing it exclusively for the purpose of a conservation-oriented film, would you introduce a fly to a spider?
2. Would you introduce a worm to a frog?
3. Would you introduce a snake to a secretary bird?
4. Would you introduce a live small bird to a hawk?
5. Would you introduce a monkey to a boa constrictor?

Boswall claimed that the point of the exercise is to show that not everybody votes the same way, so morality must "clearly be an individual choice."[1] In other words, morality is subjective. Each one of us has to decide what he or she is prepared to do.

I think Boswall reached the wrong conclusion. Whenever I give this test to audiences, I'm surprised by how much agreement there actually is. Sure, not everybody votes identically, but there is broad consensus that it is okay to stage a spider hunting a fly and even broader agreement that it is ethically unacceptable to stage a boa constrictor hunting a monkey. This suggests that morality is not totally subjective and that society has some shared ethical standards in the area of animal welfare.

The test also shows how anthropocentric people are. We can relate more empathically to animals that are similar to us, especially animals that resemble us physically. In short, we favor a monkey over a fly.

Boswall (who died in 2012) and I disagreed on conservation as well. I believe that omitting or neglecting a discussion of conservation in a wildlife film is a moral issue. He felt that the decision to include an emphasis on conservation was an artistic issue and a subjective choice that fell outside the domain of ethics. We argued about this over e-mail and remained in different camps. But Boswall and I agreed that however noble a film's intentions were, nothing could justify cruelty to and mistreatment of animals.

Where did my sensitivity to animal cruelty come from? It sounds like a cliché, but I have to think it had to do with my childhood.

When I was eleven years old, my parents sent all four of their sons to boarding school at Dulwich College in southeast London. Dulwich College was an elite, all-boy, private school. Like Exeter or Andover in the United States, the school offered a top-flight education, something that was important to my father.

61

As boarders, we moved 120 miles away from home to live at school for six years, with occasional visits home during vacations and midterm breaks. Although this practice is alien to most Americans (and is sometimes even seen as a callous abnegation of parental responsibility), it was common in England and accepted without criticism.

My parents didn't have a lot of money, and sending four boys to a fancy British boarding school was punishingly expensive, so my brother Jon and I often had to wear hand-me-down clothes. One semester, my cash-strapped father told my twin brother Jon that he would have to wear a jacket that had belonged to my oldest brother, Jeremy. When Jon put the jacket on, it was way too long, but my father told him to suck it up and stop whining. When we got to school, I was mortified to see other boys screaming with laughter at Jon's ridiculously long jacket.

In the austere, brutal, and forbidding milieu of boarding school, I suffered acutely from homesickness. My misery was exacerbated by the autocratic atmosphere, which included compulsory chapel, endless team games of cricket and rugby, and strict rituals and procedures infiltrating every communal activity and mealtime. It was only the regularity of my mother's chatty and affectionate weekly letters that kept me from being debilitated by my intense yearning for the safety and relative comfort of home life.

But homesickness was the least of my challenges. Boarding school exposed me at a young age to the sad reality of how cruel some people can be.

Dulwich College had a hierarchical system enforced with compulsory "fagging" and beatings, all implemented with rituals and protocols handed down by previous generations of prefects. Fagging, a traditional practice in British boarding public schools that goes back to the seventeenth century,

involved a junior boy acting like a personal servant to a senior boy, called a prefect. Prefects were authorized by the school to maintain discipline in any draconian way they wanted. It was one of their many privileges. The fag would have to do anything the prefect requested of him—polish his shoes, run his bath, make his bed, brush his clothes, run errands, or complete any other menial task his prefect demanded. In his autobiography, author Roald Dahl relates being told to warm toilet seats for prefects on bitterly cold days.

Senior-on-junior violence was common and deeply embedded in the school's culture. School was a terrifying place to be if you were low in the hierarchy. I was perpetually anxious and on edge. I imagine the feelings I experienced were not unlike those of a gazelle on the plains of Africa keeping an eye out for lions and cheetahs, except perhaps for my additional disadvantages: I was a skinny, small boy; thin as weak tea; vulnerable; and self-conscious.

At school, one could get beaten severely for some vague, nebulous infraction, such as showing insufficient deference to prefects. Especially recalcitrant fags were hit with a rattan cane or a leather slipper with a metal edge to the heel, like a horseshoe. This left severe bruising—if not broken and bleeding skin—particularly if the number of strokes exceeded five or six. The pain was excruciating. After the initial strokes, one of the prefects would ask you if you had learned your lesson. If you didn't answer or didn't look sufficiently chastised and humiliated, you would be beaten again.

Beatings were carried out after dinner while the rest of the house quietly toiled away at homework. This meant that the sounds of brutal whacking could be heard throughout the house, underscoring the power the prefects held and emphasizing how dangerous and frightening they could be, especially to certain boys who, for whatever capricious reasons,

the prefects designated as their targets. That fate could have been mine had my brother Jon not intervened.

"Don't move to Blew House," Jon said to me early one morning. Blew House was the senior boarding house and he had moved to it the year before. I was about to move there from Orchard, a junior boarding house.

"What do you mean?"

"Just don't. I'm telling you not to come and I mean it." My brother's voice quavered and his lips trembled. His wan and stricken face betrayed intense anxiety.

"Did you hear me? Don't come and I mean it," he repeated.

His one-syllable words were chillingly terse. He had overheard prefects discussing how they intended to beat me with a bamboo cane until I bled, and he told me to stay away from the senior boarding house for another year, which I was thankfully able to arrange by asking my father to intervene.

When I finally moved to the senior boarding house, I took makeshift weapons with me in a futile effort to protect myself against attacks. My secret stash of weapons slightly bolstered my precarious self-confidence but was otherwise useless. I was threatened with beatings but somehow managed to avoid them. Nonetheless, the constant worry and sense of foreboding kept me in a state of perpetual anxiety.

Bullying among the younger boys was rampant as well. One boy, Hogan, who was harmless and undersized, seemed baffled by his unpopularity and the relentless hostility directed at him. His books were knocked out of his hands and sent flying. He was pushed, punched, and called belittling and demeaning names. His pants were pulled down on the playground. He was taunted, teased, and tormented mercilessly. All of the other students seemed united in their overpowering loathing of him, and the teachers did

nothing to protect him. He was shunned, hit, and despised. I was one of the few students who felt compelled to befriend him so he wasn't totally isolated. I never understood why he was bullied so ferociously.

The world seemed dangerous for other reasons too. Sexual predation was rampant. Determined and cunning sexual predators, often people holding highly regarded positions in society, were ubiquitous and relentless. These issues were hidden from view in 1950s England. Molestation and pedophilia were never discussed in my family, especially the risk from familiar grown-ups who appeared to have good intentions. Everyone assumed that authority figures, such as parish priests or rugby coaches, were beyond reproach. It was a dangerously misinformed assumption.

During these years, I learned that adults could not be trusted. I became cynical of those in power and acutely aware of how such people can easily abuse those who are vulnerable. I had to be constantly aware and on my guard.

I imagine these experiences led to my sensitivity to cruelty of all kinds. I instinctively identified with terrified and powerless animals that suffered at the hands of tyrannical humans who lorded unrestrained over them.

CHAPTER NINE

The Murky Morals of the National Audubon Society and the National Wildlife Federation

"HUNTERS, IN THE MOMENT of violence and death, show a huge respect for the animal they are killing," my opponent said. "They appreciate the value of the animal like no one else can. And animals are barely sentient. They react as creatures of their environment and it's a beautiful thing to behold. When you hunt, you enter and share that environment with a unique intimacy."

I replied, "Hunting is barbaric, cruel, and inconsistent with the mission of the National Wildlife Federation. Killing a defenseless creature in order to provide recreational pleasure to the hunter is abhorrent and I don't understand its appeal."

The reply came quickly: "Of course you don't—you're not a hunter."

It was 1998 and I was having a public debate with my colleague, National Wildlife Federation (NWF) executive Wayne Schmidt. NWF's

president and CEO at the time, Mark Van Putten, wanted the NWF staff to have a better understanding of hunting and trapping. Virtually all of our powerful affiliate organizations had hunting and trapping roots.

So Van Putten invited Schmidt and me to publicly debate the issue at an all-staff meeting. We went at it back and forth for about an hour, each talking past the other and finding no common ground. The comments during the question-and-answer session following the debate were disappointing for me because it became apparent that a majority of NWF staff favored hunting and trapping or were willing to tolerate it.

I understood the allure of being out in nature, but it was impossible for me to see how hunters could take so much pleasure in hurting animals. I found their motives unfathomable. I believed we had to see animals as individuals—unique, sentient beings with feelings and emotions. I simply didn't understand how someone could go into a pristine wilderness area, shoot a magnificent grizzly bear, and then pose with his or her rifle, grinning over the dead animal's bloody carcass.

Like many within NWF, Schmidt believed hunting was in people's DNA. He correctly pointed out that hunting was one of the original driving forces of the American conservation movement. Schmidt insisted that hunters want to preserve wildlife so they, their children, and their grandchildren have plenty to hunt. "I believe we can take the life of an animal for human benefit and consumption," he argued. "We can hunt respectfully and ethically, in a way consistent with science-based professional management that assures sustainable and healthy wildlife populations."

"Conserving biodiversity and encouraging sustainability are necessary conditions for an environmental ethic, but they are not sufficient," I replied. "How we treat our fellow creatures must also be taken into account. Otherwise we are morally deficient."

When I first started working for "Big Green" organizations, I took it for granted that environmental groups were inherently virtuous and good. (*Big Green* is the collective name for the nation's largest environmental groups, including World Wildlife Fund US, Sierra Club, Friends of the Earth, National Audubon Society, Environmental Defense Fund, Natural Resources Defense Council, and NWF.) These big environmental organizations provide ideal platforms from which to criticize and attack irresponsible and myopic exploiters of natural resources. They do a tremendous amount of good fighting climate change, protecting wetlands, combating pollution, bolstering grassroots activism, and much more. For example, it was Big Green that led the campaign that resulted in the momentous passage of the Alaska National Interest Lands Conservation Act, which saved over 100 million acres in Alaska. Big environmental groups have successfully championed the Endangered Species Act and many other pivotally important laws that have advanced conservation in the United States.

Hunters have often been essential allies of Big Green in saving wild areas. Without the support of the hunting community, the environmentalists would have been far less successful in their campaigns to save vast, irreplaceable wildlife habitats from the chainsaw and the bulldozer. But Audubon and NWF's position on hunting and attitude toward animals were baffling to me.

No one symbolized this tension better than longtime chairman of the Audubon board Donal O'Brien, who died in 2013. He lived at the wealthiest and most powerful levels of society, serving as chief counsel to the Rockefeller Trust Company. I admired him for his passion for conservation, generosity of spirit, political acumen, and ability to get people to work together—but I detested his love of hunting.[1]

O'Brien's passion for duck hunting in particular was legendary. Author, scientist, conservationist, and fisherman Carl Safina opposes duck hunting because "it frightens ducks from their best feeding locations and forces them to use up more of the precious energy they need to survive the cold."[2] He adds, "Crippled birds seem to really suffer, to show true misery.... There is too commonly in waterfowl hunters a blind spot for the suffering inflicted." But Donal O'Brien, an otherwise kind and gentle man, appeared to lack compassion for the ducks he liked to shoot.

Audubon and NWF CEOs would send out during the week fundraising letters protesting the killing of a particular species of animal and then spend the weekend killing ducks or other animals for fun and recreation. For example, former NWF president and CEO Larry Schweiger once sent a letter to tens of thousands of potential donors that read, in part, "Of all the horrors I've seen befall America's precious wildlife, I think the one that upsets me most is the killing of an innocent animal for no reason."[3] His fundraising letter lamented "irresponsible individuals" who had killed an endangered Hawaiian monk seal and requested a generous donation to NWF to help solve the problem. Yet Schweiger is a devoted hunter.

NWF, where I worked from 1994 to 2004, is governed by wildlife-oriented affiliates who elect the board of directors and set policy. These affiliates are virtually all pro-gun, pro-hunting rural sporting groups. A typical example is the Michigan United Conservation Clubs, which for many years was run by Tom Washington, the one-time president of the National Rifle Association. In recent times, a few more moderate affiliates have been added.

These affiliates, despite their governing power, contribute virtually nothing financially to NWF. NWF gets most of its funding from its million or so individual members, often elderly women who love animals.

Many of these members contribute their membership dues because they believe erroneously that NWF is, among other things, funding programs to stop hunting and trapping.

Members are typically city dwellers; only a small fraction are hunters (6 percent in 2003).[4] In fact, a large number of NWF's members and donors are also members of animal welfare organizations that are strongly opposed to hunting and trapping. NWF's fundraising staff actively solicits such lists, knowing that they make good prospects. However, NWF's solicitations make no mention of the fact that NWF is an advocate of hunting and trapping and indeed is governed by state affiliates that are, for the most part, made up of hunting and trapping groups (the "hook and bullet crowd"). Too often, one of NWF's main motivations for conservation is to maintain an abundance of wildlife to hunt. If members learned of NWF's actual stance on hunting and trapping, they would likely be shocked and demand their money back.

This tension between hunt-loving affiliates and anti-hunting members gives rise to a dangerous situation, which board members are anxious to keep out of public view. The board knows that if this friction were to become overt, the stability of their organization might be in jeopardy.

Many years ago, such outrage almost destroyed the National Audubon Society, where I worked from 1980 to 1994. In the 1930s, Audubon staff at the Paul J. Rainey Audubon Wildlife Sanctuary in Louisiana hunted and trapped nutria—big, rat-like mammals—because they were overpopulated, nonnative, and ruinously damaging the marshes.

When wealthy New York socialite, citizen activist, and Audubon member Rosalie Edge, then in her fifties, learned that the Audubon staff were killing animals in one of its sanctuaries, she was outraged. She launched a blistering and relentless attack that shook the organization to

its foundation and caused a major loss of membership and revenue.

Rosalie Edge first found her voice in grassroots activism through the Women's Suffrage movement. Her passion for nature started when her family bought a summer home on Long Island and she became a regular and devoted birdwatcher. Through her love of birds, she made the acquaintance of Willard Gibbs Van Name, a zoologist working at the American Museum of Natural History. He alerted her to problems facing the conservation movement, such as the threat to many bird species from market hunters. He was highly critical of the leaders of the National Audubon Society.

Edge founded the Emergency Conservation Coalition for the purpose of "reforming Audubon." Her emphasis was on the need to protect all species of birds and animals, not just those species that had a quantifiable value. She aggressively campaigned against Audubon, which she saw as being corrupted by trophy hunters, ranchers, water developers, and pesticide manufacturers. She revealed how these men casually conspired over which lands and species would be saved on the basis of their own personal interests and financial motives.

Rosalie Edge sued Audubon for its membership mailing list and won. She subsequently flooded the list with information describing the hunting and trapping conducted by the National Audubon Society. Audubon's members left in droves. Between 1929 and 1933, membership declined by half. Top Audubon officials were fired and the trapping of fur-bearing animals by Audubon staff was stopped.

This situation is the nightmare that haunts current leaders of NWF and Audubon. Will a new Rosalie Edge appear and find ways to let the membership know that their organizations are pro-hunting and pro-trapping? If that were to happen, the funding for these groups might be placed in

serious jeopardy. With today's social media, the activist wouldn't even need to sue for membership lists—he or she could simply start a Facebook group.

Toward the end of my fifteen-year tenure at the National Audubon Society, the issue of hunting did, in fact, come bubbling up in one of my Audubon TV specials. Our film *Desperately Seeking Sanctuary*, hosted by actress Mariel Hemingway, focused on the National Wildlife Refuge System. In the film, we pointed out that although the words *wildlife refuge* would lead one to believe that such places are sanctuaries for animals and that animals can live there free of human interference and threat, the reality is that the U.S. government allows hunting in wildlife refuges.

Before the film could air, a fight erupted inside Audubon over whether to keep this information in the film. I argued that the public had a right to know this fact, but pro-hunting Audubon board members (as well as some Audubon staff) were apprehensive and argued that the information should not be disclosed. Their desire to conceal the truth, or at least not tell the full story, profoundly disturbed me.

Why did the Audubon board want the references to hunting and trapping minimized? This was partly because the Audubon leadership didn't want to upset the partnerships it had with hunting groups, such as Ducks Unlimited and the National Rifle Association, and partly because some Audubon chapters loved to hunt and trap in national wildlife refuges and didn't want their behavior criticized.

Ultimately, the board told me the film could not appear to oppose hunting and trapping on national refuge lands because it would damage Audubon's relationship with hunters and trappers. The scenes that revealed that hunting was legal in national wildlife refuges were censored by the board over my objections. Producers Mark Shelley, Richard Hendricks, and I made the requested edits, but we were furious. We believed

that concealing this information made us look bad as documentarians and Audubon look bad as an organization. In the version that aired on Turner Broadcasting and PBS, there is little mention of hunters.

While the controversy raged inside Audubon, I was approached by an investigative journalist, Mark Dowie, who had picked up rumors of the fracas and smelled a good story. Reluctantly, but with a clear conscience, I became an unidentified informant for Dowie. At some risk to my career, I shared the internal memos showing how I had been forced to delete this important information from the film, and I persuaded Mariel Hemingway to give Dowie an interview.

Mark Dowie published a revealing (and for Audubon, embarrassing) op-ed piece in the *Washington Post* on March 6, 1994.[5] If anyone suspected that I was the source of the leak, no one confronted me. Luckily for me, the Audubon board was preoccupied with other pressing problems, including firing the president and CEO, so they were distracted.

Dowie's essay, "Audubon Takes Flight: What You Won't See in Tonight's Documentary," told the story of how the pro-hunting Audubon board had forced me to edit the film so it would appear less critical of hunting and trapping in national wildlife refuges. His theme was that the hour-long film told of how the refuges, established as sanctuaries for wildlife, were being damaged and decimated by recreational and commercial activities, such as leaking gas wells, out-of-control power boats, crowded beaches, and parking lots. But he pointed out that the film mentioned nothing about trapping fur-bearing animals or hunting them with crossbows and guns.

Dowie described how hunting and trapping had been deliberately omitted from the version that was broadcast. "Snorkeling in manatee habitats receives more hostile treatment than either hunting or trapping," wrote Dowie derisively.

Despite the bad feelings stirred up by that particular film, the larger fact was that because of my television and film work, the National Audubon Society had a national and international film and TV presence that the NWF envied. NWF had tried to develop such a presence for years and had failed. Audubon and NWF were rivals and shared similar missions. Jay Hair, the six-and-a-half-foot tall, imperious, dominating, and ambitious president of NWF, decided to try to hire me away from Audubon with the hope that I would do at NWF what I had achieved at Audubon. This move did double duty for Hair: It stuck a finger in a competitor's eye while securing my services for NWF.

When NWF recruited me—with much fanfare—in 1994, it was widely considered a coup for NWF. The two organizations acted as if I were a rare talent with exceptional value. The truth was that I had managed to produce some films that got good publicity, and both organizations wanted to tap into the fleeting fame of those high-profile films.

I was uncomfortable with NWF's sympathetic stance on hunting (NWF supported hunting even more enthusiastically than Audubon did), but I convinced myself that I could do more good on the inside than the outside. I was eager to leverage the considerable NWF platform to promote conservation. Further, I was in what appeared to be the enviable position of being able to support a family while, at the same time, pursuing my passions for film and conservation, as long as I could turn a blind eye to what I felt was the dark side of the conservation movement. It's amazing how the need to support a family can help rationalize unethical decisions. I was reminded of Upton Sinclair's insight about the difficulty of getting a man to understand something when his salary depends upon him not understanding it.

My public hunting debate took place soon after I joined NWF. I

thought I was calling out hypocrisy on the part of NWF. But I was soon going to discover that I was a hypocrite myself.

CONFESSION FIVE

I Was a Hypocrite Who Enjoyed Watching Shamu Perform

CHAPTER TEN

The Pleasures of SeaWorld

I T'S POSSIBLE I WAS imagining the predatory look in the killer whale's eye as it spyhopped a few feet from us. Still, I instinctively put my arms around my fifteen-year-old daughter to protect her from potential attack—not that I'd be able to do much if the twenty-five-foot, four-ton behemoth became aggressive.

Spyhopping, or rising and holding a stationary position partly out of the water, is a behavior killer whales use to look around above the surface and to spot prey. As I watched the huge black-and-white head and massive jaws, the trepidation I felt around wild animals when I was younger came back to me.

Luckily for us, our whale-spotting expedition was carefully supervised. My daughter Kim and I were at SeaWorld in Orlando at the invitation of Busch Gardens, which owned the marine park. The year was 1995, and Busch Gardens was heavily promoting SeaWorld to members of the environmental community, putting its killer whale captivity program in the best light possible.

I was happy to take advantage of the offer to visit. I'd never been to

SeaWorld, and Kim and I were eager guests. Because of my position at the NWF and my friendship with top SeaWorld executive Julie Scardina, we got the VIP treatment. We were taken backstage to see the orcas up close. A young trainer talked about the biology of killer whales and allowed us to pet the huge animals. We were thrilled.

We were also amazed at how SeaWorld staff had managed to train the enormous animals to be obedient and docile. The animals looked, at least at first glance, like they were having as much fun as the trainers as they performed tricks and ran through their routines. The fast, funny, high-energy orca shows, featuring the park's iconic orca Shamu, were highly entertaining, as were the shows featuring dolphins, sea lions, and otters. Kim and I had just as much fun checking out the other animal exhibits and the park's thrilling rides and roller coasters.

We were impressed too by the good work SeaWorld was doing to rehabilitate injured wild animals. Kim was particularly taken with the park's rescued manatees, whose backs had been mauled by speedboat propeller blades.

To be honest, back then, I didn't give a lot of thought to whether killer whales suffered in captivity. I just assumed that the people running places like SeaWorld knew what they were doing. I believed SeaWorld's representatives when they claimed that the park's work with captive orcas benefited wild orcas and that the animals were happy, content, and well looked after. And I believed SeaWorld when they said it didn't matter that the dorsal fins of captive orcas are collapsed and folded over while the dorsal fins of wild orcas are majestically erect.

Last but not least, I accepted SeaWorld's position that there was nothing wrong with captive orcas performing like circus animals for audiences. SeaWorld insisted that the shows educated the public about wild

orcas and that performances were perfectly safe for the whales and their trainers. Orcas were first displayed publicly in the 1960s, and I knew those early exhibitions had helped to change public attitudes about orcas from apprehension to admiration.

SeaWorld staffers pointed out to us that captive orcas never went hungry. The animals were protected from pollution, ship propellers, and boat collisions and received restaurant-quality fish, as well as plenty of human attention from trainers who cared deeply about them.

Kim and I were drawn to the incredible spectacle of killer whales interacting with their trainers, careening around the pool, and making extraordinary leaps. We enjoyed a rigorously orchestrated show of seeming fun and happiness, blind to the whales' suffering and pain. We didn't give any thought to what might be going on behind the scenes. All I could think of was that we had been given a rare opportunity to see killer whales up close.

Although I am embarrassed to admit it now, I was fooled by what I perceived as the animals' contentment. I didn't think about how orca calves are traumatically separated from their mothers in the wild or realize that the subsequent stresses of captivity lead to mental and emotional illnesses and abnormal behavior. At the time, I did not yet know the many examples of captive killer whales becoming menacing and dangerous. I had no idea then that captive orcas sometimes went "off behavior" and attacked trainers.

I knew nothing about the extensive—and then-secret—record of the whales' aggressive actions: incidents of whales biting and butting trainers and caretakers and sometimes even dragging trainers to the bottom of the tank and holding them there, nearly killing them.

And I did not know that a captive killer whale had killed his trainer at a Canadian marine park just four years before I took my daughter to SeaWorld.

81

In 1995, the debate about whether orcas should be part of public exhibitions was still a quiet one, and only a few prescient observers pointed out that the shows might be extremely stressful for the animals. If I had known the facts, I would have kept my daughter farther away from the orcas. In fact, I might not have made the trip to SeaWorld at all, by way of a personal boycott.

Much later, as I reflected on our visit, it dawned on me that during my SeaWorld visit, I had learned virtually nothing about orcas in the wild: how they hunt, how they communicate, how they migrate, their complex social bonds, their life spans, or what citizens can do to conserve the oceans so that killer whales can continue to thrive in the wild. Renowned cetacean scientist Dr. Lori Marino says that the evidence is pretty clear that visitors to SeaWorld learn very little about orcas or how to help them.

In 1995, though, those concerns were far from my mind. After all, not only did I enjoy SeaWorld personally, but I also benefitted from it professionally. When we made our IMAX film *Whales* shortly after the visit to SeaWorld (in about 1996), we wanted the opening scene to be of a killer whale breaching and lunging out of the ocean toward the camera. Capturing a shot like that in the real world is impossible, so we approached SeaWorld to see if they could help us stage it. They allowed us to build a structure high over a big pool to hold our IMAX camera; they then trained an orca to leap out of the water toward the camera.

As dramatic and exciting as this opportunity was, a small voice inside me wondered if we were doing something questionable. I sensed something wasn't quite right. It wasn't the captive orcas that bothered me at the time but rather the fact that we were deceiving the audience. I knew that the audience watching *Whales* would assume that the breaching orca was wild and free-roaming, and we said nothing in the film to disabuse

the audience of that notion. The truth was that I was excited to get the dramatic footage. As a film producer, that footage was what I cared about most.

It's true that our IMAX film *Whales* promoted conservation, but our motives weren't entirely selfless. We also hoped the film would be a success and boost our careers as filmmakers. And so in the mid-1990s, I said nothing, letting my ignorance, naiveté, and self-interest take the wheel. My silence made me complicit in the whales' suffering.

CHAPTER ELEVEN

The Cruelty of SeaWorld

I **HAD ENCOUNTERED KILLER WHALES** at close quarters on another occasion, but that time it was in the wild when filming off the coast of Alaska. Three killer whales brazenly circled our small boat, coming so close we could almost touch them. Their size, charisma, and power were astonishing. They stayed for about twenty minutes, and we watched in awe and with some trepidation as they calmly and inquisitively circled our boat. I knew from footage I'd seen of hunting orcas—snatching sea lions off Patagonian beaches and skillfully dislodging adult seals from ice floes—that they were audacious, skilled, and potent hunters.

A vivid and distressing example of their power was portrayed by investigative journalist David Kirby in his excellent 2012 book *Death at Sea-World*.[1] Kirby described the February 20, 1991, killing of Keltie Byrne in chilling detail. The twenty-year-old orca trainer was wrapping up a killer whale show at a marine park called Sealand of the Pacific in Victoria, British Columbia, Canada, when she slipped. Her foot dipped into the pool containing the three performing killer whales. As Byrne scrambled to regain her balance, one of the orcas grabbed her foot and pulled her into the water.

Screaming for help, Byrne was pulled under and then tossed around between the three orcas. As other staff rushed to the rescue, Byrne managed to get away to the side of the pool, but the killer whales, who were reluctant to give up their exciting new game, swiftly recaptured her. As Byrne's terror mounted, the animals grew increasingly agitated, and the other staff members' desperate attempts to calm the animals failed. Byrne surfaced twice, screaming piteously, but eventually, she drowned. She couldn't get to the surface for air because the killer whales dragged her under and wouldn't let her come back up. Experts generally agree that the main culprit was a bull orca called Tilikum.[2]

I had never heard of Tilikum when I visited SeaWorld in 1995 with my daughter, but soon after that trip, discussions in the wildlife and environmental community over killer whale captivity seemed to grow more and more prominent—or, at least, I became more aware of them. Still, the NWF, where I now worked, strongly supported SeaWorld. It didn't hurt that Busch Gardens continued to treat leaders and well-known figures in the environmental and wildlife communities to generous trips to Sea-World, such as the one I'd enjoyed.

But I could no longer ignore the evidence that suggested captive orcas were suffering. I began to question NWF's position on killer whale displays and I became more skeptical of NWF's pro-captivity arguments, which parroted SeaWorld's talking points. After all, NWF openly supported hunting and trapping; they were hardly in a good position to suddenly get maudlin about the suffering of orcas in captivity.

I knew I was being hypocritical with my growing pro-whale stance given that I'd taken advantage of Busch Gardens' hospitality and thoroughly enjoyed my trip to SeaWorld with my daughter. Not only that, I'd asked SeaWorld to help me with my film. But then a terrible event

changed everything and ensured I could no longer straddle the line.

On February 24, 2010, 19 years after he killed Keltie Byrne, the 12,000-pound bull orca Tilikum struck again, savagely killing veteran trainer Dawn Brancheau after SeaWorld's popular "Dine with Shamu" lunchtime show. The big male dunked, battered, and rammed the experienced trainer. In his book, David Kirby called it "a purposeful killing.... Part of her arm was torn off, her scalp was ripped away, her sternum was crushed, and her liver was lacerated."[3] Tilikum rag-dolled Brancheau's body until she was virtually dismembered.

The killing changed the dynamics of the already highly charged debate over orca captures and displays and altered many people's positions—including my own. I became a strong believer in the anticaptivity arguments. I recognized and admired the love, care, and dedication of trainers like Dawn Brancheau, but there was no way around it: Orcas didn't belong in captivity, no matter how well they were cared for.

In the wild, orcas naturally roam up to a hundred miles a day in the open sea; there's simply no way to allow them that kind of freedom in a tiny pen. The Oceanic Preservation Society, creator of the Academy Award–winning documentary *The Cove*, stated in an open letter rebutting SeaWorld's defense of its orca program that killer whales "in captivity are often prescribed daily medications to treat or mask the symptoms of chronic stress associated with confinement, training, and performing for screaming crowds."[4] Additionally, marine mammal scientist Dr. Naomi Rose has argued repeatedly that despite access to ample food and veterinary care, killer whales in captivity have a mortality rate that is much higher than that of killer whales in the wild.[5]

We can only speculate about what damage is done when these whales are taken away from their families and what the separation does to them

as individuals. Scientists have demonstrated the incredible bond between a killer whale mother and her calf. Breaking that bond—and compounding the heartbreaking and vicious rupture with captivity—must do irreparable damage to the killer whales' emotional well-being.

As I learned more on the topic of killer whales in captivity, it no longer surprised me that Tilikum had killed Keltie Byrne and Dawn Brancheau. Like many other captive orcas, Tilikum was brutally captured in Icelandic waters as a young calf and forcibly separated from his mother. What's more, as highlighted in Gabriela Cowperthwaite's 2013 film *Blackfish*, as a young whale at the Canadian marine park, Tilikum was forced to sleep in an enclosed, lightless pen night after night with two older killer whales that were not part of his original family.[6] Trainers from the park at the time admit that he regularly emerged in the morning with gashes and scratch marks all over his body from the other whales' aggression toward him. As a result, Tilikum may have been psychologically damaged and perhaps even (as suggested by orca researcher Ken Balcomb) driven psychotic.

Like an increasing number of people, I no longer thought it appropriate, safe, or ethical to imprison the socially complex, long-lived, far-roaming predators in tanks far too small for them. The size of orcas alone is an argument against captivity, but they're also deeply intelligent and build close bonds with their family members. I was a convert, fully convinced that orca captivity should be phased out.

The day after Dawn Brancheau was killed, I wrote an op-ed piece for CNN.com and came out publicly against SeaWorld.[7] I argued that we all need to thoroughly rethink our attitudes toward keeping wild animals in captivity and that orcas should not be kept in marine parks.

One of SeaWorld's top educators, Bill Street, e-mailed me to say that my op-ed piece was "completely disparaging to the incredible work that

I and the other expert educators do at zoological parks each and every day."[8] He added, "I will gladly debate with you over the true impact that our parks have made on conservation and the public's understanding and appreciation of wildlife and wild places."

Bill Street didn't bring up the animal welfare issue or the problem of trainer safety, but he did obliquely touch on SeaWorld's orca research. Public radio journalist Diane Toomey, who specializes in nature stories and has extensively researched zoos and marine parks, investigated the parks' claims that they educate the public and inspire visitors to contribute to conservation. Toomey found little evidence to support that claim.[9]

Author and naturalist Roger DiSilvestro told me, "I know from my years studying animal ethology that studies of captive animals have little or no use in explaining animal behavior, with the possible exception of intelligence testing. By and large, what passes for research in zoos and marine parks is just an attempt to learn how to keep animals in captivity." In other words, zoos and marine parks are valuable because they teach us how to keep animals in zoos and marine parks, not how to better understand their natural behavior.[10]

Similarly, David Kirby's extensive investigations showed that SeaWorld conducts only limited scientific research on its killer whales, and the few studies that have been completed almost exclusively pertain to the husbandry of captive whales. He cited Jacques Cousteau, who pointed out with pithy skepticism that there is as much educational benefit in studying whales in captivity as there is in studying humans by observing prisoners in solitary confinement.[11]

Shortly after David Kirby's book *Death at SeaWorld* gave SeaWorld a black eye, *Blackfish* landed another punch. Like Kirby's book, the film eviscerated SeaWorld for abusing killer whales by keeping them captive and reaping huge profits in the process. The American anticaptivity movement was only getting stronger; more and more people were becoming

aware that captivity is cruel and unethical and leads to aggression, depression, self-mutilation, and other problems in the killer whales. In contrast, there are virtually no documented cases of serious acts of aggression by orcas harming humans in the wild. It's only in captivity that they live up to the name *killer whales* when it comes to human beings.

Amid my increasing concerns for these captive killer whales, I also worried about what was happening to the basic nature of these animals. Were they still genuine killer whales? Many of SeaWorld's current orcas, unlike Tilikum, were born in captivity and have never lived in the wild. They aren't domesticated, but they are habituated to and totally dependent on people. After several generations of dependency, are these whales even the same animals as their wild cousins? If released into the wild, they would not know how to survive. Captivity changes their very natures. Furthermore, captive whales teach people a dangerous lesson. These whale shows suggest that it's normal for humans to touch, pet, and even kiss and hug killer whales.

A growing number of experts agree that whales have no place in sea parks. In March of 2014, the editors of the highly regarded magazine *Scientific American* published an editorial that said, in part, "orcas...face unique hardships in captivity. Even though many...sea parks raise awareness of the plight of animals in the wild, the suffering of captive orcas... overshadows this worthy goal. Some currently confined individuals may not survive if released, but the ones that can be, should be, and captive breeding programs should be terminated."[12]

Ocean activist and lawyer Kim McCoy, in an essay on Scubadiving.com, said it best: "Wouldn't we be better off funneling the billions of dollars spent supporting commercial captive enterprises into learning about our oceans through more accurate and compassionate means, such as observation in the wild (with responsible operators), virtual-reality simulations, books, DVDs and/or IMAX theaters? Don't we owe it to our children, to the animals and to our planet to move forward in a way that inflicts no harm?"[13]

The drive to make money from sensational wildlife entertainment in marine parks overshadows more important considerations, such as education, conservation, and animal welfare. Unfortunately, SeaWorld has little incentive to change its operations while it continues to rake in money from a public clamoring to see Shamu perform. To survive, SeaWorld must transition to a different economic model, one that no longer derives commercial success from captive killer whales.

In the end, if there were no SeaWorld, the public would not be deprived of nature. In fact, the opposite is true. People would learn about orcas from films and television and would have more incentive to venture out into the real world to glimpse the animals as they should be: roaming freely for mile after mile.

CONFESSION SIX

I Didn't Resign, I Got Fired

CHAPTER TWELVE

Undiscovered Country

WATCHED MY PARENTS HOBBLE through the airport, struggling to drag their suitcases behind them. They'd always seemed invincible to me—strong, healthy, and sure of themselves. Now old age had gotten the best of them, and it was as hard for me to accept as it was for them to endure.

"How are you doing?" I asked my father on the way to the car.

"I'm feeling slow," he admitted.

"What do you mean, 'slow?'"

"I'm in constant pain and feel weak," he said. "It's just how life is," he continued with his trademark no-nonsense approach. My father had never tolerated complaining in his children, and he wasn't going to tolerate it in himself, either.

"I don't want you to feel that way," I said. Seeing my parents' weakness brought out a childlike concern in me.

"Can't do much about it," my father said, and that was the end of the conversation.

Even though my parents lived three thousand miles away in Bath,

England, my family and I saw them every year. But their journey to the United States grew increasingly arduous for them. I was shocked by how much difference a single year made in their overall health. Each time they visited, I noticed new and troubling changes. My once-sturdy father now wobbled when he tried to ride a bike. My formerly fit and athletic mother could barely swing a tennis racket. They asked for wheelchairs at airports, and they both nodded off frequently during the day. Now in their early 80s, frailty and senescence slowly diminished them.

In contrast, as my parents' health waned, my career grew. I was thriving professionally, and my standing at NWF had never been higher. Under my leadership, NWF produced films prolifically—from award-winning prime-time documentaries and IMAX films to music videos, computer software, and children's programs. Our films garnered critical acclaim and frequent commercial success, and my career seemed unstoppable. This success had a significant effect on my own confidence, as I became more knowledgeable and better connected—I was no longer the bumbling, callow novice I'd once been.

Unfortunately, my professional successes sharply contrasted with the suffering of my aging parents. My increasingly frail mother had a serious stroke, and my father became her full-time caregiver. I had barely come to terms with the knowledge that my mother could neither eat nor talk properly—and was likely permanently disabled—when my twin brother Jon called me from England to tell me that our father was dying. His prostate cancer had become so advanced that the doctor had told my father he had only weeks left to live.

My brother's news floored me. I'd known about my father's cancer, but I hadn't taken it seriously. My father rarely brought the topic up, so I assumed the cancer was under control. I also knew in general terms that

prostate cancer could sometimes be managed without being life threatening. If anyone could beat it, it would be my father, who I knew would face it as he did every other problem in his life—with patient stoicism. I had convinced myself that he would vanquish the disease. My brother's news shocked me.

As soon as I got off the phone with Jon, I called my father. "Hi," I blurted. "I'm so sorry to hear the bad news."

"It's okay, son. I'll deal with it."

"How are you feeling?"

"As good as can be expected."

My father ended the call shortly after that, unwilling to say any more about his illness. I wanted desperately to have a real conversation with him. And who knows? Maybe he did, too. But my father so loathed sentimentality and any hint of mawkishness that he avoided any further expression of my sympathy. We'd never talked about our feelings before, and he wasn't going to start just because he was dying. I hung up the phone with regret, wishing I knew how better to draw my father out. Expressing tender feelings toward him was not one of my strengths.

I arrived in England a week or two before my father died, but our goodbye was nothing like the intimate moment I might have wished for. In the sterile hospital room, I clumsily asked him how he was feeling. The next day, I asked the same question. "I told you yesterday," he snapped. It was as though the clock had been turned back forty years and I had become an obstreperous teenager who was irritating him.

I knew my father loved me, and I knew with equal certainty that he'd never tell me that. He simply wanted to get the business of dying over with, without insensitive intrusions from a son who lacked the skill to talk to the dying. I knew he felt awful—his suffering was obvious—but my

father had never demonstrated any hint of weakness in the past, and he was going to continue that tradition until the very end.

A sudden feeling of regret washed over me. My father deserved far more love and attention than I'd given him in my adult life. I forgave him for his irritability, but I had a harder time forgiving myself for failing to be closer to him. I had not excelled at being a dutiful and affectionate son. Of course I had plenty of excuses, like being thousands of miles away and having the responsibilities of my career and my own family. But still, I could have been more caring and involved. I could have visited and called more often. I could have pushed past his terse replies and spent more time talking to him about his life. I could have and should have done all of these things.

Through intense hard work, determination, and self-discipline, my father had risen in the highly stratified British society, transforming from a fatherless, working-class kid into a successful and affluent member of the upper-middle class. His four sons had grown up with all of the advantages he'd been denied, and he did his damnedest to ensure we would rise even higher in society.

Our father was never easy on his sons, and my earliest memories are of his harshness. In 1951, when Jon and I were four years old, England was still under strict rationing from the war. Although butter was in short supply, we had plenty of milk. Our father would make Jon and me stand in the yard and shake heavy bottles of creamy milk until the milk was transformed into butter. Our arms would ache painfully, but if we stopped to rest, he would shout at us. He grew more authoritarian and demanding as we got older. He believed that discomfort, deprivation, and hard work were the secrets of success. He insisted that we be tough enough to survive hard times.

As mentioned earlier, my father's style of parenting, although rare these days, was not uncommon back in the fifties. He was domineering and a martinet. He didn't believe in indulging his sons with relentless cosseting and coddling as is so common today, and he was unafraid to set limits and boundaries. He would tolerate no challenge to his parental authority in the house. Somewhat distant and remote, he was rarely affectionate with us. That being said, there is no doubt in my mind he believed he was doing right by us; he strived to be the best parent he knew how to be.

My father's attitude toward our female cousins was a revealing contrast to the way he treated his sons. He saved his tenderness for these girls; while he was relentless with us, he was playful and charming with them, teasing them and delighting in their laughter. As a young boy, I chafed with envy as I watched his gentleness with them. How could he treat them so differently? Why did my cousins receive his warmth and generosity when my brothers and I had to endure his continual admonishments and harsh discipline?

Once, when I was about six years old, I found myself in a deeply melancholy mood that was doubtless exacerbated by the ongoing tension in our house. My father saw that I was dispirited and instinctively hit on a solution. He ordered me out to the garden, insisting that I push our heavy lawn roller up and down the yard until I was exhausted. I protested, but he was right: Soon enough, the strenuous exercise transformed my mood from ennui to endorphin-driven optimism.

My father might have been unapproachable and stern, but he was a hero to me. I craved no one's praise and approval more than his, all the more so because of its paucity. He taught me to constantly learn and to focus on my goals, and he gave his four boys the best education money could buy.

When my twin brother and I were nine years old, we took the entrance

99

exam for Dulwich College. In socially stratified 1950s England, education was one way to improve one's status. Entrance to Dulwich meant our lives would likely be successful, at least in a socioeconomic sense. If we failed to get into Dulwich, we would be sent to an inferior school and our lives would likely be lower-middle class. My father found the latter option intolerable and was determined that his sons would pass the entrance exam.

To this end, my father laid out a daily schedule for us about a year in advance. Every weekend and holiday, we were to study from nine in the morning until the evening hours, with an hour devoted to every subject. He punctuated our rigorous study schedule with vituperative tirades, insisting we were "wet" or "stupid" and needed to work harder whenever we would make a mistake or lose focus. He was particularly harsh with us when we studied mathematics, a subject at which he excelled. If we could not understand a problem, he'd supplement his tirades with occasional cuffs about the head. It was tough, but Jon and I both passed the exam.

My father was just as attentive to our personal development. Intolerant of any sign of tenderness, he emphasized the importance of self-discipline and diligence. He stressed to us over and over again the value of developing what he called "officer-like qualities," a reference to eminent naval officers like Admiral Nelson, whom he deeply admired. He loathed vulgarity, too. Once, when he overheard my teenage brother Jeremy referring to the "bird" he was taking out on a date one evening, my father sternly reprimanded him. "Jeremy, I never want to hear you refer to a girl in those terms," he snapped. "It is crude, ugly, and disrespectful."

My father constantly battled with Jeremy. The combative and caustic attitudes they expressed toward each other destroyed any trust between them. Their harsh interactions caused me anxiety, too, and taught me that quarreling rarely achieves anything.

My father's difficulties with Jeremy were so emotionally enervating and dispiriting for him that when it came time to parent his other three sons, including me, he didn't apply quite the same level of constant criticism. He could see the strikingly unsuccessful results of unrelenting and fierce nagging with Jeremy.

Looking back, it's easy to see that my father was likely constantly exhausted and deeply worried about money. His military job was challenging, and the financial strain of raising four boys and sending them to an exorbitantly priced private school took its toll. Plus, when all four of us were home from school, he never saw a moment of peace and quiet. His own childhood, as the only son of a widowed mother, may have been materially difficult, but it had also been relatively tranquil. Our noisy, active family was a constant source of stress for my father, unaccustomed as he was to so much chaos. To make matters worse, he suffered for years from a duodenal stomach ulcer that was so painful he ultimately had half of his stomach removed to rid himself of it. The episodic, piercing pain further aggravated his naturally belligerent disposition.

When I was about eighteen years old, I came home for leave after joining the Royal Navy. My father greeted me with a perfunctory handshake and then immediately asked me about my grades. Rather pleased with myself, I told him they were above average—mostly A's, with a few A minuses and B pluses. His face darkened. "For God's sake, you can do better than that," he snapped angrily. "You *have* to do better than that. You should be getting nothing but A's. Your grades are unacceptable." I was shocked by his fierceness, but from that point on, I resolved never to get anything less than A's. His demands pushed me to achieve what I'd previously assumed were impossible goals—and after that conversation, I always earned perfect grades.

As difficult as he was, my father often tried to make amends for the tension he caused in our family. After one of his terrible fights with Jeremy, he'd try to repair the mood in the household by telling small jokes. One morning he said to me, "Did you hear the barber's not cutting hair any longer?" The punch line, which he delivered with a small smile, was, "He's cutting it shorter." I didn't find the joke funny at the time, but I appreciated my father's effort to lighten the dour mood in the house.

I really was grateful for his humor, and it was from him that I learned the importance of being funny. He worked hard at polishing his jokes and collecting jocular material. After he died, the most precious keepsakes I received as my brothers and I went through his belongings were his extensive notebooks on humorous ideas that he collected over his lifetime.

For all his intolerance of bad behavior, indolence, and poor exam results, my father also had a sense of fun. I remember him building an obstacle course in our bedroom to challenge us physically. And, as mentioned earlier, his strictness evaporated when he became a grandfather: He took great delight in teaching my three daughters how to make an English cup of tea (a task he had mastered), how to peel a tomato by boiling it, and how to play the card games whist and bridge. He adored spending time with his grandchildren. With them, he could show a softer side he'd never offered his sons.

In my work as a wildlife filmmaker, I see my father's presence in me every day. He taught me to delay gratification, to focus on long-term goals, and to avoid getting sucked into trivialities. He hated anything that smelled of duplicity or decadence.

The last time my parents visited us in the United States (I was about 50 years old), my father and I argued ferociously over something utterly trivial. He'd insisted that the United States was running out of oil and

that soon there would be none left. I countered that scarcity would simply drive up the price and make alternative forms of energy more competitive. "That's ridiculous," my father snapped. "If you keep consuming oil, you're going to physically run out of it."

"You're thinking like an engineer instead of an economist," I retorted, the blood rising in my face. Replies and rejoinders flew back and forth, voices spiraling, neither of us listening to the other. When our tempers and egos had cooled, we were both embarrassed by how heated the argument had gotten, but neither of us had the strength or humility to apologize. Ashamed, I wanted to say I was sorry, but I never found the right time or the right words to do it.

My father died on April 14, 2001. In the words of Jimmy Carter's heart-wrenching poem about his relationship with his father, I came to see

what he'd become, or always was—
the father who will never cease to be
alive in me.[1]

My dad's death filled me with regret. I wished desperately that I had apologized for the times I behaved badly and argued with him harshly without listening to his point of view. He had so many admirable traits that I highly esteemed, and I cared deeply for him. Most of all, I wished that I'd told him I loved him.

Although my father was terribly ill in his final days, he set aside his own health to care for my mother. He massaged her feet and legs every night, devoting himself completely to her comfort (he even washed her undergarments every day). He taught through his example up until the very end, facing his own death quietly and with dignity. He was officer-like until his final breath.

After my father died, my mother's health deteriorated. She moved into

a nursing home in England, where she weakened by the day. Around the same time, my career at NWF took a turn for the worse. For over eight years, I had flourished at the highest echelons of the largest conservation group in the country, where I was widely viewed as a mover and shaker. But around the time of my father's death, everything began to go wrong. One of our IMAX films caused conflicts with one of our partners, and soon strife led to lawsuits. As the legal proceedings dragged on, the top NWF management slowly began to lose confidence in my abilities. Meetings with lawyers and accountants consumed all of my time, and my spirit and energy drained away.

I knew things had gotten truly dire when my colleague Monty Fischer—one of NWF's top regional executives—dropped by my office, ostensibly just to say hello. Monty and I were good friends, and a high level of trust existed between us. When he was at headquarters, he often stopped to chat, and at first I thought his visit was routine. But after a few minutes, I sensed something was wrong. "Have you seen much of Larry Schweiger?" he asked with studied innocence. Larry, the new president and CEO of NWF, was my new boss. I told Monty that I had seen him very little since he joined NWF. "You should get to know him," Monty said casually, but his underlying message hit me immediately. Monty was telling me my job was in danger and the word on the street was that I was about to be fired. A storm was brewing and I had been caught unaware.

I gradually lost power and prestige as accountants and lawyers took over the decision making in my areas of responsibility. My energy and mood all took a hit. I faltered when closing new deals and had increasing difficulty in making new initiatives bear fruit. My self-confidence plummeted along with my performance. Less self-assured, I stopped speaking out so much at staff meetings.

From here, things only got worse. A single incident came to symbolize my declining status at NWF: I'd eaten some dark chocolate in the car on the way to a staff retreat, and a few bits of the chocolate fell into my lap as I drove. They'd melted to my seat, leaving a smeary brown mess on the back of my pants. For hours, no one at the retreat told me about the stain; they were too embarrassed to mention it. It wasn't until everyone had seen my predicament that someone finally alerted me to the humiliating mess. Shortly after that, the final blow fell.

Larry Amon, NWF's chief operating officer, called me into his office. "We're not renewing your contract," he said, avoiding eye contact and fidgeting with a pen on his desk. I had worked at NWF for ten years and was stunned to actually hear these words. NWF hadn't quite come out and fired me, but refusing to renew my contract amounted to the same thing. I'd chosen to ignore the clear signs of mutual disenchantment. The conversation with Amon shouldn't have come as a surprise, but I was shocked nevertheless. I'd refused to believe things had gotten so bad.

Deep down, though, I knew the truth. I had stopped being as productive as I once was and deserved to be fired. I had not done enough to justify a contract renewal. I was sick of the bureaucratic warfare that consumed every moment of every day at NWF, and my jaded attitude was reflected in my lack of productivity. But my job had defined me for an entire decade, and I had no idea who I was anymore without it. I struggled to come to terms with the feeling of outright rejection and the knowledge that I was dispensable. The sudden uncertainty of my future left me feeling resentful and anxious.

Then my mother died.

Like my father, she faced the end of her life with uncomplaining courage, dignity, and an indomitable spirit. Despite the degradation of

her health and bodily disintegration, she was amazingly gracious. Her loss should have come as no surprise either, but in the wake of my termination, it felt like my life was falling apart.

Also like my father, my mother found parenting a difficult path. Her sons perplexed her, and she saw her maternal role as one involving chronic drudgery. Raising us seemed to give her little pleasure. She, too, had a difficult relationship with Jeremy; whereas my father reacted with fury and violence, she resorted to pleading with him and submitting to his every whim. While my father made his awkward jokes the morning after a routine family explosion, she'd set about cooking our favorite breakfast, doing her best to restore normalcy.

My gentle mother found herself with four combative and energetic boys who refused to do anything she said. My brothers and I fought constantly, exchanging both furious words and physical blows. My mother, unable to stop us, would suffer punishing migraine headaches (or she claimed she did, at least) until my father ordered us to be quiet to give her a temporary reprieve from the tumult in the house.

She would sometimes become so frustrated with us that she'd hit us with a wooden spoon, although violence was strongly against her nature. She'd shriek over us as we lambasted each other, but her attempts to stop our arguing and her entreaties to apologize to each other were ineffective. Our constant fighting took a terrible toll on her; she hated conflict of any kind, and our antagonistic relationships upset her to no end.

My mother didn't have a cruel bone in her body, and her attempts to discipline us aroused my pity. She never hit us with any force, and her blows were no deterrent to our pugnacity and aggression toward each other. Striking us with a wooden spoon caused her significantly more pain than it ever did any of us. As desperate as her efforts were, her gentle and

forgiving nature acted like a balm, bringing much-needed comfort and stability to our family. Her sensitivity, tolerance, and empathy were gifts the rest of the family, including me, never fully appreciated at the time.

One day I heard sobbing upstairs. I went into my parents' bedroom and found my mother face down on the bed, weeping. She'd desperately wanted a daughter—a kindred spirit who she could spoil and fuss over and who could act as an ally and confidante in our chaotic family full of males. Instead, she was stuck with four sons, and she found the relentless aggression and family strife too much to bear. A deep melancholy seeped into every part of her body. My mother, a naturally warm and loving person, was devoted to her family's welfare, but bringing up a pack of mischievous and sassy boys with our stern, demanding father was almost too much for her to bear.

When I was about five years old, she had a mental breakdown and only recovered after a month in a sanatorium. Fifteen years later, after her sons grew up and left home, she had an epiphany. "I've had it with being shy, reticent, and quiet," she told herself (and later me). "It's getting me nowhere. From now on, I'm going to be the life of the party." She willed herself to transform from an ugly duckling into a swan, and she never looked back, blossoming almost overnight into a vibrant social butterfly.

My mother's transformation was a great asset to my father as he rose through the ranks and became head of the Royal Corps of Naval Constructors in Great Britain, which designs and builds all of the warships and submarines for the Royal Navy. Freed from the daily burdens of parenthood, she became a superb partner and gracious hostess. Her warmth and vivacity made her a welcome presence at every imaginable social function, and she helped my father immensely as his own professional stature grew. She loved to make new friends and especially loved to take care of

people at parties who were friendless, appeared shy, or felt left out. She would put them at ease and make them feel welcome. Always looking for the best in people, she taught me the importance of building relationships through care and concern for others. What my father lacked in gentleness and tact, my mother more than made up for with her own endowment of these qualities.

Although my relationships with my parents weren't always easy, I felt a tremendous compassion for them after their deaths. Their own suffering and deprivation—as both children and adults—shaped who they became. They transcended those disadvantages and lived thoroughly good and decent lives. I felt lucky to have had them as parents and was deeply proud of them. Understanding their struggles made me realize what very special people they were and what incredibly good parents they were to me.

Yet, unforgivably, I had never thanked either one of them. I wished I had told them while they were alive how much they meant to me. As I read each of their eulogies at their funerals, I was overcome with emotion when I underscored the ways in which they had dedicated their lives to their sons.

My mother's death came at the lowest point in my career at NWF. Her passing, combined with the loss of a job to which I had dedicated a decade of my life, sent me reeling, and I had no idea how I'd get back on my feet.

CHAPTER THIRTEEN

Letting Go

"WHY ARE YOU LEAVING the National Wildlife Federation?" friends and colleagues asked when I told them the news. At first, I didn't know how to respond. I only knew that I had to be less than fully honest. I was so embarrassed to be fired that I hid it from everyone except Gail. I was too insecure and too proud to tell the truth. When the question inevitably arose, I responded that I was pursuing new opportunities.

No one except the top management at NWF knew I'd been fired, not even the NWF board. Our board members held me in high regard, and there could have been trouble for top management if the board thought I had been pushed out. The management had as much invested in my fiction as I did and were only too happy to keep the truth a secret. I told friends breezily that I'd taken a year off to write a book and was thinking about starting up a new nonprofit.

My friends accepted the story, but nothing could have been further from the truth. I was frightened and uncertain, and I had no idea what I was going to do with my future. I hadn't felt so at the mercy of the world

since I was a young student back at Dulwich College. I lay awake at night, rife with anxiety. What would happen next? What if I never worked again?

My identity was inextricably bound to my conservation and film work; now I feared that the best part of my professional life might be over. It was possible that I would never find work that gave me a sense of purpose or meaning again. I felt myself starting to slip into obscurity.

With my self-confidence at an all-time low, I fell into a despondent mood the likes of which I hadn't experienced since I was an adolescent. I knew an attitude of resignation was a terrible force that would have consequences on the rest of my life, but I found myself unable to shake free of it. Although many of my fears were hazy and nebulous, some were all too concrete. Gail had a good job as a health policy analyst, but we needed two incomes to pay the mortgage and send our three daughters to college.

"We may have to sell the house and move into something smaller," Gail said one night, her brow furrowed with worry.

"What if you lose your job, too?" I asked her.

"Then we're really in trouble. Let me run the numbers again."

Gail, with her strong analytical and financial skills, managed all of our money, a family task I was relieved not to shoulder. The worry on her face as she went through our finances yet again intensified my concern. There was no doubt we were in trouble. I wasn't sure I even had a professional future. I was 56 years old and knew that people that age often have a very hard time finding work. Elder members of society are not revered for their wisdom in the United States as they are in Asia. I lived in a culture that glamorized youth and worked in an industry that preferred vigorous, charismatic young people, not declining old men.

Throughout my life, books had helped and sometimes even saved me in times of challenge. Now I turned to them again. I plunged into a biography

of Abe Lincoln and was fascinated by his reaction to the devastating Union defeat at the First Battle of Bull Run. He didn't despair, he didn't panic, and he didn't blame others. Rather, he got out a sheet of paper—literally—and made a list of everything he needed to do to correct the situation and make sure it never happened again. Inspired by his example, I did the same. I got out a sheet of paper and wrote out a detailed plan. I began thinking more proactively about how to recover and blossom again after the loss of my job.

I found similar inspiration by watching a documentary on how wolves hunt. About nine out of ten hunts fail, but, unlike humans, wolves don't succumb to moods of despair, lethargy, or resignation. They simply rededicate themselves to their goal. They don't have the luxury of depression: Not hunting means not eating. They simply can't afford to give up, so they persevere. I had to do the same.

Finally, one morning I had a revelation. I'd assumed getting fired was a death blow. What if, instead, it was an opportunity in disguise? Once I waded through a miasma of fear and misery, I began to see a light at the end of the tunnel. I started to plan and to think strategically about my next steps. In my plan, I listed mentors and potential networking events. I wrote out endless ideas for avenues to explore. I dreamed up goals even bigger than the ones I'd had before.

Step by step, I restored my faith in my own future and began to work toward it. Throughout my entire career with NWF, I'd wondered if it was possible to make truly ethical wildlife films: films that didn't exploit their subjects, rely on fakery, or depend on cruelty; films that might change the way the industry operated.

I'd thought getting fired was the end. Instead, it was a chance at a new beginning. I was starting to dream bigger than I ever had, and a new future was more than just possible. It was probable.

CONFESSION SEVEN

I Was a Professor Who Didn't
Know How to Teach

CHAPTER FOURTEEN

Teaching and Preaching

"**P**ROFESSOR PALMER, I HAVE** a request. Would you please do a handstand for us?" It was my first class as a teacher at American University (AU), and my students were ready to challenge me. This particular student had heard that I could do handstands, a regular part of my daily exercise regimen. The request came out of the blue. At first, I hesitated, but then I thought, "Hell, why not?"

From the beginning, I instinctively knew my teaching style would have to be entertaining and engaging. If I couldn't hold my students' attention, they would grow bored and passive, and they'd learn very little from me. To some extent, teaching was like making wildlife films: A film can contain all of the information in the world, but if it doesn't keep viewers engaged, nothing will be conveyed or accomplished.

I'd ended up in the classroom almost by chance. A few months earlier, my phone rang one morning. "I want you to meet Dean Larry Kirkman," Pat Aufderheide, a professor at AU, said after a brief hello. She had heard I was leaving NWF and thought that I could add something to the AU faculty at the School of Communication, where Kirkman was dean. It

had been thirty years since I'd set foot on a college campus—I barely even knew what a dean was. But her call sent a frisson of excitement through me that I couldn't ignore.

As mentioned earlier, my father had been a professor of naval architecture for five years at the Royal Naval College in Greenwich, London, when I was a boy. I'd been hugely impressed by the prestige and authority of his position, not to mention the fact that he was so clever he'd been asked to educate others. As an adult, teaching seemed not unlike parenting to me, and I loved being a father. In addition, I'd given hundreds of speeches over my twenty-five-year career, and I loved being in front of an audience, passing valuable information on to others while inspiring and entertaining them. Teaching seemed like the perfect blend of all of those aspects of my personality. I'd never tried it before, but I had nothing to lose. I told Aufderheide that I'd be delighted to meet with Dean Kirkman.

On a sunny day in May of 2004, I confessed to Dean Kirkman that I knew little about teaching but was intrigued by the prospect. What I really wanted to do, I told him, was to start a new nonprofit organization to encourage the creation of ethically made and highly entertaining wildlife films. Kirkman responded by saying, "Why don't you come to AU, start your new nonprofit here, and also teach?"

The idea of creating a nonprofit organization within a university initially befuddled me. But Kirkman persisted, and I agreed to give the project a try. At the same time, Kirkman invited me to join the full-time faculty at AU's School of Communication. After the setback of being fired from NWF, my professional life took off with fresh vigor and vitality. Leaving NWF had freed me to experience a new and dynamic beginning.

With Kirkman's support, in 2005, I founded the Center for Environmental Filmmaking at AU, which produces films and creates programs

for film students. Most important to me is the center's particular focus on ethics in wildlife filmmaking. I wanted to focus attention on the way audiences were deceived and manipulated by staging, computer graphics, and game farms; how animal suffering caused by filming was often swept under the carpet and ignored; and how conservation was too often neglected in wildlife and environmental films.

I was convinced, perhaps naively, that there were ethical ways to produce commercially viable wildlife films. The Center for Environmental Filmmaking gave me a platform where I could raise issues that had begun to haunt me and allowed me to create and launch new opportunities. I could continue to make films and videos, develop classes, establish scholarships, design competitions, schedule film festivals, and more—the sky was the limit.

I founded the center on the belief that powerful films, images, and stories can play a key role in fostering conservation and bringing about constructive change. I was committed to raising awareness and empowering action through the innovative use of media. My mission was and still is to inspire a new generation of filmmakers and media experts whose commitment to environmental stewardship drives them to produce creative work that is informative, ethically sound, and entertaining—and that makes a positive difference. There's no question that the world is facing unprecedented environmental challenges. I believed that media could play a key role in raising awareness about conservation and even be a starting point for real transformation.

Twenty-five years earlier, I had become a wildlife filmmaker despite knowing virtually nothing about wildlife filmmaking. Now I was becoming a teacher even though I had no experience teaching. I had no real philosophy other than a vaguely articulated conviction that I wanted my students to do well, whatever that meant.

Unsurprisingly, I made my share of rookie mistakes. I was repetitive, talked too much, and gave grades that were too high. I embarrassed students by brazenly pointing out their mistakes in front of the rest of the class. Sometimes I failed to allow a class discussion to blossom, while other times I let discussions run rampant to the point that I lost control of the class altogether. I allowed verbose students to talk too much and did not properly listen to what students were saying. I rushed through material. I thought it was important to convey all of the information I had, not realizing that getting through all my notes had little to do with whether my students were learning. Occasionally, my students described the homework I gave them as "busy work" and criticized me for wasting their time.

I would sometimes say "Any questions?" to a roomful of blank faces. Usually, my students' silence meant I hadn't explained the issue well and they were afraid to look dumb, but I assumed their lack of response indicated understanding. I would get on such a roll with my own ideas that I would explain them poorly and forget to provide the proper context for those ideas. I was sometimes too slow to return my students' papers or dashed off glib, superficial comments in my hurry to get through them. Sometimes I was given a class to teach that I didn't want—or even know how—to teach. I was worried that I would say something stupid and end up feeling embarrassed and self-conscious. Most of all, I hated it when students obsessed over grades. I was sorely tempted to stave off their harassment by raising their grades, which would have been yet another egregious error on my part.

Over time, I learned from these mistakes. I continually asked my colleagues for advice and I studied some excellent books on teaching, such as *McKeachie's Teaching Tips*. I also learned from my students. Every four weeks, I asked them for honest and candid feedback, assuring them that it would be anonymous. One day, a student wrote, "You are not pushing

us hard enough. I want to get as much out of this class as possible. Please teach us everything you can. I want to learn more."

This feedback hit me hard. Some part of me had already known that I wasn't pushing my students hard enough, but that one student comment meant I could no longer ignore my inner voice. My students didn't want to be passive listeners—they wanted to transform their lives. They wanted real knowledge and the tools to use it. I updated my personal goals to reflect my desire to be a more inspirational teacher, always available to my students, and someone who consistently encouraged, supported, and challenged them. I resolved to provide my students with a life-changing experience. I wanted to be renowned for my exceptional teaching skills and for getting my students actively engaged in their own learning. But writing down these goals and turning intentions into action turned out to be two very different things.

Phoebe Bradford was one of my brightest and most conscientious juniors. She told me that when she was nine years old, her parents had taken her to see her first IMAX movie: my film *Whales*. She loved it. The underwater footage, the stories, and the whales all fascinated her. The film's tale of Misty and her calf Echo had been particularly entrancing.

Whales followed Misty and Echo's journey from Echo's birthplace in the waters off of Hawaii to their feeding grounds in Alaskan waters. The tension in the film builds as the audience wonders whether the pair will get to Alaska safely while running a gauntlet of threats, including collisions with ships, entanglement with fishing nets, and attacks from killer whales. Against the odds, Misty and Echo make it through the 3,000-mile journey, and in the final, emotional scenes, the camera lingers on their arrival in the waters of Alaska. The story was so moving that Phoebe could still remember it years later.

In that class, I told Phoebe and her classmates the truth about the story

of Misty and Echo: It was complete fiction. The footage of the mother and calf arriving in Alaska was not actually of Misty and Echo but a different female humpback whale and her calf. We'd meant well, of course. The film championed whale conservation. We hadn't deviated from the scientific facts of whale migration. At the time, the demand for an engaging and dramatic story had trumped the need for truth. We were just employing the conventions of filmmaking artifice.

Many filmmakers would not consider what we did to be unethical. After all, the science was accurate. It would have been impossible to film the same mother and calf leaving Hawaii and then arriving in Alaska, and we'd served the cause of whale conservation by creating an emotional story that people would care about and be invested in. Today, I believe it was wrong to deceive the audience, and I regret it.

Phoebe felt the same way. She was crushed to learn the truth. *Whales* had meant a great deal to her. She'd believed every scene in the film—and why wouldn't she? It was a science-based documentary endorsed by the world's top whale scientists. When I told her the truth about the movie, she was distressed and felt betrayed. She'd been tricked all those years; the beautiful story that she'd carried with her had been a lie.

Phoebe's disappointment raised plenty of issues for me. It was my job to teach filmmaking ethics, and yet I'd made decisions in the past I that no longer agreed with. Should I tell my students the truth and risk their censure or should I continue to lie? Ultimately, I chose to confess the mistakes I'd made in the hopes my students would be able to learn from my experiences, even if it meant the possibility of losing my students' respect. I tried to explain to them what it was like to be hungry for recognition and success and how desperately we'd sought the money shot that would catapult a film (and its producer) to fame and fortune.

I knew that my students would face their own difficulties in their filmmaking careers. Low-level crew members usually have little input in crucial decisions, and their ethical concerns would likely be ignored until they had real power in the industry. I've heard any number of filmmakers say that they were uncomfortable with unethical behavior that they had witnessed on the set but didn't feel like they were in a position to object. Not enough time is devoted to teaching film students how to behave ethically when making wildlife films and how to speak up in a professional way without getting fired, blackballed, or ostracized. These are skills students need to be taught by examining case studies and other techniques.

There are plenty of other skills film students are not currently taught, including self-discipline, resourcefulness, and the ability to work with others. Many talented filmmakers lose out on jobs because they lack these basic life skills. I didn't want my students to fall into the same trap.

My graduating students would regularly come to me and tell me they'd done everything they could—networked like crazy, looked everywhere—but to no avail: They'd be graduating without a job in the industry. They were worried that after all the time, energy, and money they and their families had poured into school, they'd have nothing to show for it, that they'd fail to make anything of themselves. I listened to these fears over and over again.

As I made clear to my students, the film industry is an incredibly difficult one. Even if they're lucky enough to hear about a potential job opportunity, the competition for it is ferocious. And even if they're lucky enough to land the job, it may not pay well enough to compensate for their student loans. Teachers like me can pass on valuable technical skills, like animation, cinematography, and editing methods. We can support them in creating meaningful and purposeful media through storytelling. But all the technical skills in the world won't help them if students can't find jobs

or can only find jobs that painfully underemploy them and don't use their full potential, which seems to be the case for far too many film students.

Professors like me need to do more than teach our students technical skills. We need to teach them how to succeed and sharpen their real-life skills—leadership, professionalism, collaboration, lifelong learning, resilience, and integrity—to help them develop that extra edge necessary to effectively compete for opportunities inside the industry and to be able to transfer those skills outside of the industry if they so choose.

Professors need to make sure that students know that they need to constantly initiate actions to make things happen. Students must be entrepreneurial, seize opportunities, and work hard. They must learn how to run a business, to persevere, and to stay focused even in the face of setbacks and rejections. They need to be able to negotiate, listen, and raise money. They need to be self-motivated, tenacious team players. They need to mold themselves into human beings with great trustworthiness, reliability, and honesty so that people want to work with them.

Students also need to become persuasive speakers so they can pitch their films, campaigns, and projects in the most exciting and dynamic way possible. They have to have the ability to enroll people in a vision and to pursue that vision with passion. They need to network relentlessly so that they are in a strong position to hear of new opportunities, hire the best people, and tap into the best financial resources.

Above all, they need a moral compass.

I knew I couldn't change the culture single-handedly, but I resolved to make a critical difference in the life of every student I encountered. My students would walk away from my classes with not only the skills to make movies but also the ability to face real-world challenges, including the challenge of making wildlife films ethically.

CONFESSION EIGHT

I Tried Stand-Up Comedy
and Got the Boot

CHAPTER FIFTEEN

Wildlife Filmmaking Is Easy, Comedy Is Hard

I COULDN'T STOP THINKING ABOUT Phoebe Bradford. Could she have still been riveted by *Whales* if we had not used deception? Was there more than one way to make a wildlife movie powerful? Did any of those ways not involve lying? What about the power of humor? Few had tried humor before. Wildlife films, including my own, were often serious and sometimes seriously dull. Maybe it was time to break the rules a little. Maybe it was time to make people laugh in the name of conservation.

I was 57 years old and enjoying a second career as a professor. Things in my life had never been better. My oldest daughter, Kimberly, a young journalist, one day brought me a flyer she had picked up advertising a series of classes on how to be a stand-up comic.

"Dad, you should do this—you like making people laugh," she said.

I looked at the flyer. My heart stirred, but I played coy. I replied, "Kim, I don't have time for that, but thanks for thinking of me."

The flyer stayed on my desk for a week or so, nagging at the edges of my consciousness, and then I picked it up again. "Why not?" I said to myself. "If not now, when?" I could see from the flyer that the final class involved performing at a local comedy club; the challenge intrigued me. I signed up for the six evening classes and started thinking up funny ideas.

Kimberly was right—I had always enjoyed making people laugh. My earliest happy memory is of making my family laugh as a small child. I'd overheard my mother ask another family member rhetorically how many famous people there were in the world, and I saw my chance. "Well, let's see," I said, with as much mock seriousness as I could muster. "First, we have Sir Winston Churchill...." I knew the sight of a five-year-old acting like a professor would send my family into hysterics, and I was right. Of course, I have no idea now whether they were laughing with me or at me, but I relished the power and delight of making them laugh. The older I got, the more pleasure I took in being the class clown. I delighted in slapstick and verbal comedy, often at the expense of the teacher.

When I was about 17 years old, I joined the Royal Navy and was sent to Plymouth to the Royal Naval Engineering College on the south coast of England. One of my first assignments was to give a presentation on a tugboat to my class of about thirty people. I worked hard on my presentation and took it quite seriously, but within the first minute of my talk, I made a joke—now long forgotten—that set my classmates laughing. Seriousness was suddenly forgotten, and I was off and running. Soon, the entire class was roaring with laughter, some of them doubled over and clutching their stomachs. My classmates' delight meant far more to me than the presentation itself.

I'd always taken joy in making people laugh, but it had never occurred to me to pursue a career in comedy. The option wasn't even on the table—my

parents never would have countenanced such a move. They wanted their boys to succeed in *real* careers, as professionals: in other words, traditional careers that they were familiar with. As an adult, my film career took over my life. I was focused on environmental activism and filmmaking—becoming a comedian never even crossed my mind. I was fulfilled by my work and didn't waste time thinking about what might have been. But the flyer Kimberly brought home had awakened something deep within me. On my first day of stand-up comedy class, my heart thumped with anticipation. I felt as though I was finally acknowledging a long-denied interest.

The class itself came as a complete shock. Being funny was serious work. I found it much harder to create humor-filled material than I'd anticipated. In sum, my early efforts as a comic were, in a word, pathetic. But taking the class gave me the self-discipline to keep working at it. I used material from my own life to develop my jokes, gently poking fun at my students, my family, and myself. "My health is perfect except for a particular hearing problem—I can't hear a word my wife says. On the other hand, her hearing gets better every year—she can hear our three grown daughters' biological clocks ticking louder and louder."

I presented my jokes to my classmates, carefully gauging their reactions. The jokes that won a smile or a laugh were keepers. Everything else was out. Here's one that made the cut: "I make wildlife films, for example, on bears. Bears can kill you, so you always go into bear country with someone...that you can outrun. Also, wear tiny bells to warn bears away. And look out for bear poop, easily recognizable because it contains tiny bells."

I finished the class with a short routine, and I was eager to keep polishing my skills. I began to perform once or twice a week at special events and at the local Washington, D.C., comedy clubs and I invited everyone I knew—friends, family, coworkers, students—to come to the shows.

I loved the challenge of performing. Keeping the audience's attention was difficult, and I felt like I'd really accomplished something when I was successful.

Sometimes the challenge came from my fellow performers. My material was all G-rated, but I was the exception. Most other comedians, unfettered by decorum, relied on boorish, coarse, and smutty humor laced with profanity and told jokes about botched sex lives, unfunny bodily functions, and other unappealing and unpleasant topics.

My friends and family were not universally supportive of my new hobby. Gail came to one of my performances and was shocked by the material from the other comedians and the atmosphere of the club. "How can you invite your students to these places?" she muttered.

Some of my friends were a little bewildered by my entry into the comedy world as well. I had a rich, fulfilling life engaged in pursuits that were suitable for someone of my age and standing. I was a respected filmmaker and professor—why on earth would I want to enter a world many people saw as trivial and undignified? But the more I performed, the more I grew to love comedy. I'd always wanted to create more laughter and joy in the world, and now I was doing it. I could see the results right in front of me in the happy faces of my audience. I was hooked.

Humor had always been a huge part of my life, but for the first time, I was finally allowing myself to acknowledge its power. Laughter can bring people together and break down barriers; it can defuse tough situations and put challenges into perspective. Working hard at a new skill brought me joy, and I practiced becoming a sharper observer of the humor hidden in everyday situations.

I worked as a local comic for about a year, and then Curt Shackelford, a local impresario who ran several comedy clubs, saw me perform and

invited me to do a set at one of his clubs. We got to know each other and, after a lot of work, we founded a new comedy club at the Bethesda Hyatt in downtown Bethesda, Maryland. I was the resident emcee for about four years and performed regularly there and at other clubs; Curt took care of the business end of the operation. Every Saturday evening from 8 p.m. to 10 p.m., our room at the Hyatt was usually packed and about five comics, including me, would perform our sets. The audience generally had a good time laughing. Then one day, Curt fired me suddenly, via an e-mail, citing rising competition from other comedy clubs as the reason. My sets were too inconsistent, he said. He needed professional comics to stay afloat.

The rejection stung, especially after all of the hard work I'd poured into the club. I couldn't help feeling embarrassed and indignant. But deep down, I had to admit he was right. I wasn't a brilliant or original comic. With hard work and constant practice, I could make people laugh, but my real professional work was as a filmmaker and teacher. I'd never be nationally successful as a comic and likely would never make it past the status of a local, poorly paid act. Even while knowing this, I found the humiliation of being relieved from my position at the comedy club—one that I had helped to found, no less—hard to bear. Nothing was stopping me from continuing to perform at other venues, but the sting of losing my emcee role at the Hyatt ruined my appetite for performing at other comedy clubs.

Now that some time has passed, I look back on my venture into stand-up comedy with great fondness. I performed weekly as a stand-up comic for five years. I never achieved my goal of breaking into bigger, regional venues, but I got laughs. These days, the pain of being fired has long since dissipated and I'm proud that I gave comedy a shot. I don't have to spend the rest of my life regretting never having tried it.

In addition to giving audiences pleasure, comedy taught me major lessons about being in front of people that I could take with me into other arenas. My speaking career has hugely benefited from the work I put into being funny, as has my teaching career. And my experience as a comic solidified my conviction that humor is an important element sadly missing from most wildlife films.

We greenies tend to be too serious. On the one hand, there's a lot to be serious about, but self-righteous zealousness can turn people off. Humor, on the other hand, is one of the most powerful tools available to us. Humor can actually push people to take environmental issues more seriously by helping them listen. Making viewers laugh is an effective—and fun—way to grab their attention and ideally hold on to it long enough to get an important message across. Comedy has so much potential that we would do well to learn to harness that potential to do good.

It's possible to add light humor in quite simple ways to regular nature programming. David Attenborough loves to be humorous, as when in *Planet Earth*, he stealthily climbed a ladder to say "boo" gently to a wild sloth. The sloth eventually climbed down the tree to defecate, and Attenborough accompanied it while providing interesting facts about the sloth laced with whimsical and droll comments for his viewers.

Sometimes humor can arise naturally from the situation being filmed. In *Frozen Planet*, male Adelie penguins in Antarctica are shown gathering pebbles to build nests to attract females. While some penguins diligently gather stones from areas beyond the immediate nesting site, other Adelies turn to a life of crime and steal pebbles from other nests. The confused expressions on the faces of the penguins who have been robbed are priceless. These beautiful creatures are inherently comical and it makes viewers laugh to see them acting as people do.

Another example is in Disneynature's *Oceans*. A mantis shrimp is shown defending its territory by facing off against a crab. The fight ends quickly when the shrimp delivers a knockout blow to the crab. The crab slowly rolls onto its back with its legs fully extended. A nice comedic thud sound is added as the feisty shrimp throws its final whack.

A final example is in *Planet Earth,* when a family of sleek river otters battles an intimidating crocodile. It's funny to watch the mighty crocodile retreat diffidently from these cute, gutsy little aquatic animals.

More humor is needed in the environmental movement. Nobody wants to sit through a finger-wagging lecture on how the world is doomed. Serious arguments have their place, but they don't bring people together in the same way that humor does. Organizations like the Rainforest Alliance and Greenpeace have used humor to great effect, creating viral marketing campaigns with serious impact.

Melissa Thompson, senior video producer at Greenpeace, told me that the most gratifying comment she received about one humorous Greenpeace video was "I didn't used to like Greenpeace. But I love this video."[1] Such can be the power of humor. Rainforest Alliance president Tensie Whalen told me that "conservation is great but for many it can be dull and boring. Humor makes things more interesting, so people are more likely to listen. Humor opens the door."[2] Environmental and wildlife issues have huge implications for the planet's future, and it's imperative that conservationists find a way to bring an effective message to an audience.

Humor can go awry in the conservation movement, of course. Videos that exploit or harass animals for the sake of comedy or that are designed to make audiences laugh but contain no serious message accomplish nothing and can even be counterproductive. Humor has to be warm and empathetic, not cruel, and it needs to have a point. Universities and colleges

should offer classes in the effective use of humor and should integrate comedy into their curricula. Professors need to teach and research the role of humor in crafting powerful messages that produce real results. People need to understand why laughter opens a person up to new ideas that they might otherwise reject. Activists need to learn how to use humor to bring people together and inspire action.

Diane MacEachern, a leading communication expert in Washington, D.C., suggested that schools of communication like mine at AU invite groups like the Second City, the Capitol Steps, or Hexagon to collaborate with us.[3] All of those organizations have done an excellent job of using humor, irony, and satire to bring political issues to the public spotlight, and the conservation world can learn from their lead.

Humor alone may not change behavior, yet that doesn't mean conservationists shouldn't use it—it just means the humor should be combined with strong conservation messages. Humor gets people's attention, increases sharing, and starts conversations. Humorous conservation videos can lead an audience to websites and other resources with substantive articles about the issues and become more involved.

Comedy can play an important role in getting people's attention, and when it is part of a larger campaign, it can more deeply engage people in conservation messaging. Sometimes the best way to instigate and catalyze change is to get someone to laugh. My colleague Professor Caty Borum Chattoo always says, "Laughter opens our ears and our hearts—and once people are listening, who knows what they might be inspired to do?" Humor can allow us to present insights that audiences might otherwise resist acknowledging.

To encourage environmental and wildlife filmmakers to use more humor, in 2008, some colleagues and I created and launched the annual

Eco-Comedy Video Competition, which we opened to everyone.[4] The winner receives a $2,000 prize from the Center for Environmental Filmmaking and the Nature Conservancy.

The author William Zinsser wrote, "What I want to do is to make people laugh so that they'll see things seriously."[5] This reflects my attitude exactly. For example, I was emceeing the BLUE Ocean Film Festival Awards Gala in September 2012 in Monterey, California. As I welcomed the audience of over five hundred VIPs, all dressed up in their best finery, I noticed the lack of diversity in the crowd, a problem that environmental leaders have lamented for years. As it stands now, the environmental movement has few black or other minority members. "We are a very diverse community," I quipped. "We have white people here from virtually every country in the world." The audience burst out laughing: I hope William Zinsser would have been pleased.

Although I'd found temporary fulfillment in my work as a comic—and long-term satisfaction in better incorporating humor into my work—I was also wrestling with a growing concern about some of the things I was doing in my own films.

CONFESSION NINE

My Own Mistakes Pushed Me to a Tipping Point

CHAPTER SIXTEEN

My Own Mistakes

THE THEATER WAS PACKED with over five hundred people, all of whom, judging by the fervor of the applause and the level of excitement in the room, seemed to have enjoyed our IMAX film *Wolves*. The film showed close-up shots of a wolf pack interacting in complex, subtle ways, as well as the nurturing, cooperative way each wolf assumed its share of responsibility for the welfare of the pack.

The film was designed to combat the disinformation campaigns of the ranching and hunting lobbies, which portrayed wolves as vicious killers. We wanted to focus attention on the interactions of a family group and on the important communal task of rearing a litter of pups. Few people know how communal and caring wolves are. They put a high priority on the protection, parenting, and mentoring of their young, and they are playful and affectionate parents with extraordinary communication skills. They're fierce and determined hunters, true, but the point of *Wolves* was to show something deeper. Wolves are incredibly social and rely on many forms of physical and vocal communication to show submission and dominance. We wanted to put their rich social lives on the screen.

I worked with wolf experts and advocates Jim and Jamie Dutcher while making the film. We camped at the edge of Idaho's Sawtooth Wilderness with a pack of captive wolves, giving us the ability to observe the pack closely. Filming the intimate lives of wild wolves is virtually impossible because they do not tolerate the presence of people. Getting up close and personal with wolf families is almost unheard of. Moreover, if we did film wild wolves, our footage would skew toward predation and pack feeding because those are relatively easier shots to capture, but that would give viewers the wrong impression. As a result, we made the decision to work with captive wolves.

Before the screening, I had given a rousing speech to inspire the audience to support wolf conservation. After the film was over, I opened up the floor to questions from the audience. A mass of hands went up and I pointed to a preteen boy. "How did you film the mother wolf in its den?" he asked.

My heart sunk. Answering truthfully meant betraying the trade secrets of wildlife filmmaking. I was not eager to reveal that the "den" in which the mother wolf suckled her newborn pups was an artificial set. Nor did I want to admit that we used captive wolves rented from a game farm for some of the scenes. As with Phoebe Bradford, if I exposed such secrets, people might feel cheated. I was facing a moment of truth, and I only had seconds to decide whether to equivocate or come clean.

By industry standards, we'd done nothing unethical. In fact, we'd made the ethical choice. Renting captive wolves allows filmmakers to avoid disturbing wild populations and potentially habituating them to human beings. Habituation renders them no longer fully wild and possibly less likely to survive, because if they are not afraid to approach humans, it's just a matter of time before they approach a person who feels threatened

by them, which may lead to that fearless wolf being shot as a result of the person's fear. Wild wolves would be deeply affected by prolonged and intrusive filming requirements.

But we'd deceived the audience all the same, and now the boy's question put trust on the table. In that instant, I decided to come clean with an apology and an explanation: I owed my audience transparency, not duplicity. I explained that the wolves were captive and the den scenes staged—that as realistic as they were, they still weren't the real thing.

Even though I told the audience that it was for the good of the wolves, I could feel their visceral disappointment as I talked. I realized I was speaking in front of a room full of fans who suddenly felt let down and cheated by the movie I'd poured so much of myself into. Sure, we'd included the game farm in the credits and disclosed in the small print that we'd worked with captive wolves, but how many people actually read the credits of a wildlife movie? The audience had naturally assumed the wolves featured in the film were wild. We had intended to give that impression.

That single question marked a profound shift in the way I thought about my work. Staging and manipulation were no longer clever and necessary filmmaking skills; to me, they had become simply unethical. I could not continue to dupe audiences and look myself in the eye in the mirror every morning. I was ashamed of the tricks I'd used in the past, and I knew the future had to change.

Although that question was the turning point, *Wolves* was hardly the only movie I'd worked on that presented me with ethical dilemmas. We filmed the southern right whale footage for our IMAX film *Whales* in a six-week shoot in Argentina. After five and a half weeks, we still didn't have all the footage we wanted. With just two days left, our money was nearly gone, and although our cameras were well-positioned high on the

cliff overlooking the bay, the whales simply weren't coming close enough for us to capture compelling shots.

We needed something powerful to make the film work, but our chance of obtaining such footage was decreasing by the hour. With the weather closing in and time running out, we did something we wouldn't normally do. Guided by the eminent whale biologist Dr. Roger Payne, who was codirecting the film, we climbed down the cliff to the sea and transmitted whale calls into the water in an attempt to attract whales to the bay below our waiting cameras.

Ethical or not, the trick worked. After two hours, a lone right whale swam below our cameras and our elated crew went to work. Our joy turned to euphoria as a second whale and then a third followed. We asked one of the young assistants to put on a red wetsuit and get in the water, and we watched with bated breath as she climbed down the steep cliffs to the water.

She bravely dove into the water and swam slowly up to the huge animals as our cameras at the top of the cliffs whirred, capturing every second of what we knew would be a money shot. In the film, of course, we omitted the fact that the shot was staged. We wrote the script to suggest that the assistant was a biologist inspecting the whales' skin to check on their health.

That wasn't the only trick we pulled in the film. We also filmed a shot of a killer whale skull on the ocean floor, using close-ups of its teeth to indicate the serious threat migrating right whales faced from predatory orcas. We chose not to mention that we'd planted the skull ourselves.

The most important moral question of the film is whether it had done enough to end whaling for good. Our goal was to create as compelling a film as possible to get people to appreciate whales more and, as a result of

that appreciation, to combat the whaling activities of Japan, Iceland, and Norway. I'm sure the film helped, but to what extent it is hard to say.

The ethical dilemmas I faced with every film were different. With our IMAX film *Bears*, I found myself conflicted over the issue of irresponsible behavior around wildlife.

In 1984, Troy Hurtubise, a scrap-metal dealer from Ontario, was hiking in the Canadian Rockies when he was attacked and knocked down by a 600-pound grizzly bear. The bear retreated into the bush, and Hurtubise got away without serious injury. He subsequently became obsessed with building a bear-resistant suit that would allow him to get close to bears and protect him from injury in the event of an attack.

Our film director David Lickley came to me with the idea of featuring Troy Hurtubise goading a grizzly bear into attacking him while wearing the bear-resistant suit to show the armor's effectiveness, or lack thereof. From an entertainment perspective, I thought it was an intriguing idea that was likely to make the film more interesting, but I decided to check with an expert. Eminent bear scientist Dr. Sterling Miller shot the idea down before I'd finished my sentence. "While bears can be dangerous, if you behave properly around them—keeping one's distance, and so on— then they are very unlikely to attack," he said sharply. "Including this scene with Hurtubise would set a bad example of the proper and responsible way to behave around wild bears and might encourage copycat behavior." He added, "I also object to the gratuitous harassment and goading of a wild bear for the sake of entertainment."

Miller pointed out that the best way to deal with a bear attack, which is highly unlikely, is to carry lightweight and effective bear spray. Endeavoring to keep from disturbing the bears is a significantly better approach than any bear armor. "Giving the message that you have to be dressed up

like a knight in titanium armor to be safe is about as wrong a message as could be sent," Miller said.

Miller didn't think much of Hurtubise's attempts to get close to the bears, either. "If you have an inexperienced person like Hurtubise coming into close proximity with wild grizzly bears, ultimately he is going to do something stupid that will provoke an aggressive response." The scene with Hurtubise might have gotten attention for the film, but Miller was blunt in his dismissal of it, and I knew he was right.

We dropped the Hurtubise idea and used respected bear naturalist and bear guide Chris Day as our main character instead. I'd gotten to know Chris Day on one of my trips to Alaska. She'd taken me by float plane to see brown bears in a remote wilderness area in Katmai National Park and Preserve, nestled below the towering Chigmit Mountains. "The only dangerous bear is a surprised bear," Day told me.

We used a long camera lens to set up shots that made it seem as though Day was within thirty feet of the bears. She actually wasn't that close, but I'd publicly criticized the late Steve Irwin and other television presenters for getting too close to wild animals, and so the shots made me look hypocritical. Being criticized for hypocrisy, as well as the conversations I'd had with Sterling Miller, pushed me to reflect further on the ways wildlife films are made. The ethical state of the wildlife filmmaking industry was in trouble, and I couldn't keep quiet any longer.

CHAPTER SEVENTEEN

Going Out on a Limb

WHEN I INVITED BROOKE Runnette, then head of the popular annual television event Shark Week on the Discovery Channel, to speak at AU, she accepted. "Your reputation precedes you as a great hater of Shark Week and all that Discovery does," she added drily, "so I fully expect to be greeted with sharpened knives and cutting remarks."[1]

A few months later, I saw British wildlife film producer Harry Marshall at the 2011 Jackson Hole Wildlife Film Festival and went over to him to say hello. I had known him for years and we had always liked each other. But this time he refused to shake my hand. "Do your students pay you?" he asked scornfully. "You should get your facts right." He disdainfully turned away.

In some ways, I'd known what I was getting into when I published my first book, but the reaction it elicited from a few people in the wildlife filmmaking community still surprised me with its intensity. *Shooting in the Wild: An Insider's Account of Making Movies in the Animal Kingdom* was published in 2010 by Sierra Club Books with an eloquent foreword

by Jane Goodall. With that book, I launched a campaign to reform the wildlife filmmaking industry.

Shooting in the Wild took readers behind the scenes of popular nature and wildlife films, sharing the adventures of the daring and creative people, like Brooke Runnette and Harry Marshall, who made these films and television shows. But it also pulled back the curtain on the dark side of wildlife filmmaking, revealing an industry driven by money, sensationalism, extreme risk taking, misrepresentation, staging, fabrication, and even abuse and harassment of animals.

I wasn't the only person concerned about the dark side of nature documentaries, and I was hardly the first person to air the industry's dirty laundry. Earlier in this book, I discussed the 1982 documentary *Cruel Camera*. Twenty-five years later in 2007, the same investigative journalists—led by Canadian Bob McKeown—took another look at wildlife filmmaking to see how things had changed since his first investigation. McKeown's new film showed that the embarrassing and disturbing revelations of the original 1982 investigation were still major problems.

Harry Marshall was angry with me because I'd written in *Shooting in the Wild* that some wildlife programs on television "deliberately cause violence to get footage" and "often make little attempt to conceal their exploitation, demonization, and harassment of animals."[2] I cited Marshall's highly successful and award-winning Animal Planet series about freshwater fishing, *River Monsters*, as an example. Marshall told me that my allegations were "cavalier and unfounded" and that he would be "taking the appropriate legal advice" (whatever the advice was, it apparently did not involve suing me, as I heard nothing from Marshall's lawyers).[3]

River Monsters is a fast-paced, exciting show with plenty of thrilling footage, but I judged it harshly in my book *Shooting in the Wild* because of

the trauma that the enormous, fierce-looking fish are subjected to as they are hooked and landed. The show is marketed as a sensational look at the most vicious killers in fresh water and centers on violent fights to subdue the fish that are caught. The show's commercial success depends on searching for wild fish in a dramatic way, carefully choosing and casting some enticing bait, hooking a fish, and then exhausting it as it battles for its life and is slowly overpowered and driven into submission.

Recent research has shown that fishing is not as harmless as most people think. Even if fish are put back after they're caught, the experience can be extremely stressful and painful for them—especially for bigger, bonier fish, like the ones caught on *River Monsters*. According to biologists, fish are not just swimming cabbages but rather have the brain and nerve capacity to experience pain and fear.[4] This is why they struggle so violently and intensely at the end of the hook. Being handled out of the water only makes the stress worse for them.

Biologist Jonathan Balcombe, author of *Pleasurable Kingdom*, said, "The science clearly supports what common sense tells us: The hooked fish thrashes in earnest. Fishes are sentient. They show awareness and intelligence, and they experience pain and pleasure."[5] Animal biologist Dr. Culum Brown pointed out that "the extensive evidence of fish behavioral and cognitive sophistication and pain perception suggests that best practice would be to lend fish the same level of protection as any other vertebrate."[6] He added, "I think the manner in which we catch them really needs to be looked at from a welfare perspective."

Jeremy Wade, the host of *River Monsters*, releases the fish after he's captured them on camera. But catch-and-release fishing is hardly an innocuous sport. Fish are frequently badly injured in the process, and they often die of shock from stress or physical damage. They routinely swallow the

hooks with which they're caught, and retrieving them can cause permanent damage to the fish's throat, jaw, gills, or stomach. Handling the fish for the camera damages the protective mucus coating on their bodies. Although Wade does his best to minimize damage, the reality is that fishing is a brutal and traumatic sport. Animal Planet would never make a television series about impaling, say, rabbits on barbed hooks and dragging them to and fro until they were exhausted. Torturing an enormous and often ancient fish is no more ethical.

The problems with the show don't stop with the treatment of its subjects. *River Monsters* demonizes big river fish as "monsters," "mutilators," and "flesh eaters," although the fish are for the most part nothing of the kind. The program reenacts vicious attacks on ordinary people, when, in fact, such attacks are incredibly rare. Like Shark Week, a television event that portrays sharks as terrifying predators, *River Monsters* grossly exaggerates the threats these fish pose to human beings for the sake of viewer attention and ratings. There is no escaping the irony of such portrayals when the violent toll humans take on fish is considered.

Unfortunately, Jeremy Wade is not the only fishing show host exhibiting behavior that should come to a stop. Aquatic ecologist Zeb Hogan treats elusive freshwater megafish in the same way in his popular Nat Geo Wild television show *Monster Fish*.

These hosts may at heart want to conserve and protect the fish they film, but they seem to have allowed their desire for high ratings to trump their duty to treat animals with respect. Viewers want to see monsters, and monsters are what they get, even when the truth is something far less splashy and much more significant. These animals are sometimes endangered, and portraying them as mindless killers does nothing to motivate public sentiment toward conservation and protection. Hyperbole and

146

violence might be profitable in the short term, but in the long run, they do more harm than good. The quest for attention and acclaim comes at a price—and it's the animals that are paying it. Wade should stress conservation more, and he should also enumerate the ways he works to stress the fish as little as possible when he's catching them.

I had gone out on a limb by writing *Shooting in the Wild* and inevitably was going to experience some push back from those who felt I had criticized them unfairly. But to stay silent was unacceptable, because every day I witnessed on television examples of irresponsible, even decadent, programming.

As I was giving this book manuscript a final polish, Discovery announced that they will air a special, *Eaten Alive*, on December 7, 2014, consisting of a man in a "snake-proof" suit being eaten alive by an anaconda.[7] It's hard to imagine this stunt happening without injuring the snake, or possibly the person. Discovery bafflingly defends the program on the basis of snake conservation, but as one filmmaker friend said to me while commenting on *Eaten Alive*, "We really have reentered the times of the Roman circus."

CONFESSION TEN

I Don't Have All the Answers
(but Am Still Searching)

CHAPTER EIGHTEEN

Deceiving and
Misleading Audiences

AUTHOR AND JOURNALIST MARK Dowie recently told me a story about a trip to Ecuador on which he'd befriended a renowned wildlife photographer. Over drinks one evening, this photographer invited Dowie to join him on a shoot the next day. The photographer's subject was a very rare and beautiful tropical viper. They met the next morning and drove with a small crew to the edge of the rainforest. Familiar with the rigors of the jungle, Dowie had come prepared for a grueling expedition in search of the elusive snake.

As it turned out, Dowie needn't have bothered: The photographer's porter had a viper waiting for him in a cloth bag. Three paces into the rainforest, the porter removed the snake from the bag and set it gently on a branch. The snake coiled itself comfortably around the branch and posed while lights were assembled and the photographer snapped a series of perfect shots. "Oh, sure, most of my wildlife photos are posed," he breezily confessed on the way back to Quito.

"I'm sure this is not new or shocking to you," Mark observed drily to me. "But it did rather spoil all those hours I'd spent watching *Wild Kingdom*, *Nature*, and Attenborough on Sunday morning TV as a child."[1]

PSEUDOSCIENTIFIC AMERICA

This practice of staging and fabricating shots is benign in comparison to other more pernicious ways in which audiences are deceived and misled through the broadcasting of deliberate misinformation and lies. *Mermaids* and *Megalodon* are examples of programs that illustrate how brazen lying and hyperbole have become in wildlife filmmaking. These programs lead the public to believe that they are based on genuine science, when, in fact, the science is 100 percent phony. Instead, viewers are misled with superstition and pseudoscience.

Animal Planet broadcast *Mermaids: The Body Found* in 2012 and *Mermaids: The New Evidence* in 2013. The network and its producers fabricated evidence, cast actors to play scientists, and seamlessly staged both programs so that viewers would think they were real.[2] *Mermaids* exploited viewers' faith, engaging them in a program built on fakery and superstition. That a network rooted in education and science would promote belief in myths such as mermaids is shameful and abuses the trust of their viewers.

Both mermaid programs presented "scientific evidence" that mermaids exist. The programs did their best to convince viewers that aquatic humanoids are roaming the oceans and that the U.S. government is involved in a massive cover-up to hide proof of their existence. The National Oceanic and Atmospheric Administration has stated unequivocally, "No evidence of aquatic humanoids has ever been found."[3] But that's not a problem for Animal Planet—or its high ratings.

Both mermaid programs were promoted as serious documentaries and

both garnered huge audiences. No doubt champagne bottles popped all over the executive suites of Animal Planet as the titanic ratings rolled in. A spokesperson for Animal Planet, already in "internal talks to keep this ratings gravy train going," told the *Washington Post* that "we're thinking big."[4] For Animal Planet, success appears to be more about ratings and less about accuracy, truth, scientific evidence, or education.

"I wouldn't have minded so much if Animal Planet clearly advertised the shows [on mermaids] as fiction," science writer Brian Switek lamented to me, "but many people were clearly taken in by the lie. It's truly a shame when a network abuses its reputation as an educator in order to deceive."[5] Switek called the shows "rotting bits of pseudoscientific nonsense."[6]

In its defense, Animal Planet did include in the end credits of the mermaid shows a statement that the preceding programs were fictional. But this admission was in small print and surely went undetected by many viewers as they rolled quickly by on-screen. A far more responsible approach would have been to include a clearly readable statement at the beginning of the show indicating that the production was fictional, with all of the "scientists" featured being actors.

Marine biologist David Shiffman condemned these fake documentaries for misleading people and for encouraging the American public's irrational belief in figments of the imagination, such as mermaids, Sasquatches, and aliens.[7] After all, the shows are airing on Animal Planet, which most viewers reasonably assume to be science based and to have a mission to educate viewers about animals.[8]

Why does it matter if a few million gullible people swallow Animal Planet's faked science? What's wrong is that these individuals are in the dark about what's really going on in the ocean; as Shiffman noted, they're totally "unaware of the important problems, much less how to solve

them."[9] Animal Planet could be doing tremendous good by educating and raising awareness about the dire problems our oceans are facing, like the fact that "marine resources are being overexploited and mismanaged, leaving us in serious danger of losing them forever," as Shiffman pointed out. Instead, viewers are distracted by creatures that don't exist.

Animal Planet is not alone in its deception of audiences. In the summer of 2013, the Discovery Channel (a sister network to Animal Planet) launched its popular Shark Week with a two-hour "documentary" titled *Megalodon: The Monster Shark Lives*. Like the *Mermaids* specials, the program featured interviews with "scientists," "archival footage," and "scientific evidence" to convince viewers that a sixty-foot prehistoric shark thought to be extinct was still roaming the oceans and leaving a blood-soaked trail of havoc in its wake. But as with *Mermaids*, the scientists were actors, the footage fake, the evidence fabricated, the photos falsified, and the whole program from start to finish a mockery of science.[10]

The program won huge ratings (4.8 million viewers, the best opening for Shark Week in its twenty-six-year history), and the executives in charge of *Megalodon* received effusive praise (and likely major bonuses) from their superiors at Discovery. But many people were outraged by Discovery's betrayal of its long-held and founding educational mission.[11]

Megalodon was a work of complete fiction presented as solid science, and there was no clear disclaimer to alert viewers to what was really happening. Three disclaimers were buried in the end credits and were very difficult to read, including "Though certain events and characters in this film have been dramatized, sightings of [massive sharks] continue to this day. Megalodon was a real shark. Legends of giant sharks persist all over the world. There is still debate about what they may be."[12]

None of the disclaimers even acknowledged that the program was a

fabrication. Any viewer would reasonably think he or she was watching a serious piece of investigative journalism. Indeed, polling after the broadcast showed that 73 percent of those watching believed that an enormous prehistoric shark roams the oceans, even though this is untrue.[13]

Actor and writer Wil Wheaton said he was disgusted by Discovery and fiercely criticized the broadcaster for its deceptive show.[14] Social analyst and author George Monbiot wrote that Discovery "had abandoned its professed editorial standards."[15] *Discover* Magazine's Christie Wilcox also directed harsh criticism at Discovery, writing, "You used to expose the beautiful, magical, wonderful sides of the world around us. Now you just make shit up for profit. It's depressing. It's disgusting. It's *wrong*" [her emphasis]. She added, "It's inexplicably depressing that. . .[you are] peddling lies and faking stories for ratings."[16]

Discovery's decision makers clearly believe that the short-term achievement of high ratings is worth the blow to the network's reputation, but these self-serving decisions have far-reaching effects. How can a great nation effectively govern itself when its citizens are steeped in irrational superstition? These networks and their fraudulent documentaries only increase ignorance and fear when they could be changing the course of history by bringing true science education to a broad audience.

Viewers' gullibility is alarming when it comes to issues like alien abduction, UFOs, witchcraft, faith healing, demons, ghosts, mermaids, and prehistoric sixty-foot sharks. The list of superstitions and supernatural beliefs espoused by Americans is astoundingly long. For example, according to a 2013 Harris poll, 42 percent of Americans believe in ghosts, 36 percent believe in UFOs, and 29 percent believe in astrology.[17] These ideas lack evidence and scientific backing, yet they are cherished by millions of people. My point is not to judge people on the basis of their beliefs but

rather to show that audiences are predisposed to believing false programming if no prominent disclaimers are provided.

Broadcasters who claim to promote sound educational content have a responsibility to help slow the harmful growth of irrationality rather than exacerbate the problem by broadcasting programs like *Mermaids* and *Megalodon*. Scientific literacy is important and needs to be encouraged, not undermined. (Discovery, Animal Planet, and National Geographic were invited to respond to the criticisms of them in this book but declined to comment.)

WELL-INTENTIONED TRICKERY

Whereas inaccurate portrayals of animals and fake documentaries might irritate some portion of viewers, old-fashioned staging, fabrication, and trickery would likely irritate a large number of viewers as well—if they only knew about it. Wildlife filmmakers often pretend captive and controlled animals from game farms are wild and free-roaming, stage events to make them look real, and use computer graphics to manipulate images. Filmmakers heatedly debate how much all of this furtive subterfuge matters.

In fictional Hollywood films, people expect to be tricked and misled—it's all part of the show. For example, a scene in the Oscar-nominated narrative film *The Bear* (1988) shows a fierce and aggressive cougar hunting down a terrified bear cub. The footage looks authentic, but, in fact, it was all carefully scripted, down to the last pant and squeal, and shot with trained and captive animals from game farms. The animals in these films look wild and free-roaming, but they are actually directed by their wranglers, who are adhering to a detailed script. No one complains about the staging: It's a Hollywood movie, and viewers understand that it's fiction.

In contrast, viewers of science-based documentaries expect accuracy, authenticity, and truth. Two recent examples of wildlife documentaries that may have crossed the line from legitimate filmmaking artifice to unacceptable deception are *Turtle: The Incredible Journey* (2009) and *Frozen Planet* (2011).

Turtle: The Incredible Journey, a film about loggerhead turtles, is billed as a documentary. Viewers assume they're watching genuine footage of this highly threatened species. In fact, the film is full of impossible-to-detect and unannounced computer-generated imagery and special effects.

The film, which has a commendably strong conservation message, tells the amazing story of a little loggerhead turtle that follows the path of her ancestors on one of the most extraordinary journeys in the natural world. Born on a beach in Florida, she rides the Gulf Stream all the way to the frozen north and ultimately swims around the entire North Atlantic to Africa and back to the beach where she was born. Dangers and threats lurk everywhere. Although the film is scientifically accurate, viewers have no way of knowing what is real and what is digitally manipulated. Is it ethical to have so much unlabeled artificiality and artifice in a so-called documentary?

As Manohla Dargis said in her *New York Times* review of the movie, "without a disclaimer that explains what's real and not, how can viewers, including those who may already be skeptical about claims of environmental crises, trust that the whole thing hasn't been made up?"[18] Audiences have no way of knowing where nonfiction ends and fiction begins. If viewers learn they've been lied to—that much of the film is computer generated—they might feel betrayed or even be suspicious of the entire film, undermining its excellent conservation message.

Of course, there's nothing wrong with using animation in documentaries,

as long as viewers are told. In fact, using animation reduces the need for handling of the actual turtles, which benefits the animals themselves. Informed audiences might even support extensive animation and computer manipulation, knowing these tricks of the trade protect the endangered animals whose stories they portray. But no one likes being duped.

Frozen Planet, an outstanding BBC/Discovery Channel seven-part television series, depicts the Earth's polar regions in all of their magnificence and beauty, but even this show used a little artifice. The *Daily Mirror* in Great Britain revealed that in one program, the producers filmed polar bear cubs in an artificially constructed den in a zoo while leading viewers to believe that the animals were filmed in the subzero Arctic wilderness. Viewers thought they were seeing real polar bear habitat when, in fact, it was fake.

The BBC did mention on its website that some of the show's footage was shot in a zoo, but few people found that information before the *Daily Mirror* and the *Daily Telegraph* pointed it out, and the short "behind the scenes" film that concluded the program made no mention of the manipulation.[19]

The newspaper revelations struck a nerve. By the time the Discovery Channel aired the series in the United States in 2012, the series included a prominent disclaimer admitting that some of the shots were captured under "controlled conditions."

It was the right choice to film the polar bear cubs in a zoo. Harassing wild bears to capture den footage would be irresponsible—but, unfortunately, so is deceiving viewers, because it breeds mistrust. Placing a simple note in the frame that the cubs were filmed in a zoo or a readable disclaimer in the final credits would have avoided viewers' protests that they had been misled and manipulated.

The BBC could have even used the zoo footage as a conservation

teaching moment, explaining why it's unethical to film bear cubs in the wild. Bear biologists say that an attempt to capture such in-the-wild footage might even lead the mother polar bear to kill her cubs. In documentaries, staged footage should surely be labeled to maintain strong trust between filmmakers and their audiences.

GLIMMERS OF TRANSPARENCY

Fortunately, the landscape does seem to be changing. For example, when the BBC series *Africa* came to the United States in 2013, the network announced with some fanfare that it had made the unprecedented decision to be transparent whenever it used staging and manipulation. For the first time in television history, viewers would know when the animals they were watching on-screen were filmed under controlled conditions. As series producer James Honeyborne told the *RadioTimes,* "We feel it is important to maintain trust and credibility with the audience."[20] The BBC is taking critical first steps in acknowledging the long-hidden secret that a sizable portion of wildlife footage is, in fact, not shot in the wild.

BBC executive producer Tim Martin shared that "With the increasing pressures from commissioners and ratings-chasers to deliver bigger, better, more dramatic shows at lower budgets, it can be hard to stick to our guns and ensure we stay on the right side of the ethical line."[21] Nonetheless, because the broadcaster takes wildlife filmmaking ethics seriously, Martin spearheaded a new ethics initiative at the BBC's Natural History Unit in 2014.

As part of its new guidelines, the BBC now offers a set of workshops to help establish clarity and direction in this complex, thorny area and to develop best practices so that audiences accept and agree with the level of artifice used. "The most important thing for us as wildlife filmmakers is our relationship with our audience—everything else flows from that,"

CONFESSIONS OF A WILDLIFE FILMMAKER

Martin said. "We have to engender trust. There have been stories in the press in recent years in which the BBC has been accused of deceiving the audience and getting things wrong, and so it's even more important than ever to take this relationship seriously." The BBC's commitment to staying on the right side of ethics will have a significant impact on the global wildlife filmmaking industry; the corporation's new ethical guidelines will set a global standard.

Professor Dennis Aig, head of the Montana State University film school in Bozeman, Montana, said, "The trust issue is significant. I have encountered situations where the filmmakers were totally ethical and did not stage anything and simply did an excellent job of capturing natural events, but viewers thought the behavior was staged."[22] In other words, some segments of the public are becoming so cynical and mistrusting of broadcasters and filmmakers that they see ominous subterfuge when there is none.

Award-winning filmmaker Adam Ravetch told me that another consequence of these fabrications is a broken trust between future filmmakers and the local people where the film is shot.[23] If a film crew leaves a bad taste with the locals by irresponsibly manufacturing demeaning stories, it becomes difficult, if not impossible, for more responsible filmmakers to return to these communities and film again.

Ravetch noted that especially in remote places, people think that all wildlife filmmakers are somehow connected or part of the same team. It is difficult to regain their trust and make an accurate and responsible program about their lives if they refuse to talk about their relationships to the nearby wildlife or ecosystems in which they live.

For example, Ravetch went to Alaska in October 2014 to film commercial divers who harvest sea cucumbers and geoducks for a living. In Ketchikan, he was filming the town and a young man in his 20s came up

to Ravetch and said with a distrustful and suspicious tone, "So what are those cameras for?" Before Ravetch could answer, the young man said, "Are you here to exploit us again? You're from that *Alaskan Bush People* series, right?" He was angry that the 2013 Discovery Channel reality show depicted Alaskans incorrectly and inaccurately. The trail of damage created by film crews, who behaved badly and fabricated ridiculous stories about the interactions between people and animals to achieve high ratings, made it challenging for Ravetch to regain the trust of the Alaskans in the town where he was filming.

How do broadcasters and filmmakers navigate these treacherous waters where people have conflicting opinions? After decades of experience in the industry and in line with Tim Martin's point, the best barometer I can offer is the trust of the audience. If the audience discovers the truth about the footage, will they feel disappointed or even betrayed? Will they still feel that way even after receiving a full and detailed explanation of why the broadcaster and filmmaker approached the filming in the way that they did? If the answer is yes, then that's a red flag. Perhaps the use of focus groups during film production could help to alert broadcasters and filmmakers to potential ethical problems before the film is finished and released.

There's no need to deceive the audience and risk losing their trust. What's more, it's unfair to trick audiences or hold back the truth. Instead, broadcasters and filmmakers should clearly identify footage of captive animals and computer-enhanced images. They have a responsibility to not formulate lies by demonizing predators or by presenting pseudoscience and superstition without labeling it as such. Honesty is the key to building trust with audiences. Honesty can lead to a new era of wildlife filmmaking in which conscientious filmmakers engage conscientious viewers in a real dialogue about the state of our shared planet.

CHAPTER NINETEEN

Failing the
Conservation Test

ARE BROADCASTERS AND WILDLIFE filmmakers advocates for the species they feature in their documentaries, or is their role simply to inform and entertain? Should they be passive observers or conservation activists?

These questions aren't new, and they aren't limited to wildlife filmmaking. Journalists and photographers who are on the front lines of natural and humanitarian disasters must constantly engage with these questions. If they witness people fighting for their lives in the flood waters of a tsunami, should they set down their cameras and help? Or is it their role to document tragedy so that the world can bear witness? Likewise, wildlife filmmakers must negotiate complex moral situations. Are we storytellers or advocates? Are we responsible for instigating change? Should we aim to move viewers to action? Or is it enough for us to be educators?

CONSERVATION BLUES

Hardy Jones is a wildlife and environmental filmmaker who, along with actor Ted Danson, founded BlueVoice.org, a nonprofit dedicated to saving dolphins. Jones compared filmmakers who ignore "the nastiness of humanity's impact on the planet" with German filmmakers in the 1930s who depicted their fellow citizens only as charming peasants in lederhosen waving steins of beer. "Sure," he said, "that happened in Germany during the 1930s, but something enormously sinister was also happening in plain sight, something which would soon engulf the world in conflagration and cost tens of millions of human lives."[1]

Jones's point is that it is irresponsible to make films about wildlife and natural history that ignore the impact of the world's greatest predator, polluter, and habitat destroyer—us. If we do that, he says, wildlife filmmaking "will be reduced to well-deserved irrelevance."

Wildlife biologist Alan Rabinowitz, CEO of the wild cat conservation group Panthera, echoes Hardy Jones's point. Film and television programs about big cats are wildly popular, but the animals themselves are declining calamitously in numbers. He has warned filmmakers and broadcasters that they are too complacent.[2] All of the metrics on our environmental health are going down, he has pointed out, whereas all of the metrics on wildlife films—festivals, awards, and attendees—are going up. The explosive growth in wildlife films seems inversely related to the actual care given to wildlife. Since the 1960s, wildlife and nature programming has boomed, and yet the environment has become more threatened, not less. All of those films don't seem to matter when it comes to real results.

Author and principal of Wildeye (The International School of Wildlife Filmmaking) Piers Warren agrees: "As we are currently tipping into

the sixth mass extinction, a mind-numbing phenomenon ignored by most television channels, future generations will look back on this period and wonder what madness could be creating the current sensationalist 'wildlife' programs. Instead we should be educating the world about what is actually happening in the real natural world."[3] The *sixth mass extinction* is the name of the massive extinction of species, currently underway, that has been caused by human activity.

ATTEMPTS AND FAILURES

Four recent television events (or series)—*Wicked Tuna*, Shark Week, *Yukon Men*, and *Man-Eating Super Wolves*—illustrate how poorly broadcasters are rising to the challenge articulated by Piers Warren.

Wicked Tuna

The Atlantic bluefin tuna is one of the largest and fastest of all the world's fishes. Its streamlined, torpedo-shaped body is built for speed and endurance. On average, bluefin tuna are over six-feet long and weigh more than 500 pounds, although much larger specimens are not uncommon. The largest bluefin ever caught weighed almost 1,500 pounds.

Bluefin tuna are prized for their meat. As a result, they're overfished. But National Geographic, a venerable and revered organization often lauded for its bold conservation efforts, is producing a series called *Wicked Tuna* that glamorizes the hunting and killing by fishermen of this depleted and magnificent species. The catch the show depicts might be legal, but the show's focus on killing members of a species whose population is badly damaged tarnishes National Geographic's name.

I first heard about *Wicked Tuna* from scientist and ocean advocate Carl Safina, who denounced and condemned the series in a 2012 *Huffington*

Post article.[4] Immediately following Safina's withering criticism, National Geographic senior executives invited him to their headquarters in Washington, D.C., for a meeting. Safina said that National Geographic promised to improve the program but that the executives also defended themselves by claiming a conservation emphasis in the program would lose their audience.[5]

The promised improvements included a mention of conservation and several references to overfishing, and National Geographic beefed up information about conservation on the show's website. Although those small changes are commendable, the bottom line is that the show still glamorizes the killing of members of a depleted species for entertainment and ratings.

Shark Week

Whereas the producers of *Wicked Tuna* attempted to clean up the show's act because of external pressure, it took an inside agitator to improve, if only temporarily, the hugely popular and long-running annual event Shark Week. Shark Week is habitually dominated by footage of bloody feeding frenzies and scary shark attacks. Over the years, typical titles of Shark Week programs have included *Teeth of Death*, *The Worst Shark Attack Ever*, *Perfect Predators*, *Top Five Eaten Alive*, and *Ocean of Fear*. These shows might garner high ratings and attract advertiser dollars, but they mislead audiences, exploit animals, and fail to promote conservation. Their skewed view of sharks focuses on violence that is, in fact, rare. The real threat comes from humans, who are decimating shark populations through shark finning, overfishing, and pollution.[6]

Discovery made a positive turn in 2010, when executive producer Brooke Runnette made it her mission to work closely with conservation

organizations like Oceana and the Pew Charitable Trust's Global Shark Conservation group. She added more conservation and natural history to the programs and focused on sharks' fascinating behavior rather than their menace. To everyone's surprise, the ratings in 2010 went up. Runnette was quoted in the *Washington Post* as saying, "I helped to turn 'Shark Week' around. Previously, it would not rate well unless people were getting killed, blood was running thick through the water, and the sharks were psycho killers. I didn't think that needed to happen."[7]

One of Runnette's initiatives was a program called *Jaws Comes Home* made by veteran underwater cinematographer Nick Caloyianis. *Jaws Comes Home* tells the story of the infamous great white shark's return to the North Atlantic. The show follows Greg Skomal, an exuberant marine biologist with the Massachusetts Division of Marine Fisheries, as he tracks two of these majestic fish for six months along the eastern coastline of the United States. *Jaws Comes Home* doesn't sacrifice entertainment value despite its basis in real science and accurate facts. It also doesn't stoop to easy stereotyping of great whites as threatening, man-eating machines.

Greg Skomal has become a regular on Shark Week in recent years. He told me that he is frequently criticized by his colleagues "for participating in what they perceive to be a negative force for sharks." His response is that he will continue to work with Shark Week as long as he can "include the science." He favors documentaries that are science-based, objective, and factual. He said, "The perfect documentary states the facts as we know them and allows the viewer to decide."[8]

Runnette left Discovery in 2012, and the quality of Shark Week has declined since her departure. In February 2012, before she left the network, I invited her to speak at AU, where I teach. During her talk, she admitted that Discovery is driven by ratings and that she would get fired

if the ratings for Shark Week declined.

In 2013, writer and activist Chris Sosa called Shark Week a "disgrace," writing in the *Huffington Post* that "rather than using valuable time to teach people about the importance of protecting these dying creatures, Discovery is cynically playing off cultural fears to make a buck, portraying sharks with a level of realism akin to *Sharknado*. There may be educational material mixed in, but the image being promoted is inexcusable."[9]

Shark Week in 2014 was even worse than Shark Week in 2013. Although its programming sporadically contained good science-based information, it more frequently presented fiction as fact. Unbelievably, Discovery even launched the week with a fake documentary, *Shark of Darkness: Wrath of Submarine,* about an attack by a 35-foot-long great white shark (nicknamed Submarine) off the coast of South Africa. None of it was real. The attack never happened; footage was computer generated; and the eyewitnesses, scientists, and shark experts were all actors. The film carried the opaque disclaimer "Events have been dramatized, but many believe Submarine exists to this day."[10]

This "documentary" spreads gross misinformation, claiming that monster sharks swim in the ocean and pose a genuine threat to people. Actors pretending to be scientists say three different times that humans are sharks' "meal of choice," which is completely false. The writer and actor Wil Wheaton wrote, "In a cynical ploy for ratings, the network deliberately lied.... **Discovery Channel betrayed its audience**" (bold in original).[11]

In 2014, journalist Alastair Bland wrote on the NPR blog that "through the decades, however, [Shark Week] has devolved into a B-movie-style blend of fiction, bad acting, a few facts, and potential injuries to sharks."[12] He quoted shark scientist Sean van Sommeran as saying, "Now [Shark Week] is big game trophy fishing, extreme sports diving, and science

fiction monster sharks that sink ships in the night. The science highlighted is wildly speculative and harmful."[13]

Testosterone-fueled programs that depict sharks as vicious, man-eating killers only make it more difficult to convince the public of the need to protect sharks. Sharks are an essential part of the ocean ecosystem, keeping prey species in check and weeding out diseased or genetically weak individuals. They are also increasingly endangered. Instead of emphasizing the need to support these beleaguered animals, programs like Shark Week are practically an argument for their extermination. But Shark Week is a ratings juggernaut and the Discovery Channel is ratings driven. The network is loath to mess with the event's enormous success.[14]

Yukon Men

Yukon Men is a popular Discovery Channel reality series about the citizens of the small town of Tanana in central Alaska. It portrays wolves as highly dangerous predators that besiege the town and threaten the safety of all of the residents. One of the show's characters, Charlie, says, "Wolves are mean, ferocious animals.... They're the worst kind." A menacing voiceover intones, "There have been twenty fatal wolf attacks in the last ten years." The camera cuts to Charlie brutally killing a wolf with a semiautomatic assault rifle.

In *Yukon Men*, all predators, including wolves, wolverines, bears, and lynx, are depicted as vicious, nasty, and fully deserving of excruciatingly painful deaths via steel leghold traps and other means. But zoologist Adam Welz noted in his *Guardian* blog NatureUp that much of *Yukon Men* is grossly misleading.[15] He could find no evidence to support the claim that there have been twenty fatal wolf attacks in Alaska in the past ten years. He is also baffled why Discovery would produce and broadcast

a "factual" show that portrays wolves as "man-eating monsters straight out of Victorian fairytales, a serious threat to life and limb," when the evidence shows that wolves rarely attack people. Wolf experts Jim and Jamie Dutcher, authors of the National Geographic book *The Hidden Lives of Wolves*, say emphatically that fatal wolf attacks are extremely rare—there have been only two possible cases in North America in the past 100 years.

In fact, wolves are more similar to humans than perhaps the residents of Tanana recognize. The social structures of wolves resemble those of people: The animals live cooperatively in family-based packs, are highly social, and are caring parents. *Yukon Men* shows none of this. By characterizing wolves as menacing, cunning man-eaters, the series deals a significant blow to wolf conservation efforts. Furthermore, these programs revitalize old stereotypes that do not match reality but do fuel human fear and aggression. Playing on a cultural fear that dates back to Little Red Riding Hood and far beyond, *Yukon Men* sends a clear message: that wolves are aggressive, violent, and predatory—a species the world is better off without. Yet science has shown that the world is, in fact, much better with wolves playing their part in the ecosystem.[16]

Shows like *Yukon Men* encourage viewers to think that these animals deserve to die, a fraudulence that has no place even in the cheap and overheated world of reality television. Broadcasters like Discovery and Animal Planet should not characterize, for example, wolverines (which are shy and elusive) as being a threat to a whole town like Tanana. Adam Welz told me that wolverines have never been known to attack humans unprovoked, nor has there ever been a documented case of a wolverine killing a human.

This vilification and demonization of predators (which overrides science and gives credence to lies) has serious negative consequences for wildlife, generating misunderstanding and encouraging public policies

that promote the killing of wild animals. As is the case with sharks, land predators like wolves and wolverines serve vital roles in keeping ecosystems healthy. They cull sick and injured prey animals and maintain the population numbers of species that would otherwise overproduce.

Yukon Men is just one of many "factual" programs on television that mislead audiences into thinking that it is perfectly acceptable to trap, snare, shoot, or poison predators like wolves and bears. Other programs that exaggerate and lie about the dangers from predators include *Mountain Men* (History Channel), *Swamp People* (History Channel), and *Wild West Alaska* (Animal Planet). *Mountain Men* glamorizes trapping animals for their fur, as well as using hounds to track and hunt mountain lions. *Swamp People* celebrates the hunting and killing of American alligators. And *Wild West Alaska* promotes aggressively killing many of the animal species found there. Why do these programs rely on misinformation instead of facts? Because reality—actual reality—doesn't drive ratings. Programmers believe that only stories of monsters—even if they are outright lies—grab viewers' attention, especially that coveted "male 18–49" demographic so important to advertisers and sponsors.

Man-Eating Super Wolves

Pressure on broadcasters from concerned citizens can sometimes make a concrete difference. In May 2013, Animal Planet promoted a new show, *Man-Eating Super Wolves*, with this description: "Razor sharp teeth, killer instinct, and senses so precise they hear your beating heart, and your fear. They're on the hunt, and now with numbers growing out of control, they're threatening humans like never before."

The environmental community was outraged.[17] "At first I was so shocked. I actually thought it was a joke," Jamie Rappaport Clark, president

171

of Defenders of Wildlife and former director of the U.S. Fish and Wildlife Service, told me.[18] The show was "reprehensible on so many levels." Clark leapt into action, drafting a letter to Defenders of Wildlife members that urged them to demand the show's cancellation. "Animal Planet has sadly joined the legions of wolf-haters waging war on our struggling wolves," she wrote. "This despicable distortion of reality could not come at a worse time for wolves. Wolf-haters have mounted extermination efforts in Idaho and elsewhere, threatening to reverse two decades of hard-won progress for one of America's most beloved wild animals." Clark called the program a "shoddy tabloid pseudo-documentary."[19]

Criticism from Clark and many others, including the International Wolf Center and renowned wolf expert David Mech, led Animal Planet to cancel the program in the United States (but not in other parts of the world, like Great Britain, where the criticism was more muted).[20] Public pressure on networks can work if it's a significant enough force.

Shows like *Wicked Tuna*, Shark Week, *Yukon Men*, and *Man-Eating Super Wolves* romanticize and glamorize an exploitative and unsavory attitude toward nature. Richard Brock summarized this problem in a letter to the *RadioTimes* in November 2013: "This brutalization of animals, simply going about their natural business, degrades the animals, the presenters, and the filmmakers."[21]

Far too many broadcasters have resorted to creating "nature porn"—productions focusing solely on the blood, guts, and sex of the animal kingdom. Graphic footage of shark attacks and feeding frenzies might make for thrilling entertainment, but they actively damage public sentiment toward animals whose very survival is in question. By misleading audiences and inspiring fear and terror, these television programs are harming the conservation movement.

SUCCESSFUL CONSERVATION MESSAGES

Of course, not all wildlife shows neglect conservation and demonize animals. Well-made films and TV shows that incorporate a conservation message may be the exception, but they do exist. Some of my favorites are *Frozen Planet* (BBC/Discovery, 2011), *Grizzly Man* (Discovery/ Lions Gate Entertainment, 2005), *Battle at Kruger* (National Geographic Channel, 2008), *The End of the Line* (2009), *Kingdom of the Oceans with Alexandra Cousteau* (Nat Geo Wild, 2013), *The Last Lions* (National Geographic, 2011), *Eye of the Leopard* (National Geographic, 2006), *The Cove* (Participant Media, 2009), *Whale Wars* (Animal Planet, 2008–2013), *Chimpanzee* (Disneynature, 2012), *Green* (Patrick Rouxel, 2009), and *Kingdom of the Apes with Jane Goodall* (Nat Geo Wild, 2013). Here's a look at three of these films and how they've successfully promoted conservation.

"On Thin Ice"

"On Thin Ice," the seventh and final episode of the BBC/Discovery series *Frozen Planet*, investigated what climate change will mean for the people and wildlife living near the poles. Because climate disruption is such a contentious issue, many networks are not courageous enough to broadcast shows asserting that climate change is real. The Discovery Channel itself considered not airing the seventh episode in the United States out of concern that it would spark too much controversy. The Discovery Channel did ultimately air the program, and I commend them for that decision.

Nonetheless, Discovery was still criticized for not going far enough. "On Thin Ice" acknowledged climate change but did not mention its chief cause: carbon-producing human activity.[22] The conservation organization

Forecast the Facts called the omission "dangerous self-censorship" that only satisfies climate-change deniers. As climate change activist Bill McKibben said in the *New York Times*, "It's like doing a powerful documentary about lung cancer and leaving out the part about the cigarettes." Still, the fact remains that *On Thin Ice* carried a conservation message, and a step in the right direction is better than no step at all.

The Last Lions

The Last Lions was produced and directed by Dereck and Beverly Joubert, whom I featured in my book *Shooting in the Wild* as examples of heroism in the wildlife filmmaking industry. They teamed up with National Geographic for the 2011 documentary, which focuses on a lioness named Ma di Tau (Mother of Lions) as she fights to protect her cubs. The film underscores the drastic decline in the big cats' numbers—from 450,000 lions in Africa fifty years ago to fewer than 20,000 today. Despite conservation efforts, wild lions' numbers are still plummeting across the majority of their range. Ma di Tau's cubs may literally be some of the last lions. Not only was all of the footage shot without interfering with the lions' natural behavior (crucially important for a lioness feeding cubs), but the film's launch, marketing, and distribution were also integrally tied to National Geographic's Big Cats Initiative. The initiative works to combat some of the most problematic threats to lions, including wire-snare poaching, trophy hunting, and the illegal bush-meat trade. The film's ethical approach and direct ties to conservation make it an excellent example of wildlife filmmaking done right.

Green

Patrick Rouxel's *Green*, the story of the last days of a female orangutan victimized by deforestation and resource exploitation, won a slew of top

festival awards for very good reasons. The moving, emotional film high-lights the treasures of rainforest diversity and the devastating impact of logging and land clearing for palm oil plantations. All of Rouxel's films are about animal suffering, deforestation, and human folly, and *Green* is no exception. Rouxel intended it to be a film that was "a mixture of poetry and activism."[23] With virtually no narration and no music, the film does a superb job of depicting the complex ways consumers and viewers are interconnected with dying orangutans and ruined forests halfway around the world.

Green was released on the web and has never been broadcast on U.S. television because the companies that promote palm oil use and, by extension, deforestation advertise on television and are easily powerful enough to stop *Green* being broadcast. They are listed in the film's credits to shame them. The role of advertisers in deciding which programs get aired is a neglected topic.

More and more wildlife filmmakers, driven by their concern for conservation and the broadcasters' neglect of conservation, are bypassing traditional broadcasters like National Geographic, Discovery, and Animal Planet and finding innovative ways of using new media to reach their key audiences. Filmmakers are thinking of themselves as campaign managers, making their films part of large, multiplatform crusades involving a variety of media forms and social actions. They are partnering with appropriate nonprofits that work toward the same goals. More and more filmmakers are realizing that finishing a film is only 50 percent of the job. The other 50 percent is creating an outreach, distribution, and marketing plan to make sure the film gets seen by people who will be inspired to take up the conservation banner.

PROSECUTE, DON'T PROSELYTIZE

Whether or not a filmmaker works with traditional broadcasters, it is important to think about the audience and, as my colleague Professor Pat Aufderheide urges, to be strategic long before shooting begins. The size of the audience is important—but who is in the audience is even more crucial. Digital storyteller Russell Sparkman's web series *One World Journeys* had an impact far bigger than its audience size because it shrewdly targeted key audiences, including policymakers and legislators. Although only a few hundred thousand people watched the series, it helped bring about real results, including World Bank funding for new national parks in the country of Georgia, helping the Nature Conservancy raise significant funds for their Palmyra Atoll project, and influencing citizens to clean garbage from freshwater springs in Florida.[24]

For films to impact behavior on the ground, broadcasters and filmmakers must take into account the voices and experiences of the people they're trying to reach. Both broadcasters and wildlife filmmakers must recognize that wildlife filmmaking will be forever fettered if it remains dominated by affluent white people. The profession's output needs to consist of more than preachy conservation films. Poachers don't generally kill imperiled species for fun—they often do it as a matter of economic survival. New technology offers the opportunity to democratize media and create platforms that allow local people to tell stories about why conservation matters to them instead of being patronized by the large media productions of wealthy outsiders.

"Most importantly," American environmental journalist and author Todd Wilkinson told me in an interview, "ethical wildlife filmmakers from the developed world are able to reach influential mass audiences—and

through a wide variety of mobile devices being carried by younger generations. Technology is also giving local indigenous storytellers access to worldwide audiences in ways they didn't have before. This is all good."

Wilkinson added,

And, at the same time, the industry as a whole, because of mounting pressure, is becoming more sensitized to demands that stories be told more authentically. This allows wildlife filmmaking to be a potent tool for educating across traditional cultural boundaries and in ways that unite the world in universal concern for loss of biodiversity. It is enabling messages of conservation to flow up to policymakers and well as flow down. Given the urgency of the times, that's exactly what is needed. The bottom line is accountability. And the new standard is filmmakers not just saying they care about the fortunes of wildlife and local people but producing work that yields positive outcomes and is meaningful.[25]

Richard Brock has taken all this to heart. After 35 years working at the top levels of the BBC Natural History Unit, he left to develop the Brock Initiative, a program that uses films to raise awareness of local conservation issues within targeted communities. Rather than broadcasting the programs in the traditional way, Brock finds clever, innovative ways to reach local people, local communities, and local decision makers, "even that one fisherman who uses dynamite fishing over that one coral reef."[26] The Brock Initiative may be a good model for linking wildlife films to conservation. He reaches those who have a direct impact and who can make a difference. The types of films he produces are quite varied, because for his films to be effective, they need to be "as carefully targeted as possible"—even if that means crafting different, audience-specific versions of the same film.

When filmmakers design a distribution plan that does not involve traditional broadcasters, they obviously should not ignore the realities of the work it is going to take to attract and maintain an audience. Programs need viewers to be successful. But films can tell the truth *and* entertain and inspire audiences. The grimmest material can be palatable if it's paired with dramatic story elements and offers solutions to the problems it documents.

Hardy Jones told me that in 2014, his organization, BlueVoice.org, investigated the rumored slaughter of thousands of dolphins in Peru's shark fishing industry. Dolphins, Jones was told in numerous undercover audio interviews, are harpooned for use as free shark bait. To begin the process of remedying this tragedy, BlueVoice.org needed documentary evidence—video and still images that would arouse public opinion and lead to government action. They sent two camera teams to sea with the fishermen. This was difficult and dangerous work.

The rumors were true: Both teams brought back dreadful footage of dolphins being harpooned. The public needed to know about the slaughter, but, unlike exciting shark attacks, depressing images of popular, charismatic animals being killed are difficult to get on television. BlueVoice.org solved this problem in a creative way: Their filmmakers wove the shocking footage into a dramatic story about the documentary crew's nailbiting adventure at sea. The crew endured real danger, including violent weather and hostile harpooners. Capturing groundbreaking footage like this requires courage, skill, and determination, which are not always evident on a television screen. Framing the story in terms of the crew's courageous acts not only draws an audience into the human drama but also allows the shocking dolphin slaughter footage to be shown in a different context. Further, telling the crew's story lends the footage additional importance

by revealing the lengths to which the crew was willing to go to document the atrocities. Also important is the fact that the program offers a solution.

It's against the law to harm dolphins in Peru, so BlueVoice.org followed up its footage with advocacy within the country to both expand and enforce protections for dolphins. In the process, BlueVoice.org has disseminated its footage around the world in a massive global campaign, including a petition drive that has amassed over a million signatures. This campaign gave viewers, outraged by the horrendous footage, an avenue for action.

Savvy strategies, like linking televised programming to online campaigns for action, are a powerful way to involve and empower viewers—and, of course, to work ultimately toward real change. Without hope, there is no incentive to act. But when specific courses of action are available and revealed by wildlife programs, viewers can be turned into informed, motivated, and committed activists.

NATURAL HISTORY FILMS ABOUT ANIMAL BEHAVIOR AND ECOLOGY

I used to glibly dismiss most natural history films as "pretty wallpaper" without any power to change society, but now I realize I was wrong. For example, award-winning filmmakers (and husband and wife) Vicky Stone and Mark Deeble have devoted their lives to producing these types of films and feel that natural history films featuring animal behavior can, if done right, have an impact on conservation. They told me that they would not make these kinds of films if they did not think that they were effective conservation tools. Deeble said, "We believe that knowledge and wonder promote care that can result in love. Only when we care about something, and perhaps love it, will we be bothered to do

anything about it. It is what ultimately stimulates action. So much is about what you do with the film, about the passion you feel."[27]

Stone and Deeble's very first film, *Yndan an Fala—Valley Beneath the Sea* (1984), made when they were students, showed people what they stood to lose if a container port was built in the Fal Estuary in Southwest England. The prevailing attitude in the late 1970s toward British marine life and the Fal Estuary in particular was that beneath the surface, it was a muddy wasteland. When a container port was proposed for the Fal Estuary, the plan was greeted with delight. At public meetings, the consensus was "We are losing nothing but mud, and we are gaining jobs, infrastructure, and economic growth."

Appeals to the public about the importance of sediments, polychaete worms, and estuarine ecology fell on deaf ears. It was only when Stone and Deeble launched a Kodak-sponsored exhibition of underwater photographs and an illustrated book that awareness began to spread.

When Deeble and Stone took the information campaign further and made a self-funded film about the importance of the estuary, which showcased the beauty and interconnectedness of the creatures that lived there, public opinion began to change. People were amazed at what lived in the estuary's eel grass beds, the coral reef–like maerl beds, and the kelp forests. The couple realized that whatever else they did to publicize the plight of the estuary, such as bringing in news crews or a current affairs program, the film was the central hook that everything else hung on. They say it is the same today, when they translate their films into Kiswahili or donate DVD rights to conservation organizations. Said Stone, "The film is the starting point, the raw material, for a number of different conservation initiatives. A film is an extraordinary resource—it is up to us to use it for good, in whatever way we can."

Deeble said that their first film showed them that people connected on an emotional level and became proud of what they had on their doorstep yet previously knew nothing about. They showed the film at public meetings, women's groups, schools, and so on, and eventually it was broadcast internationally. The reaction was always the same—wonder, enchantment, and surprise. Above all, the film inspired an appreciation for something its audience could not see in their day-to-day lives: The film made the estuary's ecosystem visible, vivid, and real. Eventually, the initiative for the port foundered; Mark Deeble said that he thinks that their film played a part in that.

SPURRING AUDIENCES TO ACTION

What does it actually mean when a film is described as a "conservation film?" Did the film provoke an emotional response to a conservation topic or encourage viewers to see conservation as a valuable cause? What if viewers emerge more sympathetic to conservation causes but still don't bother to take action? Does that mean the film has failed? If viewer action is what determines success, what form should that action take for the film to be considered a success? If a viewer posts his or her indignation regarding the film's topic on Twitter or Facebook, is that enough?

Organizations that want to use film and social media to change the world want to know what actually prompts people to take action rather than just think more carefully about conservation. One such company is Participant Media, an activist entertainment company started by Jeff Skoll, the billionaire philanthropist.[28] Participant produces movies with a message, such as the anti-dolphin-killing film *The Cove* and the anti-fracking film *Promised Land*. The people with Participant are eager to find out whether a documentary about conservation (or any other fraught social

issue) can get viewers to change their behavior or beliefs. Although inspiring and encouraging conservation-minded viewers is important, activists working with Participant and similar organizations worry that such films only reach those already committed to the cause and predisposed to agree with the message.[29]

Measuring the social impact of films—both viewers' emotional involvement as well as the level of behavioral engagement prompted by viewing a film—is no easy task. No one really knows if conservation films actually work to produce measurable results in terms of tangible consumer action. Anecdotal evidence suggests they do (look at *Blackfish*, for example, whose heart-breaking story of captive killer whales makes some viewers feel it's unconscionable to visit SeaWorld), but little science-based evidence exists, partly because it is so difficult to disentangle the impact of film from all of the other influences on public policy or personal behavior, such as newspapers, books, articles, and opinions shared on social media. The absence of hard evidence doesn't mean nature films can't have an impact; it only means that filmmakers have to have a little humility and admit to some uncertainty as to what that impact is.

Ideally, films will spur audiences to some action, such as boycotting a product, voting differently, volunteering for a campaign, signing a petition, convincing a friend, or giving a donation. But a conservation film does not necessarily have to provoke immediate action. Films can work in subtle ways to create the basis for long-term change by introducing viewers to novel ideas, fresh perspectives, and inspirational people. Although change can be quick, it can also be slow and nearly imperceptible. Films can plant seeds that will someday grow into full-fledged forests. That kind of transformation is impossible to quantify.

CHAPTER TWENTY

Harassing and
Harming Animals

AWARD-WINNING PHOTOGRAPHER SAM ABELL stood in front of a packed and excited crowd at the Environmental Film Festival in Washington, DC, in 2013. After I introduced him and described his extraordinary credentials, I was not surprised to hear him flatly declare that most commercial photos of wild animals are staged, with animals often "baited, narcotized, and chilled." Behind the pretty pictures lies a terrible truth: Those are images of animals being abused.

HIDDEN CRUELTY

Of all of the ethical issues involved in wildlife films and filmmaking, animal harassment is one of the most troubling as well as one of the most challenging to combat. Most of the cruelty happens out in the field, with no witnesses to stop it or point it out to television audiences.

Of course, not everything broadcasters do is unsavory and unethical

when it comes to animal welfare. Discovery Channel, National Geographic, Animal Planet, the BBC, and other major broadcasters do produce and air ethical programs like *Nature* (on PBS), *Planet Earth*, *Whale Wars*, *Frozen Planet*, *Animal Cops*, *America the Wild with Casey Anderson*, and *Wild Justice*. Not only are these well-made programs ethically filmed, but their focus on conservation over sensationalism helps audiences appreciate and protect wild animals.

Many filmmakers successfully fight the constant pressure from the networks to sensationalize facts, exaggerate stories, and stage scenes in their work. For example, filmmakers Dereck and Beverly Joubert go to extraordinary lengths to remain unobtrusive so that they can film natural, unaffected animal behavior. Dereck Joubert cringes if a leopard so much as looks up at the camera. If an animal senses the cinematographer with "a look or reaction," he said, "we have failed in our job. If it charges us, or runs away, we have failed twice."[1]

Filmmaker and photographer Jeff Hogan feels the same way. He said, "So what I try to do is to be that fly on the wall. You can't get these privileged views of animal behavior unless you are either unnoticed or ignored…. [T]hey shouldn't know you are there."[2]

But not all wildlife filmmakers are as ethical or conscientious as the Jouberts or Hogan, and animal harassment and cruelty have been pervasive in wildlife filmmaking for decades. This harassment ranges from simply getting too close and disturbing animals to deliberately goading, harming, or even killing them. The use of live bait was a longstanding and common practice when filming predators—although, fortunately, it is no longer so common. I know of one filmmaker, under pressure from broadcasters to capture money shots, who uses GPS technology to track and film his subjects more easily. He stuns animals like hyenas

with a tranquilizer gun and then slices open their skin with a sharp knife to implant a GPS transmitter, thus leaving the animals injured but easily trackable.

PROFESSIONAL MEDDLING

The modern era of intrusive hosts began when Steve Irwin took close wildlife encounters to a whole new level. His Animal Planet series *The Crocodile Hunter* began in the mid-1990s and aired in over 200 countries. It ended with terrible finality in September 2006, when Irwin was fatally stabbed in the chest by a bull stingray's tail spine. The accident was puzzling because stingrays are typically gentle animals and don't attack unless provoked.

Irwin's engaging personality and edgy encounters with wild animals—including snakes, spiders, and, of course, crocodiles—brought him hefty ratings and worldwide fame. There's plenty to admire about Steve Irwin: He taught audiences to love animals that most people consider unappealing and repellent, like reptiles and insects. He got kids interested in and excited about wildlife. I have no doubt that scores of graduate students are now pursuing doctorates in biology because they loved watching Irwin and were inspired by him. The work of those motivated by Irwin will have positive impacts for wildlife conservation. He also created a foundation (Wildlife Warriors) dedicated to wildlife conservation, which conducts important conservation work around the world.

Steve Irwin was a passionate and well-meaning advocate for wildlife, but he got too close to the wildlife he loved. He regularly manhandled animals and invaded their personal space, provoking aggressive responses that they wouldn't have displayed if left alone. He unintentionally taught people that it's okay to get close to wild animals and even grab and wrestle

with them. This was obviously dangerous for him, for the animals, and for impressionable audience members.

Young people naturally imitate dynamic television personalities like Irwin. In addition, his programs inadvertently encouraged wildlife paparazzi, video and still photographers who approach wild animals aggressively to photograph and film them. In the process, these shooters get an adrenaline rush and perhaps some nice footage but often leave the animals stressed and primed to attack human beings.

The dangers of coming too close to wild animals should be obvious. The harassed animals, at best, are disrupted and upset and, at worst, strike out at the people doing the disrupting. Although the beleaguered animals are merely defending themselves against perceived threats, these attacks perpetuate inflated and irrational fears about the dangers of wildlife. On a case-by-case basis, the attacks can also lead to injury or death for the harasser, the animal, or both.

Irwin's legacy proved a dangerous one. Today's presenters often close in on wildlife, forcing dangerous animals into interactions that can be physical, confrontational, and extremely stressful for both parties. Audiences are misled into thinking that invading wild animals' space is acceptable. Charming and charismatic hosts often behave in ways that end up hurting the wildlife they profess to love.

The MTV series *Wildboyz* (2003–2006) had Steve Irwin's energy level but not his concern for conservation. The hosts of *Wildboyz* grabbed crocodiles, chased cheetahs, stuck their tongues in a giraffe's mouth, deliberately allowed scorpions to sting their bare buttocks, smeared their faces with wildebeest blood, and put antelope turds in their mouths to see who could spit them the farthest. In one episode, they jumped into water next to a brown bear and her cubs, enjoying themselves at the expense of

the bears, who, it is reasonable to assume, felt alarmed and stressed.

Wildboyz was unethical and irresponsible. It focused on exerting power over wild animals rather than respecting and learning about them. MTV's ratings were achieved on the backs of harassed animals—although, paradoxically, *Wildboyz* cohost Steve-O went on to do excellent work fighting the fur industry and SeaWorld.

More traditional animal trainers are no more likely to treat animals ethically than are the hosts of *Wildboyz*, which deliberately positioned itself as antiauthority and antiestablishment. In the Animal Planet show *Into the Pride*, animal trainer Dave Salmoni informs viewers that an overly aggressive pride of lions must be calmed down enough to accustom themselves to ecotourists. But Salmoni "calms" the animals by increasingly aggravating them—neglecting to mention that if he were to leave them alone, they'd likely settle down on their own.

Salmoni rides around the Namibian bush on a quad bike looking for a close encounter with lions. Lions quickly get habituated to vehicles, but when Salmoni gets off his bike, as he likes to do, the lions become aggressive and charge him. This makes for great television, but it is a lousy way to treat animals. The lions are gratuitously provoked for the sake of ratings and, in the process, they become upset, alarmed, and needlessly stressed.

Panthera's president Dr. Luke Hunter wrote a withering critique of *Into the Pride* for the *Huffington Post*.[3] Under the title "Tormenting Lions for TV," Dr. Hunter chastised Dave Salmoni for being a "self-absorbed ignoramus" and the program for being "self-indulgent baloney." Salmoni deliberately gets too close to animals, goading and provoking them simply to produce exciting television and high ratings.

At least Dave Salmoni doesn't deliberately kill wild animals: Other hosts are not so civilized. Bear Grylls took pleasure in doing so on his

Discovery Channel reality show *Man vs Wild* (2006–2011). He was ostensibly demonstrating how a person could survive alone in the wild, but he went out of his way to hunt wild animals. Grylls was hardly a starving, desperate traveler lost in the wilderness. He was the host of a popular show who enjoyed killing animals for the ratings boost. His savagery included yanking a rattlesnake out from under a shrub and bashing its head in with a rock, gnawing the heads off of live fish, and throwing a flaming object into a cave to "smoke out the bats," which he swatted to the ground with a homemade club and stomped to death.[4]

In another program, Grylls thrashes around wildly in a murky stream in Indonesia and finally emerges with a three-foot monitor lizard, which he has by the tail. He points out the lizard's razor-sharp claws and then swings the lizard violently by the tail, bashing its head against a tree. When that brute force doesn't achieve the kill, he pulls out his knife and plunges it into the lizard's neck.

Discovery senior vice president Steve Reverand brushed off animal welfare concerns, insisting that Grylls's techniques "have been credited with saving the lives of ordinary people who have found themselves in treacherous situations."[5] Outdoorswoman Rhonda Krafchin is skeptical of that claim: "I'd like to know how many injuries and rescues there have been due to people trying to imitate some of his idiotic stunts," she observed dryly.[6] Given that Grylls has been outed as staying in hotel rooms and getting food catered while shooting, it's clear that he has no intention of surviving using his techniques. His actions, many of which have been panned by real survival experts, are clearly stunts designed for ratings and nothing more.

Similarly, Sarah Palin's caribou slaughter on her short-lived Learning Channel show *Sarah Palin's Alaska* was a calculated move to attract controversy and attention. Perhaps hunting is an important part of her life in

Alaska, but showcasing footage of an animal's death for viewer enjoyment takes a special kind of insensitivity. Writer and producer Aaron Sorkin, in his excoriating critique of Palin's program, drew an important distinction between killing animals for food and killing them to boost television ratings. "You weren't killing that animal for food or shelter or even fashion," he wrote to Palin, "you were killing it for fun."[7]

COPIES OF COPIES

Since Steve Irwin, Steve-O, Dave Salmoni, and Bear Grylls hit it big on television screens, a plethora of copycat presenters have deluged the market. More and more networks are broadcasting nature shows about people who wrangle, mistreat, and slaughter innocent animals like alligators, catfish, wild hogs, and snakes. Examples include *Swamp People, Call of the Wildman, Rattlesnake Republic, Hillbilly Handfishin', Mountain Men, Yukon Men, Wild West Alaska, Duck Dynasty, Animal Fight Night, Shark Wranglers, Under Wild Skies,* and *Shark Hunters.* Here's a closer look at some of these shows and what's wrong with them.

Swamp People

Swamp People (History Channel, 2010) is about alligator hunters in Louisiana who go out daily during the hunting season. The hunters set traps, baiting massive hooks with rotten chickens or fish. Alligators swallow the bait, and the hooks often become lodged in their stomachs. Sometimes the hunters do not return to check the lines until the next day. Obviously a gut-hooked alligator suffers horrendously during this waiting period. When the hunters finally return to the line, one of them pulls the doomed animal toward the boat. Once the hooked animal is in sight, another hunter shoots the alligator dead.

People in Louisiana need to make a living, but does the History Channel need to make entertainment out of the relentless and barbaric slaughter of alligators? What message does that send children who are watching? As critic and actor Dominic Monaghan said, "Death is not entertaining for me—certainly not the death of an animal as beautiful and charismatic as an alligator."[8]

Call of the Wildman

Call of the Wildman (Animal Planet, 2011) is a hit cable reality show that follows the exploits of Ernie Brown, Jr., also known as Turtleman, a wildlife rescuer from Kentucky. In a seven-month *Mother Jones* investigation, journalist James West found that contrary to the impression that the series conveys on television, *Call of the Wildman* tolerated ethically and legally questionable activities, such as using a sedated animal and trapping wild animals to be "caught" again later once the cameras were rolling.[9] The report found evidence that the desire to get high ratings took precedence over the welfare of the animals and that animals were abused during filmmaking. Staging and fabrication are rampant on *Call of the Wildman*, as they are on virtually all reality shows.

Marjorie Kaplan, head of Animal Planet, rejected the findings of the *Mother Jones* report and claimed no animals were harmed in the show's production. But Turtleman's on-screen handling of the animals is undeniably brutal and aggressive. The show often treats Turtleman's capture of the panicked, terrified animals as slapstick comedy, with Turtleman chasing the animals round and round in a tumultuous series of fights, scuffles, and brawls. The creatures are clearly stressed and often traumatized.

Rattlesnake Republic

Rattlesnake Republic (Animal Planet, 2011) follows four teams of rattlesnake hunters in Texas. In its promotional material for the series,

Animal Planet described the rattlesnake as "the continent's most dangerous predator,"[10] even though rattlesnakes rarely bite humans unless provoked or threatened. The majority of rattlesnake bites are the result of people intentionally interacting with the snakes. In the process of making the show, the producers deliberately antagonize and goad these creatures in an effort to construct a compelling storyline and get higher ratings.

Again, a show presents animal cruelty, slaughter, and stigmatization as entertainment. Rattlesnakes are a vital part of maintaining a healthy ecosystem and even save ranchers and farmers millions of dollars annually by eating rodents. Doesn't this program violate the values that Animal Planet allegedly stands for?

Hillbilly Handfishin'

Hillbilly Handfishin' (Animal Planet, 2011) involves a group of "hillbillies" instructing city slickers on how to wade into the muddy waters of Oklahoma's rivers, streams, and lakes to "noodle" (or catch) giant catfish in holes beneath the water's surface. In other words, ignorant, thrill-seeking tourists and complicit locals gang up on a nesting catfish, yank it with their hands from its hole where it is likely protecting its eggs, terrorize it, and then slowly suffocate it to death. This is called a sport, and Animal Planet airs it during prime time at 9 p.m. without regard to how it might desensitize the public to animal cruelty.

Mountain Men

Mountain Men (History Channel, 2012) follows three mountain men in Alaska, Kentucky, and Montana as they trap, hunt, and live off the land in the backwoods, pursuing a harsh and challenging wilderness life off the grid, far from civilization. Tough, resourceful, and fascinating, these men live much like our prehistoric ancestors did. My one objection to this

series is the way it glamorizes hunting and trapping (for example, using barbaric and agonizingly painful snares and leghold traps), paying no attention to the intense suffering these methods cause. Hunting and trapping should be positioned as a last resort, not something to be celebrated and promoted.

Duck Dynasty

Duck Dynasty (A&E, 2012), the highest rated show on A&E, is about the Robertsons, a family that runs a thriving business based on hunting ducks. The Robertsons are defined by their passion for hunting, their camouflage gear, their love for the Bible, and their frankness.

The family shoots constantly at anything that walks or flies. Animals are brutalized and killed on-screen and off. Pop singer and animal rights activist Morrissey cancelled his scheduled appearance on Jimmy Kimmel Live when he discovered he would be on the same show as the Robertsons, calling them "animal serial killers."[11] In January of 2014, Robertson promoted a new line of Robertson-branded guns by quipping, "Do you know what makes me happy, ladies and gentlemen? To blow a mallard drake's head smooth off."[12]

The family's relish and delight in killing ducks shouldn't be given so much glamorization and legitimacy through this series. Like virtually all reality shows, it is largely staged. Their perceived independence and love for individualism is all scripted. What aren't staged are the very real deaths of the animals they kill on the show.

Animal Fight Night

Animal Fight Night (Nat Geo Wild, 2013) is a series that features battles between some of the biggest and fiercest animals in the world, including lions, hippos, wolves, bison, and crocodiles. National Geographic claims

the programs will deliver "the bright lights, drama and testosterone of the Ultimate Fighting Championship."[13]

To create the series, National Geographic hired a British production company called Arrow Media, which, in turn, quietly put the word out to young, hungry cinematographers that they were looking for exciting animal fight footage. This resulted in the following post on Facebook on March 26, 2014, from an impecunious young filmmaker hoping to get hired by Arrow Media: "I need to film bobcats and mountain lions fighting, and also red squirrels, coach whips, and raccoons fighting. I'm looking for help." This is a good example of how the furtive system works. National Geographic remains arms length from the dirty underbelly of how its footage is filmed. If social media or the press exposes what is going on, broadcast executives can pretend to be as shocked as everyone else.

The filmmaker's Facebook post resulted in an explosion of outrage over young filmmakers being pressured to behave unethically by staging animal fights. As wildlife photographer Melissa Groo reflected on this incident, she said to me, "Our first concern must be for the wildlife rather than the needs of the television program." As more and more filmmakers and photographers weighed in and the discussion became more heated, the original post was suddenly deleted by the young filmmaker, who clearly regretted the post and the uproar and embarrassment it had caused. The furor soon subsided and nothing changed.

In fairness to Nat Geo Wild, they would argue that no one is under pressure, directly or indirectly, to force or fake money shots that are simply not there. They would say that they can't stop everyone from acting in unethical ways and that they have put into place as many controls as possible to discourage bad behavior. Writer Jason Goldman observed, "Nat Geo Wild has largely bucked the trend [in science television in America] of misleading or

lying outright to viewers."[14] Yet, as can be seen with *Animal Fight Night*, the pressure on Nat Geo Wild to take risks to get high ratings is intense.

Shark Wranglers

Shark Wranglers (History Channel, 2012) shows big game anglers and filmmakers capturing great white sharks, which they ironically label "the planet's most notorious killers," with a large hook and line. The hooked shark is reeled in during a long, torturous battle during which the angler deliberately exhausts the shark to make it more compliant and manageable. The shark is then hauled out of the water and onto a platform, where mutilating holes are drilled through its dorsal fin to attach a satellite tag. The traumatized shark remains out of the water for up to 15 minutes while the tag is attached and blood is taken. The shark, now compromised, is then released back into the water. Most shark scientists have spoken out against this invasive program, pointing out that it is unnecessary because the same data can be collected using far less damaging methods and without putting the rare and endangered great white in harm's way.

When *Shark Wranglers* was filming in South Africa, their permit was temporarily suspended when surfer David Lilienfeld was attacked and killed just days after the crew began chumming in local waters. Although the filming could not be tied to the attack on the surfer, the government review hearing revealed something else: that one great white shark had died as a result of the brutal capture process during the filming of the show.

Shark Wranglers spotlights the thrill of catching a magnificent fish, but despite the lip service given to conservation and research, the treatment of these animals during filmmaking clearly undermines such efforts. Broadcasters are demanding money shots and filmmakers are pushing themselves hard to deliver at the expense of the animals.

Under Wild Skies

Under Wild Skies was funded and produced by the National Rifle Association (NRA) for NBC and the Outdoor Channel. The show's host, NRA strategist Tony Makris, was filmed getting within 20 feet of an African bull elephant in Botswana before shooting it in the face two times—apparently this is not illegal. Then he toasted his success with a glass of champagne next to the dead animal.

Outrage exploded across social media, but, tellingly, NBC and the Outdoor Channel only pulled the show after Makris compared his critics with Hitler, intensifying the outrage he provoked to stratospheric levels. It's puzzling that the NRA, renowned for its lobbying skills, would be so tone-deaf to the fact that African elephants are currently being poached at record levels for their ivory. Is shooting an elephant in the face the type of activity NBC wants to be associated with in its efforts to win high ratings?[15] Partly as a result of conservation films made by filmmakers like Dereck and Beverly Joubert, all hunting was banned in Botswana in April 2014, so the Tony Makrises of the world can no longer shoot elephants in the face.

A LEGACY OF VIOLENCE

The shows described above are suffused with brutality and cruelty to animals. They portray the environment as if it is nothing but a resource to be harvested and hunted. This cruelty seems to contradict the professed values of the networks airing these shows. National Geographic's slogan "Inspiring people to care about the planet since 1888," for example, doesn't seem consistent with harassing and killing animals.

None of these shows run disclaimers that "no animal was hurt during the making of the program" because such a disclaimer would be a blatant

lie. Animals are hurt and killed during filming, routinely and intention-
ally. I have to wonder if the time is coming when it will be acceptable for
a broadcaster to make a show about the hideous and abhorrent sport of
"trunking," in which local hoods throw a couple of agitated dogs into the
trunk of a car and drive around until one is dead. You might insist that
networks like Animal Planet or National Geographic would never do
that, but some of us never thought they'd air shows like *Yukon Men* or
Rattlesnake Republic.

Writer and former CNN anchor Campbell Brown has made a special
study of violence in the media and found that increasingly graphic vio-
lence is being depicted in television shows, movies, and video games.[16] If
violence is spreading and intensifying in the media, it should not be a sur-
prise that it is also spreading and intensifying in wildlife shows. The vicious
attitude toward animals shown in many television programs reflects aber-
rant behavior that deviates drastically from the humane attitudes held by
most people.

Virtually no one would say that animal abuse is a positive influence on
the life of the nation. Yet it proliferates because it enhances ratings and
profits for the broadcasters. These wildlife programs desensitize viewers,
including impressionable children, to the reality of hurting living things.

In 2009, the American Academy of Pediatrics thoroughly reviewed the
literature on media violence and found that media violence is one of the
causal factors of real-life violence and aggression.[17] So if it's not healthy
for children to watch violence against people, how can it be healthy for
children to watch violence against animals?

Many studies show that perpetrating and witnessing animal abuse
strongly correlates with violence against human beings.[18] According to Dr.
Kenneth Shapiro, clinical psychologist and president of the Animals and

Society Institute, a child or adolescent who harms an animal or who witnesses an animal being harmed is more likely to engage in violent behavior toward humans, concurrently or in the future. [19] He noted that depending on the age and gender of the child, witnessing animal abuse also can result in later anxiety and replaying of the event in fantasy and nightmares, as is seen in posttraumatic stress disorder.

Dr. Shapiro told me that children who witness heavy doses of animal abuse tend to become less sensitive and empathetic, which leads to our society being coarsened and degraded. When audiences see animal harassment and cruelty on television, the abuse gains a gloss of legitimacy. Healthy, compassionate societies don't treat animals as disposable property.

Attending a bullfight or dogfight, watching a "nature" program that features human violence toward animals or gratuitous or staged animal-on-animal violence, and witnessing animal abuse, are psychologically loaded events. People have no problem recognizing the effects of real-life violence on children; why are television programs allowed to legitimize and popularize animal abuse? It should not be acceptable for broadcasters to facilitate antisocial behavior. As a society, we want children and adults to be appalled and upset by cruelty, not desensitized to it.

The goal of many of these programs is mastery and conquest of the natural world rather than understanding and connecting with animals. On August 22, 2011, journalist Andrew Marshall published an article in *Time* magazine criticizing "gonzo nature-television presenters." [20] He wrote that the "pet-and-pester approach that [Steve Irwin] pioneered has now become the standard way for nature programs to produce cheap dramatic footage." While "Irwin lookalikes" hassle animals on the screen, they "unwittingly [record] our dysfunctional relationship with [nature],

teaching our children to both fear and subjugate creatures already pushed to the brink of extinction."

Marshall identified the key message in these wildlife shows as being that "animals are vicious, so humans are justified in using any means to subdue them." He wrote, "I've given up on finding a show that teaches us how to live in harmony with animals. Instead, we invade their habitats and, when they defend themselves, we brand them violent."[21] Broadcasters, in their greed for ratings, are failing to convey to their viewers, including children, an appreciation for nature and an understanding of animals.

GRAY MORALS, GRAY MATTER

Even if the abuse isn't evident on-screen, it can still happen away from the camera. Many animals are rented from game farms, crude storage facilities for the wildlife media industry. When I visited a prominent game farm that had many well-known broadcasters and high-profile wildlife filmmakers as clients, I saw lynx, bears, wolves, bobcats, and many other animals penned in cages only slightly bigger than the animals themselves, looking miserable and catatonic.

Television host and naturalist Casey Anderson, a strong advocate of ethically made wildlife films, told me, "I saw some of the most awful things you can imagine when I worked at game farms, including euthanizing animals with gunshot, staging conflict that resulted in death, goading animals to make them snarl for the camera, and starving animals to get them to perform better. It is truly a dark, shady world."[22] Most people—including most television network executives—don't know that game farm animals are constrained or held in abusive ways.

Footage of animals held captive in game farms should be labeled as such. This is done routinely now for photos in the top-tier wildlife magazines,

including *National Geographic* and *National Wildlife*. It is time for broadcasters to follow their example.

Not all animal harassment in wildlife filmmaking is intentional. Sometimes highly honorable wildlife filmmakers make mistakes and have second thoughts. In a reflective moment, veteran filmmaker Tom Campbell told me about the time he was shooting a sequence of white sharks breaching in South Africa.[23] Over the course of several days, he got them to perform spectacular aerial displays of predatory power by dragging a dummy rubber seal behind his boat. The sharks would perform amazing lunges in their desperate attempts to seize the "seal." He captured the result in incredible slow motion on his Sony F-900 cameras.

Later, while interviewing one of the world's top shark scientists, Campbell learned that white sharks have a limited amount of energy for capturing prey. At some point, they no longer have the stamina to go after fast-moving prey if they miss too many times. "I couldn't help but wonder if I'd behaved unethically," Campbell confessed. "I had lured all those white sharks into a fantastic display of predation on a dummy seal that produced nothing to eat."

Photographer and filmmaker Jeff Hogan provided another example of harassment of animals that, although unintentional, has its consequences: "You might have a lot of people traveling in Yellowstone or Grand Teton and when someone finds a bear, suddenly 30 photographers and filmmakers show up, alerted by radios and cell phones, and surround the animal, impede its movement, and behave like obstreperous paparazzi. It used to be just me and the animal, but now there might be a crowd of us, all hustling to shoot video and take photos. It really catches me off guard."[24] The hemmed-in bear is unintentionally hassled and pestered.

Tom Campbell and Jeff Hogan are among the most ethical filmmakers

in the industry. I have tremendous respect for both of them as people as well as for their work. Their candid testimony shows how easy it is for good people with the best of intentions to still have an adverse effect on wildlife.

For those who doubt the importance of avoiding animal harassment, it's important to note that animals are not dummies without sensation or mere robots with fur. They are sentient creatures that feel pain when hurt. My impression was that even as late as the 1990s, most scientists (Jane Goodall was an exception) would dismiss claims that animals can experience pain (in the same sense that people experience pain) as sentimental rubbish that anthropomorphized animals and wrongfully endowed them with human thoughts and feelings. This perceived lack of pain sensitivity made it easy for people to distance themselves from animal suffering and allowed them to do with animals what they pleased.

But new scientific research has shown that animals ranging from elephants, dolphins, and chimpanzees to house cats, farm animal like cows and pigs, and certain birds do experience emotional pain and suffering when they survive a relative or close companion's death, as explained in Barbara King's 2013 book *How Animals Grieve*. We now also know that animals can feel joy and gratitude. Biologists have noted how sometimes a freed whale exhibits body language that seems to reflect thankfulness toward the diver who cut it free. This suggests that animals value their own lives and attach a high value to their freedom.

Michael Fishbach, codirector of the Great Whale Conservancy in California, experienced this firsthand on a 2011 trip to the Sea of Cortez.[25] He and his party came upon what appeared to be a lifeless humpback whale with 200 feet of fishing net wrapped around her body like a straitjacket. After determining that the trapped animal was still alive, Fishbach and his crew undertook an exhausting, hours-long effort to set the humpback free

by laboriously cutting the net away. Once free, the whale breached over and over again (which is unusual) and engaged in a display of tail slaps and pectoral fin slaps. Fishbach has no doubt that the whale was demonstrating pure joy—and perhaps was even saying "thank you."

Since the 1970s, scientists have made amazing discoveries about animal emotions. Thirty years ago, it was scientific heresy to ascribe delight, boredom, or joy to an animal. But as author and scientist Dr. Jonathan Balcombe wrote in his 2010 book *Second Nature*, animals' thoughts and feelings are far more complex than humans previously imagined. "Animals are conscious beings with feelings," Balcombe noted, "yet our treatment of them remains medieval. Our humanity lags behind our emerging knowledge of animals' sentience."[26]

THE ALTERNATIVE

So how can cinematographers get satisfactory shots if they are not allowed to stress and harass animals or encroach on their habitats? The solutions include using better cameras and longer zoom lenses; hiring local scientists; budgeting more money; showing more patience; lowering expectations for blood, gore, and extreme close-ups; and embedding the photography in better and more biologically accurate stories. Filmmakers should also use disclaimers at the start of programs to tell audiences that certain standards were met during filming (such as, "no animals were harmed during production"). Jeff Hogan has had great success filming wild behavior of elusive wildlife from a distance by capturing intimate close-ups with camera traps. Camera traps are remotely activated cameras equipped with motion sensors or infrared sensors. Hogan also uses lights that go undetected by the animals.[27] New technologies like camera traps, remote vehicles, and drones can sometimes

201

allow the capture of exciting, up-close footage while giving wild animals their space.

The more we humans learn about animals' consciousness, the more we must reassess our relationship with them. Even beyond that, however, we must realize that promoting brutality as entertainment is preying on the worst, most base parts of human nature. If broadcasters are only making these programs to appeal to audiences, then it is up to us, the audience, to speak out against the malicious harassment and killing of innocent animals.

Says author and animal advocate Marc Bekoff, "We can no longer continue to be over-producing, over-consuming, arrogant, big-brained, big-footed, and invasive mammals who don't give other animals the respect, compassion, and love they deserve."[28] Broadcasters need to get on the right side of history and rediscover their moral compasses. I realize that we live in a commercial world and have to face the reality that ratings are king. Yet wildlife films don't need violence to be compelling, and greed and ignorance are no excuse for senseless violence.[29]

CHAPTER TWENTY-ONE

Where Do We Go from Here?

WHAT UNDERLIES SO MANY ethical lapses—audience deception, lack of conservation, animal harassment—is the desire by broadcasters to achieve high ratings. In many instances, filmmakers, egged on by broadcasters, have become wildlife paparazzi who harass and even kill animals to capture alarming, exciting money shots. The aggressive tactics they use to obtain sensational footage produce nature porn, which exploits animals and misleads audiences.

Wild animals already face the obvious threats of habitat destruction, poaching, pollution, and climate disruption. Now they're also threatened by broadcasters who stand to profit from their suffering.

In *Yukon Men* (Discovery Channel, 2012), for example, audiences are shown a lynx struggling in a leghold trap and then strangled to death by a hunter with a wire noose; a man beating to death a snarling wolverine caught in another leghold trap; and a man killing a wolf by pursuing it on a snowmobile and then shooting it with an AR-15 semiautomatic assault rifle. Some filmmakers, under pressure from broadcasters, will incite violence to get the footage they want.

Wild West Alaska (Animal Planet, 2013) is no better. This series takes place in Alaska and focuses on Anchorage gun shop owner and weapons aficionado Jim West as he and his team build guns for hunting and other uses. West has been accused by Alaska state troopers of trespassing, illegally shooting a black bear, and helping to illegally track and kill a moose.

Shark Hunters (NBC Sports Network, 2014) premiered in July 2014 with the tagline "The sharks are on the hook, and there's money on the line." The program is a documentary series that features three East Coast shark tournaments in which anglers from all over the world compete to catch and kill the biggest shark to win large financial rewards (at least $100,000). The show casts the fishermen as courageous sportsmen who "put themselves in harm's way." As writer Rich Juzwiak put it, "The sharks are the bad guys, fearsome food chain lords that need to be toppled."[1] In a world where shark finning (the slicing off and harvesting of shark fins while the remainder of the living shark is discarded to slowly die in the ocean) and loss of apex predators are major concerns, killing these animals for entertainment is simply wrong.

Broadcasters defend shows like these by claiming that they are only giving the public what it wants. What's more, they say they're trying to survive in an intensely competitive ratings environment.

Indeed, the viewing public does bear some of the responsibility for the content of wildlife films. The networks offer films that they think will attract viewers. If people didn't watch lurid wildlife films, there would be no lurid wildlife films.

Yes, the competition for television market share is fierce and relentless. It's challenging for a commercial media company operating in an intensely competitive environment to act in the best interest of future generations and the long-term best interests of the country, especially when its pursuit

of short-term ratings conflicts with those interests. Animal Planet and similar networks compete not only with animal shows but with everything else on television as well, including *Dancing with the Stars*, *Game of Thrones*, and *Monday Night Football*.

The pressure for "bigger" and "more" is intense, and sensationalized imagery is the typical end result. It's hard for me to believe that the public wants to routinely watch animals being shot, trapped, and harassed on national networks, but broadcasters achieve high ratings by airing such content. Some large percentage of the public apparently craves the supercharged excitement of wild animals killing or being killed. From the safety of armchairs, the audience experiences the thrill of the kill and the pleasurable resulting rush of adrenaline.

The networks are not in an easy position. What's sensational, thrilling, and climactic this year seems mundane, commonplace, and prosaic a year or two later because viewers have become more desensitized. Thus their standard for what constitutes edgy and entertaining wildlife footage becomes increasingly demanding. In the intense pursuit of high ratings, broadcasters constantly need to ramp up the shock and awe just to maintain viewers' attention. Given this escalation of expectations in wildlife programming, it is understandable that broadcasters airing wildlife shows are moving away from more traditional hands-on-hips, direct-to-camera, presenter-led storytelling and toward something that appears more compelling—something that shows viewers protagonists who are actively immersed in adventures, allowing viewers to vicariously experience the exotic world of nature through these people.

But broadcasters cannot escape their ultimate responsibility by blaming viewers. It is the broadcasters who pay for the programs and choose what to air: The buck stops with them.

205

Broadcasters (as well as the global community) cannot continue down this path. Not only is the abundance of animal abuse intolerable, but if things continue as they are, there may be no Shark Week in the future because there may be no sharks, no *Meerkat Manor* because there will be no habitat for meerkats, and no *March of the Penguins* because there will be no ice. Wild animals are going extinct at unprecedented rates. On October 1, 2014, the World Wildlife Fund revealed their calculation that about half of the animals on this earth have been destroyed since 1970; in other words, animal populations today, on average, have declined 52 percent from what they were in 1970.[2] Broadcasters need to use their power and influence to save the planet rather than to exploit the remaining animals that live on it.

Television programs are essential tools in the struggle to protect wildlife. Stephanie Flack, the executive director of the annual Environmental Film Festival in the Nation's Capital, said, "I believe in the power of film and television—its ability to engage, move, and motivate people in ways no other media can."[3] The cliché about a picture being worth a thousand words is true. Powerful, emotive, and affecting images and films can play a key role in drawing attention to conservation and bringing about change.

Nature films are needed to play this role more than ever before. Over half of the world's population now lives in cities. Author and psychotherapist Mary Pipher wrote, "In the history of the world, this distance from the natural world is a new phenomenon."[4] Peter Seligmann, chairman and CEO of Conservation International, noted, "Urbanization and the rapid pace of development are fostering a false sense of disconnection from the natural world within us, as we grow ever more removed from the sources of our food, water, energy and material goods."[5] Without nature films, where will people learn the importance of the natural world and humanity's dependence on it?

This is where shows like *Yukon Men* have their true negative impact. Through their use of crudely sensational and graphic blood-money shots that celebrate animal exploitation and violence, they portray the natural world dishonestly and inaccurately.

So how can the global community achieve a more desirable world in which nature films stop sensationalizing violence and instead promote conservation and celebrate wildlife? We will only get there through the combined efforts of viewers, filmmakers, reviewers, educators, and—most important—broadcasters.

Viewers

First, viewers can speak up and demand higher standards from the networks. Although many people enjoy irresponsibly sensationalized programs, those who care about animals and the environment should join together to demand higher standards. The minority, historically, has set the stage to enlighten others and create a new majority. The lone voice in the crowd can evolve into a chorus.

Viewers must contact the men and women who run these networks, as well as their advertisers and corporate sponsors, and demand that they improve the quality of their programs and that they think about more than just ratings. Perhaps social media outlets offer ways to raise and respond to issues in real time, allowing concerned viewers to comment on aspects of shows that they consider ethically questionable, making public the reprehensible practices often hidden from view.

Obviously, what the public wants matters. It is idealistic to think that broadcasters would self-regulate, but they will respond to public pressure. Think of the cigarettes that now come with health warnings, processed food packaged with nutrition labels, cars with safety belts and

airbags, and calorie counts on fast food restaurant menus. These changes didn't happen because of the altruism of the industries that make these products; rather, they came about as a result of public demand (sometimes enforced through government regulation) for the companies to do better.

We viewers can ask questions about the media we consume and share our concerns with our friends, spreading the word, for example, about the harassment and abuse of animals on television. Here are seven ways you can make a difference right now.

1. When you see a wildlife show that features footage of animals being harassed or abused, send a tweet or share a Facebook post voicing your concerns.

2. Start a hashtag like #StopHurtingAnimals4Entertainment, #FakeTV, #WildlifeFilmEthics, or #CrueltyForRatings.

3. Reach out to the creators of the film or to the broadcast channel via social media or more traditional means like e-mail or letter to let them know how you feel.

4. Boycott shows that mistreat animals. Communicate with others what you're doing and why you're doing so by sharing your concerns with your friends via social media and in person.

5. Write to animal protection nonprofit groups about your concerns and ask them to help.

6. Use social media and traditional means to reach out to the sponsors and advertisers of television programs that don't treat animals humanely.

7. Share your enthusiasm for programming that still manages to be entertaining while capturing its footage in an ethically responsible way.

Together, we can change the status quo and make more ethical wildlife films, putting an end to the abuse of our fellow animals. We each have the power to celebrate films produced ethically and to disparage those that are not. Social media gives us the means to easily share these views with hundreds or even thousands of other people.

FILMMAKERS

Second, wildlife filmmakers must also make changes. Although filmmakers are tempted to cut corners to raise their incomes and meet deadlines, they are also in a frontline position to resist network executive producers who push for irresponsibly obtained footage. Filmmakers could also take the lead in creating a relationship with scientists to ensure that the science in documentaries is presented accurately.

A good model to emulate is the Science & Entertainment Exchange, a program of the highly regarded National Academy of Sciences, which connects entertainment industry professionals with top scientists and engineers to improve the scientific accuracy of films without sacrificing their entertainment value. The goal is to use the vehicle of popular entertainment media to deliver sometimes subtle but nevertheless powerful messages about science. The Science & Entertainment Exchange brought together Neil deGrasse Tyson and Seth MacFarlane to produce *Cosmos* (under the auspices of Fox and the National Geographic Channel). The success of this production shows that there is an audience for well-produced, presenter-led science programs that do not rely on exploitation.

Many filmmakers are already on board. Author and filmmaker Michael Parfit is outraged by the misleading programs that National Geographic produces for television, which he believes are harmful to children. In a March 20, 2013, article in Canada's national newspaper *The Globe and*

Mail, Parfit wrote, "It must be baldly stated: The National Geographic Society, through several channels that are now its primary voice, is using its once-honorable name to produce misleading shows that can cause harm to children.... Like competitor *Animal Planet*," Parfit added, "the National Geographic Channel seems to have abandoned its principles....[by producing shows about] ghosts, UFOs, scary cultures, doomsday, booze.... Places such as National Geographic were once like the village that helps parents raise a child. But the village has turned on the child, just because of the shine of a coin."[6]

Filmmaker Richard Brock also vehemently denounced National Geographic for its irresponsible programming, writing, "NatGeo has degraded itself from a respected international organization to one that is now recognized as sensational, exploitative, and downright misleading. How will future generations care for these beleaguered creatures (like sharks and crocodiles) when their reputations are continuously damaged or destroyed by the famous National Geographic Society name?"[7]

But National Geographic also does a lot of good. In fact, we can learn something from wildlife filmmakers like Dereck and Beverly Joubert, who work hand in hand with the National Geographic Society. Dereck told me, "Beverly and I can make films that inspire conservation and while that may be a lot more than the majority of wildlife programming, it is not enough. We need to incubate causes and inspire people to follow them."[8]

The Jouberts looked at their lives and their massive awards cabinet, and they weighed that against the numbers of big cats on which so much of their success is based. They found that as their careers grew, big cat numbers fell, and they felt they should be doing more to help them. So, as mentioned earlier, they formed the Big Cats Initiative at National Geographic to raise money to put back into saving the cats they had filmed. As

of fall of 2014, they have funded over fifty projects in twenty countries. They continue to use their films as conservation tools to draw attention to cats and other animals.

They are also moving one hundred endangered rhinos from the highest poaching zones in the world in South Africa to some of the safest in Botswana. This project to fly rhinos to safety starts in February 2015. The Jouberts have also managed to borrow money and use their earnings from natural history filmmaking to buy land (or leases on land) and convert it from hunting to photographic conservation territory. They presently lease or own one million acres and hope to build that to seven million acres in a few years.

The Jouberts are moving beyond just making films. They offer moral leadership and will leave a legacy that gives their lives enduring meaning.

NEWS MEDIA AND REVIEWERS

Third, news media and critics who review nature programs and report on trends in programming must be more discriminating. That starts with providing program listings and reviews that do not hype or promote unethical wildlife programs. Critics' reviews should routinely gauge the programs' honesty, promotion of conservation, and treatment and depiction of animals. These details must become staples of every review, just as consistently as the program's air date and director are included. Reporters and reviewers who publicize and review television shows have a responsibility to provide complete, accurate information to readers and viewers, which extends to informing readers and viewers about the socially responsible (or irresponsible) techniques used by broadcasters and filmmakers. In this way, reviews can become an important source of information for viewers to make informed choices about what they watch.

EDUCATORS AND PROFESSORS

Fourth, educators and professors are responsible for hundreds of thousands of hours of education about media each year. Educators have a responsibility to provide accurate, balanced, and relevant information about media in general and unethical wildlife programs in particular. Teachers (and parents, too) who assume that Shark Week and similar programs are appropriate for children because they are "about nature" need to be disabused of that opinion.

Educators must get the issues raised in this book into the curriculum. Film schools should establish required classes that focus on ethical issues, similar to ethics classes required in journalism schools. Journalism students study specific cases of ethical dilemmas, some strikingly similar to those in wildlife filmmaking caused by cutting ethical corners to achieve higher ratings. In the media-dominated world of the twenty-first century, the study of media effects needs to be included in the educational process.

The rise of three academic graduate programs with specialized work in natural history filmmaking—at Montana State University in Bozeman, Montana; at Otago University in Dunedin, New Zealand; and at American University in Washington, D.C., where I teach—suggests that the next generation of filmmakers may, through training, be much more sensitive to the issues raised in this book. All three programs include an emphasis on ethics.

BROADCASTERS

Ultimately, though, viewers, filmmakers, the news media, and professors can only do so much. Networks, which commission the shows and decide what to air, must bear responsibility for the programs they broadcast. They are not powerless pawns pushed around by the public's

appetite for exciting and tasteless distractions. At the very minimum, networks should do no harm—a task they are failing at spectacularly—but their real calling should be moral leadership in keeping with the noble values of their founders.

Broadcasters like Discovery and National Geographic were founded on the ideals of education, conservation, and wildlife protection. Discovery Channel founder John Hendricks said in 1982 that he wanted Discovery "to satisfy curiosity and make a difference in people's lives by providing the highest quality content, services and products that entertain, engage, and enlighten."[9] On its website, Discovery asserts its desire to support, among other causes, "animal welfare and environmental protection."[10] National Geographic's founders talked about their mission being to "increase and diffuse geographical knowledge while promoting the conservation of the world's cultural, historical, and natural resources."[11]

But these broadcasters have turned against their founding visions. Their honorable goals are now often forgotten in the desperate pursuit of ratings. They might still talk the talk in their mission statements, but, as Peter Senge, author of *The Fifth Discipline*, says, "There is a big difference between having a mission statement and being truly mission-based."[12]

In one well-known departure from its founding values, National Geographic partnered in 2001 with Fox Cable Networks (part of News Corp). Fox Cable Networks is part owned by billionaire media mogul Rupert Murdoch, who is well known for his sensational approach to news gathering. The Fox and Nat Geo brands would seem incompatible to most neutral observers. In June 2014, the *Washington Post* reported "sheepishness, if not outright embarrassment [within the ranks at National Geographic], over the 'Fox-ification' of National Geographic's programming and the potential pollution of the Society's vaunted brand name."[13]

What is going on within these companies? Although decent, well-meaning people run the networks, once they are in positions of authority, they are often sucked in (under pressure from stockholders who demand profits) and seduced by the hegemonic institutional culture of commercial success at any cost.

Celebrated philosopher Hannah Arendt referred to this process as the "banality of evil": people behaving according to the status quo of a system while ignoring its moral consequences. The executives who run broadcasting networks like Discovery and National Geographic are not immoral or ill-intentioned people in their everyday lives, but in their jobs, they have a separate moral code driven by the singular goal of high ratings. To that end, they become complicit with a larger system built on animal suffering, audience deception, and harm to conservation.

Of course, some network employees feel a powerful urge to resist the internal rules, but they've either been pushed out or left of their own accord. Many are too afraid to speak up for fear of losing their jobs. Broadcast companies exist for their own prosperity, not to promote ethical niceties. It is extremely difficult, for example, for Discovery Communications CEO David Zaslav to recognize the systemic problems in his own organization when every show that demonizes wild predators becomes a chart topper.

Nonetheless, broadcasters play a major role in molding the culture of the United States, and that means they have a duty to behave ethically. They've lost their way, largely abandoning their exemplary and honorable original missions. Decadence has set in. Their desire to act decently for the good of the nation and for society seems to have withered and been replaced by a shameless philosophy of self-enrichment at odds with their founding principles.

These ethical issues will persist until the networks are led by innovative visionaries who can build on the legacy of great leaders like Discovery founder John Hendricks and CNN founder Ted Turner. Although high ratings attract the advertisers that will, in turn, bring profits, broadcasters cannot afford, as Harish Manwani, the COO of Unilever, said, "to be just innocent bystanders in what's happening around us in society."[14]

According to Bloomberg, Discovery Communications CEO David Zaslav stands to make more than $110 million in compensation in 2014.[15] Imagine the benefits that could accrue if Zaslav diverted a portion of his income to appropriate nonprofits to help them deal with the damage his television programs create.

It might seem idealistic to suggest that for-profit broadcast companies would ever change their ways if those ways are commercially successful. But broadcasters will be better off in the long run if they air more reputable programming. With their current programming, broadcasters risk being viewed as parasites that flourish at the expense of the nation's emotional and cultural health. The more they focus on ratings, the more their image will decline. They are in a race to the bottom.

Broadcasters must build a high level of trust with their viewers to succeed over the long term, and honesty is the key to building trust. There's no justification for violating viewers' trust by secretly using rented (and badly treated) animals, allowing unlabeled digital manipulation of images, demonizing predators, or producing fraudulent documentaries. Many viewers will stop watching once they know the truth.

Moreover, conservation is critical to the future of the broadcast industry; after all, it's impossible to make wildlife films if animals are extinct. As Piers Warren said, "Broadcasters rely on the future of the natural world for the future of their supply of wildlife films. How can they turn their backs

on its destruction while reaping short-term rewards?"[16] Broadcasters rely on wildlife to make money, and part of their profits should go toward wildlife conservation—not only as a way to sustain their success but also as a means of giving back.

Just like companies in other industries, broadcasters can do well and do good at the same time. For example, TOMS donates a pair of shoes for every pair sold and Whole Foods allows consumers to direct their bag credits to a charity. Why can't broadcasters be inspired by these ideas and come up with their own initiatives for building societal benefits around their programs? These kinds of programs build good will and loyal viewership. They can also have a positive impact on the animals and habitats the shows depend on. Broadcasters might be able to attract more viewers by being ethical and differentiating themselves from other networks. If they are leaders in the movement toward change, they can use that activism for branding purposes. People like to make responsible, informed choices about everything from their produce to the cars they drive. The television they watch should be no different.

Of course, more and more films and videos are bypassing the broadcasters and being released directly onto the web—and successfully at that. Streaming and online delivery and promotion are the wave of the future, as are selected screenings, special events showings, and large video-on-demand releases. *Green* was probably the pioneer in this arena because, as mentioned earlier, it was originally released on the web.

Professor Dennis Aig at Montana State University told me, "Satellite and cable subscriptions are dropping precipitously. Virtually none of my students have cable or satellite.... The next generation is looking to Netflix, Hulu, Amazon, etc., for their programs. These online presences are also beginning to produce programming, although not yet in natural history

or wildlife." Aig added that "a seismic shift is shaking the distribution landscape; since it ties into social media, the change could provide a major opportunity for more enlightened and responsible filmmaking."[17]

Efforts to get Discovery, Animal Planet, and National Geographic to respond to the criticisms of them described in this book proved unfruitful. Typical of their responses was this one from Patricia Kollappallil, senior vice president of communications for Animal Planet, who wrote,

> As I think you know, we differ on some of the points you make and I don't think it's productive to respond to specifics. We know that the ways we choose to engage, inspire, and challenge our audience are sometimes at odds with the ways you might prefer. However, and far more important than the places we differ, we, like you, are deeply committed to conservation and animal welfare, deeply concerned about the state of the biological life of the planet and determined to bring attention and awareness and drive change with larger and more committed audiences.[18]

Although a letter like that can be easily dismissed as PR speak, it is still true, as I wrote in the Preface, that the networks are full of decent and honorable people who care about wild places and animals. Regrettably, the business side of television seems to coerce them into practices that sometimes harm wildlife, spread misinformation, and coarsen society's appreciation of nature.

What exactly am I suggesting that broadcasters do? I don't pretend to have all the answers. But I do have some ideas.

- Broadcasters should give more protection to whistle blowers (insiders who expose unethical conduct in programming), mandate ethics training for all of their top executives, place more emphasis on producing ethically made programs, make executive

producer bonuses dependent on critical response rather than just ratings, invite candid feedback from critics, allow scientists to have approval of how their interviews are used on air, and reach out to wildlife filmmakers to find ways to ensure that wildlife films can be produced without harming animals or deceiving the public.

- Broadcasters should take a Hippocratic-type oath or at the very least pledge publicly and on the record to do no harm and to act with integrity.

- Just as government agencies have independent inspectors general to sniff out corruption and improper conduct, so must broadcasters have an internal, independent watchdog. At the very least, broadcasters should have stronger, more vigorous standards and practices departments or ombudsmen such as those employed by National Public Radio.

- Up-and-coming filmmakers, as well as executive producers and others involved in creating wildlife films, should be schooled in wildlife filmmaking ethics, similar to how medical students have mandatory classes on medical ethics and journalists have mandatory classes on journalistic ethics. Such changes are already beginning abroad: The BBC has established an initiative supporting ethical filmmaking practices. Tim Martin, who is heading up the BBC initiative, told me, "The BBC's success has been built on a reputation for fairness, impartiality and honesty, and that applies just as much in natural history programming as in our news and documentaries. So deceiving audiences or filming animals in unethical ways is a very dangerous thing to do in terms of damaging our brand. But it's even more fundamental than that—keeping the audience's trust is critical because our primary source of funding is

218

the British public. Everyone in Britain pays the BBC's license fee, so as filmmakers we have to answer to the whole nation for our ethical standards."[19]

- Broadcasters could also create a "stamp of approval" that would accompany legitimate, science-based documentaries to distinguish them from the bogus docudramas that now proliferate and that I have described in some detail in this book. When viewers see the seal graphic on screen, they will know that the film underwent critical review to confirm that the science is real.

- Broadcasters need to find more compelling on-camera characters. They need to focus on environmentalists who speak lucidly, convey their passion for the subject, and talk without resorting to jargon. They need to produce a new generation of authentic, involved, and enthusiastic on-camera personalities who know how to attract large audiences and significant ratings while inspiring viewers to become active in conservation. Broadcasters must recognize that stories that honestly address real issues about conservation and wildlife—and even science—can also feature characters who seem authentic, motivated, and idiosyncratic and who have vibrant, if often tumultuous, relationships. The way to succeed is to put the "real" back into reality programming.

My recommendations are not about censorship or restricting filmmakers' creativity. I strongly oppose censorship of any kind. But broadcasters must exercise self-restraint, and they must be genuinely held accountable to a code of conduct. If they don't do so voluntarily, they should be subjected to the social contempt of their peers and their audiences. If someone produces junk natural history programming that exploits superstition and ignorance and encourages sadism—all for the sake of ratings—let's not

pretend that the person has any creative or social integrity. As filmmaker David Puttnam said, "It has to be possible to balance freedom of expression with wider moral and social responsibilities."[20] Freedom of speech must be matched with transparency and truth.

I'm also not suggesting that wildlife programs should be bland or vapid. Ethical, socially responsible filmmaking doesn't have to mean "peas-and-spinach" television. Films on conservation don't have to be pedantic. They can be brilliantly entertaining, as we saw with *Whale Wars* on Animal Planet. *Whale Wars*, which *New York Times* television critic Neil Genzlinger called "one spunky show,"[21] richly entertained viewers while slowing the killing of whales by Japanese whalers in the Southern Ocean Whale Sanctuary. The popular *Planet Earth* offered responsibly shot, dramatic, and exciting footage along with a conservation message, which reached viewers who don't normally watch natural history programs. Filmmaker Michael Parfit agreed that "it is not necessary for factual programming to resort to false information, superstition, fear-mongering, animal violence, or distortion to interest viewers."[22]

In the more than thirty years I've spent producing films, I've been impressed by the power of video images to raise environmental and wildlife awareness. Film, television, and online documentaries truly can inspire people to make positive changes in their lives and in their relationships with the environment. Even if most people who watch ethical environmental and wildlife films are predisposed to agree with the message, that audience is still an important constituency to reach and nurture. Despite my criticism of today's nature films as being exploitative and damaging to conservation, I still strongly believe in their power.

Sadly, this power is being wasted. As I've described in this book, wildlife films often enrich broadcasters while duping audiences, harming

animals, and doing nothing to advance conservation. Now is the time to make a change. Enlightened viewers, filmmakers, and broadcasters must join forces to overcome the enticing forces of ratings and profits. I believe it is the broadcasters who must lead the charge.

Broadcasters like National Geographic and Discovery have a duty to lay the foundation for a better tomorrow. They must jettison the hidden tactics of manipulating, stressing, and harming animals and be honest with viewers. They can seize the opportunity to take the moral high ground, become agents of positive change, and leave a legacy. They can return to the noble ideals of their founders. If broadcasters do so, future generations will hold them in high esteem for encouraging a vision of the world in which animals are respected and treated with compassion; wildlife television programs are cleansed of deception and manipulation; and viewers trust that the broadcaster, as well as the filmmaker it hired, behaved ethically and responsibly.

It should no longer be acceptable for filmmakers to clandestinely use animals from game farms, to surreptitiously manipulate images with computer graphics, or to goad animals into defensive or aggressive positions to jack up the on-screen dramatic tension. As a matter of professional practice, an outstanding wildlife documentary should contain a conservation message and seek to strengthen people's ties to the natural world. It should be exciting to watch while treating animals ethically and not deceiving audiences. Staging, fabrication, and manipulation should be minimal and always disclosed so that there is no violation of the trust that is essential to effective documentary storytelling.

I am optimistic that if viewers knew what they were really seeing—or if they at least knew to ask the right questions—many would consider changing what they watch. They would recognize their role and responsibility

for what rises to the top shelf in the media marketplace of ideas. We, as consumers of media, make a choice every time we flip a channel or click a mouse. We have the opportunity to select films that don't harm animals, that don't deceive audiences, and that promote conservation of the natural world.

I wonder, too, if the move to make more ethical wildlife films could be a major step forward for humanity—a opportunity to protect, honor, and respect our fellow animal creatures and to treat them as we would want to be treated were we to share Earth with a more powerful species. In being decent to the beautiful and charismatic creatures that share the planet with us, we will ultimately discover that we, ourselves, are decent. It is time to bring about a new era of wildlife filmmaking and make the world a better place for other species as well as our own.

NOTES

Chapter 1

1. Facts on bear attacks: Stephen Herrero, *Bear Attacks: Their Causes and Avoidance* (New York: Lyons & Burford, 1985).

Chapter 3

1. Chris Palmer, *Shooting in the Wild: An Insider's Account of Making Movies in the Animal Kingdom* (San Francisco: Sierra Club Books, 2010).
2. Nicholas D. Kristof, "How Giving Became Cool," *New York Times,* December 27, 2012, http://www.nytimes.com/2012/12/27/opinion/kristof-how-giving-became-cool.html.

Chapter 6

1. Derek Bousé, *Wildlife Films* (Philadelphia: University of Pennsylvania Press, 2000).
2. Derek Bousé, e-mail message to author, November 2, 2014.
3. Alan Rabinowitz, *Jaguar: One Man's Battle to Establish the World's First Jaguar Preserve* (New York: Anchor Books, 1986).

CHAPTER 8

1. Jeffery Boswall, "The Moral Pivots of Wildlife Filmmaking" (paper, 1988), 2.

CHAPTER 9

1. John Schwartz, "Donal O'Brien, 79, Audubon Leader, Dies," *New York Times*, September 11, 2013.
2. Carl Safina, "Enough Duck Shooting," *Carl Safina* (blog), January 18, 2012, http://carlsafina.org/2012/01/18/enough-duck-shooting-by-carl-safina.
3. Larry Schweiger to National Wildlife Federation members, fundraising letter protesting the killing of an animal, September 5, 2012. In the author's possession.
4. Wayne Schmidt, *Life with Big Green: A Memoir* (Los Gatos, CA: Smashwords, 2014).
5. Mark Dowie, "Audubon Takes Flight: What You Won't See in Tonight's Documentary," *Washington Post*, March 6, 1994.

CHAPTER 11

1. David Kirby, *Death at SeaWorld: Shamu and the Dark Side of Killer Whales in Captivity* (New York: St. Martin's Press, 2012).
2. For further analysis of the attack, see Tim Zimmermann, "The Killer in the Pool," *Outside Magazine*, July 30, 2010.
3. Kirby, *Death at SeaWorld*, 313.
4. Oceanic Preservation Society, "Marine Mammal Captivity: The Truth Is in the Facts. An Open Letter from the Informed American Public," press release, December 20, 2013, http://www.opsociety.org/announcements/marine-mammal-captivity-the-truth-is-in-the-facts-an-open-letter-from-the-informed-american-public
5. Naomi A. Rose and Richard Farinato, *The Case Against Marine Mammals in Captivity* (Washington, DC: Humane Society of the United States and the World Society for the Protection of Animals, 2009).
6. *Blackfish*, directed by Gabriela Cowperthwaite (New York, NY: Magnolia Pictures, 2013).
7. Chris Palmer, "Marvel at Wild Animals—from a Distance," *CNN.com*, February 26, 2010, http://www.cnn.com/2010/OPINION/02/25/palmer.killer.whales.captivity.
8. Bill Street, e-mail message to author, February 26, 2010.
9. Diane Toomey, e-mail message to author, February 26, 2010.
10. Roger DiSilvestro, e-mail message to author, February 26, 2010.
11. Kirby, *Death at SeaWorld*.

12. "Free the Elephants and Killer Whales in Captivity," editorial, *Scientific American,* March 1, 2014, http://www.scientificamerican.com/article/free-elephants-orcas-captivity.
13. Kim McCoy, "Large Marine Animals Do Not Belong in Bathtubs," *Scubadiving.com,* May 2010, http://www.scubadiving.com/training/ask-expert/should-big-animals-live-aquariums.

CHAPTER 12

1. Jimmy Carter, "I Wanted to Share My Father's World," *The Virtues of Aging* (New York: Ballantine, 1998), 44–45.

CHAPTER 15

1. Melissa Thompson, e-mail message to author, October 20, 2014.
2. Tensie Whalen, e-mail message to author, May 17, 2014.
3. Diane MacEachern, e-mail message to author, February 24, 2014.
4. For more information on the Eco-Comedy Video Competition, see http://www.american.edu/soc/cef/eco-comedy-film-competition.cfm
5. William Zinsser, *On Writing Well,* 2nd ed. (New York: Harper & Row, 1980).

CHAPTER 17

1. Brooke Runnette, e-mail message to author, August 29, 2011.
2. Palmer, *Shooting in the Wild,* 146.
3. Harry Marshall, e-mail message to author, January 6, 2011.
4. Jonathan Balcombe, *Second Nature: The Inner Lives of Animals* (New York: Macmillan, 2010); Victoria Braithwaite, *Do Fish Feel Pain?* (Oxford, England: Oxford University Press, 2010).
5. Jonathan Balcombe, e-mail message to author, September 16, 2014.
6. Culum Brown, "Fish Intelligence, Sentience and Ethics," *Animal Cognition* (forthcoming), http://dx.doi.org/10.1007/s10071-014-0761-0.
7. Chris Palmer and Shannon Lawrence, "Nature Television Is Running Wild: The Man-Eating Anaconda is Just the Latest Atrocity," *Washington Post,* December 9, 2014, PostEverything sec., http://www.washingtonpost.com/posteverything/wp/2014/12/09/nature-television-is-running-wild-the-man-eating-anaconda-is-just-the-latest-atrocity.

CHAPTER 18

1. Mark Dowie, e-mail message to author, March 14, 2012.
2. Andrew David Thaler, "Mermaids: The New Evidence Is a Fake Documentary," *Southern Fried Science* (blog), May 28, 2013, http://www.southernfriedscience.com/?p=14946.
3. National Oceanic and Atmospheric Association, "No Evidence of Aquatic Humanoids Has Ever Been Found," *Ocean Facts*, June 27, 2012, http://ocean-service.noaa.gov/facts/mermaids.html.
4. Lisa de Moraes, "Animal Planet Nets Its Biggest Audience with 'Mermaids,'" *Washington Post,* May 29, 2013, sec. C.
5. Brian Switek, e-mail message to author, June 8, 2012.
6. Brian Switek, "Mermaids Embodies the Rotting Carcass of Science TV," *Wired Science* (blog), May 31, 2012, http://www.wired.com/2012/05/mermaids-embodies-the-rotting-carcass-of-science-tv
7. David Shiffman, "Mermaids Do Not Exist, and Five Other Important Things People Should, but Do Not, Know about the Ocean," *Southern Fried Science* (blog), June 5, 2012, http://www.southernfriedscience.com/?p=13199.
8. Discovery Communications, "Animal Planet: Surprisingly Human," accessed November 24, 2014, http://corporate.discovery.com/brands/us/animal-planet/.
9. David Shiffman, "No, Mermaids Do Not Exist: What Animal Planet's Fake Documentaries Don't Tell You About the Ocean," *Slate,* May 30, 2013, http://www.slate.com/articles/health_and_science/science/2013/05/mermaids_aren_t_real_animal_planet_s_fake_documentaries_misrepresent_ocean.html
10. David Bauder, "Discovery Hammered for Shark Special," *US News & World Report*, August 7, 2013; Jacob Davidson, "Discovery Channel Provokes Outrage with Fake Shark Week Documentary: The Popular Network Has Found Great Success in Airing Shows that Mislead and Misinform," *Time*, August 7, 2013.
11. Bryan Bard, "Discovery Channel Ripped by Fans for 'Shark Week' Fake Documentary," *Examiner.com*, August 5, 2013, http://www.examiner.com/article/discovery-channel-ripped-by-fans-for-shark-week-fake-documentary; David Bauder, "Did Megalodon Show Betray Shark Week Viewer Trust?" *Santa Cruz Sentinel*, August 7, 2013.
12. *Megalodon: The Monster Shark Lives,* directed by Douglas Glover (North Hollywood, CA: Pilgrim Studios, 2013).
13. John Oliver, "Sharks, Lies, and Videotape," video clip, 3:29, from an episode of *The Daily Show* televised on Comedy Central on August 7, 2013, http://thedailyshow.cc.com/videos/gnlh0e/sharks—lies—and-videotape.
14. Wil Wheaton, "Discovery Channel Owes Its Viewers an Apology," *Wil Wheaton dot net* (blog), August 5, 2013, http://wilwheaton.net/2013/08/discovery-channel-owes-its-viewers-an-apology.
15. George Monbiot, "Did Discovery Channel Fake the Image in Its Giant Shark Documentary?" *Marine Life: George Monbiot's Blog* (blog), *Guardian*, February

21, 2014, http://www.theguardian.com/environment/georgemonbiot/2014/feb/21/discovery-channel-giant-shark-documentary-george-monbiot

16. Christie Wilcox, "Shark Week Jumps the Shark: An Open Letter to Discovery Communications," *Science Sushi* (blog), *Discovery*, August 5, 2013, http://blogs.discovermagazine.com/science-sushi/2013/08/05/shark-week-jumps-the-shark-an-open-letter-to-discovery-communications/.

17. Harris Polls, "Americans' Belief in God, Miracles and Heaven Declines," news release, December 16, 2013, http://www.harrisinteractive.com/NewsRoom/HarrisPolls/tabid/447/ctl/

18. Manohla Dargis, "The Call of the Wild, Heeded with Tenacity," review of *Turtle: The Incredible Journey*, SeaWorld Pictures, *New York Times*, June 23, 2011.

19. Robert Mendick and Edward Malnick, "BBC Accused of Routine Fakery in Wildlife Documentaries," *Telegraph*, December 18, 2011; Anita Singh, "Frozen Planet: BBC Faked Polar Bear Birth," *Telegraph*, December 12, 2011.

20. BBC, "BBC to Be Clearer about Wildlife Footage on African Show," news release, December 27, 2012.

21. Tim Martin, *"Are We Doing the Right Thing? BBC Offers a Moral Compass for Wildlife Filmmakers,"* *Natural History Network*, June 9, 2014. http://www.naturalhistorynetwork.co.uk

22. Dennis Aig, e-mail message to author, November 5, 2014

23. Adam Ravetch, e-mail messages to author, October 24–29, 2014.

CHAPTER 19

1. Piers Warren, *Careers in Wildlife Filmmaking* (United Kingdom: WildEye, 2002).

2. Alan Rabinowitz, Keynote Address (speech, Jackson Hole Wildlife Film Festival, Jackson Hole, Wyoming, October 2011).

3. Piers Warren, e-mail message to author, October 12, 2013.

4. Carl Safina, "National Geographic Channel, in Race to the Bottom, Adds Killing Endangered Species to New Season Entertainment Lineup," *Huff Post Green* (blog), January 5, 2012, http://www.huffingtonpost.com/carl-safina/national-geographic-channel-wicked-tuna_b_1207859.html.

5. Carl Safina, "NatGeo's Controversial New TV Show, *Wicked Tuna*, Debuts," *Huff Post Green* (blog), April 2, 2012, http://www.huffingtonpost.com/carl-safina/wicked-tuna_b_1396966.html.

6. Chris Palmer, "Ask an Expert: Is Shark Week Good for Sharks? Shark Week Is Entertainment by Exploitation," *ScubaDiving.com*, July 2011, http://www.scubadiving.com/training/ask-expert/ask-expert-shark-week-good-sharks.

7. Vanessa Small, "On a Mission to Show the Drama of Science," *Washington Post*, December 3, 2012.

8. Greg Skomal, e-mail messages to author, October 4, 2014.

9. David Shiffman, "Shark Week Lied to Scientists to Get Them to Appear in 'Documentaries,'" *io9* (blog), August 11, 2014, http://io9.com/shark-week-lied-to-scientists-to-get-them-to-appear-in-1619280737; Chris Sosa, "Shark Week Is a Disgrace," *Huff Post TV* (blog), August 6, 2013, http://www.huffing-tonpost.com/chris-sosa/shark-week-is-a-disgrace_b_3711081.html.

10. Grant Butler, a journalist with the Oregonian, wrote several perceptive essays on Shark Week in the first two weeks of August 2014; Brad Plumer, "Shark Week Is Once Again Making Things Up," *Vox,* August 11, 2014, http://www.vox.com/2014/8/11/5991961/shark-week-is-once-again-making-things-up.

11. Wheaton, "Discovery Channel Owes."

12. Anthony Bland, "Broken Teeth and Fake-umentaries: Another Shark Week Gone By," *Monkey See* (blog), NPR, August 18, 2014, http://www.npr.org/blogs/monkeysee/2014/08/18/340630812/broken-teeth-and-fake-umentaries-another-shark-week-gone-by.

13. For more, see Rich Juzwiak, "Shark Week Returns With Its Lies," *Gawker* (blog), August 26, 2014, http://gawker.com/shark-week-returns-with-its-lies-1619356593.

14. Jonathan Feldman, "'Shark Week' Isn't Just Misguided, It's Downright Danger-ous," *Huff Post Green* (blog), August 12, 2014, http://www.huffingtonpost.com/2014/08/12/shark-week-pseudoscience_n_5671772.html.

15. Adam Welz, "Bloodthirsty 'Factual' TV Shows Demonise Wildlife," *NatureUp* (blog), *Guardian,* May 17, 2013, http://www.theguardian.com/environment/nature-up/2013/may/17/bloodthirsty-wildlife-documentaries-reality-ethics.

16. For example, here are two fairly recent studies on the importance of wolves in ecosystem health: Brian J. Miller et al., "Trophic Cascades Linking Wolves (*Canis lupus*), Coyotes (*Canis latrans*), and Small Mammals," *Canadian Journal of Zoology* 90 (January 2012), http://dx.doi.org/10.1139/z11-115; Taal Levi and Christopher C. Wilmers, "Wolves–Coyotes–Foxes: A Cascade Among Carni-vores," *Ecology* 93 (April 2012), http://dx.doi.org/10.1890/11-0165.1.

17. Laura Beans, "'Man-Eating Super Wolves' Episode Prompts Public Outcry Against Animal Planet," *EcoWatch,* May 29, 2014, http://ecowatch.com/2014/05/29/man-eating-wolves-public-outcry-animal-planet.

18. Jamie Rappaport Clark, e-mail messages to author, May 23, 2014.

19. Jamie Rappaport Clark, letter to members of Defenders of Wildlife urging them to voice opposition to *Man-Eating Super Wolves,* May 24, 2014. In the author's possession.

20. Richard Brock, "The Demonising of Wolves by Animal Planet," *Wildlife Film News,* July 22, 2014, http://www.wildlife-film.com/features/Richard-Brock-The-Demonising-of-Wolves-by-Animal-Planet-220714.html.

21. Richard Brock, letter to the *RadioTimes,* November 15, 2013. In the author's possession.

22. Darryl Fears, "Critics Say Discovery Channel's 'Frozen Planet' Sidesteps Climate

Change Issue," *Washington Post,* May 2, 2012; Brian Stelter, "No Place for Heated Opinions," *New York Times,* April 21, 2012.

23. Witness, "Filmmaker Q&A: Patrick Rouxel," last modified March 15, 2012, accessed December 12, 2014, http://www.aljazeera.com/programmes/witness /2012/03/20123131323627439.html.

24. Russell Sparkman, e-mail messages to author, November 12–19, 2010.

25. See also Todd Wilkinson, "Can Technology Save the World—from Us?" *Jackson Hole & Guide,* September 25, 2013; Todd Wilkinson, *Last Stand: Ted Turner's Quest to Save a Troubled Planet* (Guilford, CT: Lyons Press, 2014).

26. "The Making of the Brock Initiative," accessed December 5, 2014, http://www. brockinitiative.org/about2.htm.

27. The following story about Mark Deeble and Vicky Stone is based on a number of e-mail messages exchanged between Deeble, Stone, and the author between October 12, 2014, and October 29, 2014.

28. Michael Cieply, "Participant Index Seeks to Determine Why One Film Spurs Activism, While Others Falter," *New York Times,* July 6, 2014, http://www. nytimes.com/2014/07/07/business/media/participant-index-seeks-to-deter-mine-why-one-film-spurs-activism-while-others-falter.html.

29. For more on films and conservation, see Alison Byrne Fields, "Films Are Films: Measuring the Social Impact of Documentary Films," *Philantopic* (blog), *Philanthropy News Digest,* July 23, 2014, http://pndblog.typepad.com/pndblog/2014/07/ films-are-films-measuring-the-social-impact-of-documentary-films.html.

CHAPTER 20

1. Dereck Joubert, e-mail message to author, January 11, 2010.

2. Jennifer Holland, "Don't Feed the Bears: Ethics in Wildlife Photography and Filmmaking," *National Geographic: News,* January 16, 2014, http://news. nationalgeographic.com/news/2014/01/140116-wildlife-photography-film-ethics-manipulation-feeding-staging-science.

3. Luke Hunter, "Dave Salmoni: Tormenting Lions for TV," *Huff Post Good News* (blog), August 24, 2009 http://www.huffingtonpost.com/alan-rabinowitz/ dave-salmoni-tormenting-l_b_257808.html.

4. Jonathan Balcombe, "Man vs. Wild, Bear Grylls, and the Violent Nature Myth," *The Inner Lives of Animals* (blog), *Psychology Today,* October 14, 2010, http:// www.psychologytoday.com/blog/the-inner-lives-animals/201010/man-vs-wild-bear-grylls-and-the-violent-nature-myth.

5. Daniel de Vise, "Secrets of Conquering the Wild Kingdom on Camera," *Herald Media,* September 26, 2010, http://www.heraldextra.com/lifestyles/secrets-of-conquering-the-wild-kingdom-on-camera/article_89d9cf70-cde5-5460-90fd-a9c2e9e9cc7a.html.

6. Rhonda Krafchin, e-mail message to author, September 23, 2010.

7. Aaron Sorkin, "In Her Defense, I'm Sure the Moose Had It Coming," *Huff Post Green* (blog), December 8, 2010, http://www.huffingtonpost.com/aaron-sorkin/sarah-palin-killing-animals_b_793600.html.

8. Adam Benzine, "Wildscreen '12: Monaghan Gets 'Wild,'" *Realscreen*, October 12, 2012, http://realscreen.com/2012/10/19/wildscreen-12-monaghan-gets-wild/.

9. James West, "Drugs, Death, Neglect: Behind the Scenes at Animal Planet," *Mother Jones,* January 21, 2014, http://www.motherjones.com/environment/2014/01/animal-abuse-drugs-call-of-the-wildman-animal-planet; James West, "How a Coyote Suffered Behind the Scenes at Animal Planet," *Mother Jones,* March 24, 2014, http://www.motherjones.com/environment/2014/03/animal-abuse-coyote-call-of-the-wildman-animal-planet; James West, "Animal Planet's Turtleman Returns to Air Despite Damning Federal Investigation," *Mother Jones,* June 11, 2014, http://www.motherjones.com/environment/2014/06/animal-planet-new-episodes-feds-USDA-animal-mistreatment.

10. "About Rattlesnake Republic," accessed December 5, 2014, http://www.animal-planet.com/tv-shows/rattlesnake-republic/about-this-show/about-rattlesnake-republic.htm.

11. K. J. Matthews, "Morrissey Cancels on Kimmel Over 'Duck Dynasty,'" *The Marquee* (blog), February 26, 2013, http://marquee.blogs.cnn.com/2013/02/26/morrissey-cancels-on-kimmel-over-duck-dynasty/

12. "Names and Faces: Duck Dynasty Ready to Move Forward," *Washington Post,* January 3, 2014, Style sec.

13. "Animal Fight Night: About the Show," accessed December 5, 2014, http://ngc-videoauth-uat.nationalgeographic.com/wild/animal-fight-night/.

14. Jason G. Goldman, "Nat Geo Wild's Radical Approach to Science TV: Being Truthful," *io9* (blog), September 18, 2014, http://animals.io9.com/nat-geo-wilds-approach-to-science-programming-we-have-1636535446.

15. Adam Gabbatt, "NBC Cancels NRA-Funded Hunting Show After Host Compares Critics to Hitler," *The Guardian,* September 30, 2013, http://www.theguardian.com/world/2013/sep/30/nra-hunting-show-nbcsn-elephant-hitler-cancelled.

16. Campbell Brown, "The President Gives Hollywood a Pass on Violence," *Wall Street Journal*, April 4, 2013.

17. American Academy of Pediatrics, Council on Communications and Media, "Media Violence," *Pediatrics* 124 (October 19, 2009): 1495–1503, accessed November 25, 2014. http://dx.doi.org/10.1542/peds.2009-2146.

18. American Humane Association, "Understanding the Link Between Animal Abuse and Family Violence," accessed November 25, 2014, http://www.americanhumane.org/interaction/support-the-bond/fact-sheets/understanding-the-link.html.

19. Kenneth Shapiro, e-mail messages to author, August 3, 2014.

20. Andrew Marshall, "Beware of the Gonzo Nature-TV Presenter," *Time*, September 4, 2011.

21. Ibid.

22. Casey Anderson, e-mail message to author, September 14, 2014.

23. Tom Campbell, e-mail message to author, May 20, 2013.

24. Holland, "Don't Feed the Bears."

25. "Saving Valentina.6.8.2011.h264.mov," YouTube video, 8:20, posted by "elinoyes," June 13, 2011, http://www.youtube.com/watch?v=EBYPlcSD490&feature=youtu.be

26. Balcombe, *Second Nature*.

27. Jeff Hogan, e-mail message to author, September 14, 2014.

28. Marc Bekoff, "Animal Minds and the Foibles of Human Exceptionalism," *Animal Emotions* (blog), *Psychology Today*, July 30, 2011, http://www.psychologytoday.com/blog/animal-emotions/201107/animal-minds-and-the-foible-human-exceptionalism.

29. For more on animal dignity, see Frank Bruni, "According Animals Dignity," *New York Times*, January 14, 2014, http://www.nytimes.com/2014/01/14/opinion/bruni-according-animals-dignity.html.

CHAPTER 21

1. Rich Juzwiak, "That Shark Hunters Show Is Pretty Fucked Up," *Gawker* (blog), August 1, 2013, http://gawker.com/that-shark-hunters-show-is-pretty-fucked-up-989149727.

2. World Wildlife Federation, "Living Planet Index," accessed November 25, 2014, http://wwf.panda.org/about_our_earth/all_publications/living_planet_report/living_planet_index2

3. Stephanie Flack, e-mail message to author, November 2, 2014.

4. Mary Pipher, *The Shelter of Each Other: Rebuilding Our Families* (New York, NY: Putnam, 1996).

5. Peter Seligmann, "Disconnection From Nature, a Dangerous Illusion," *Huff Post Green* (blog), April 19, 2012, http://www.huffingtonpost.com/peter-seligmann/disconnection-from-nature_b_1435769.html

6. Michael Parfit, "UFOs, Bigfoot and Booze: This Is National Geographic?" *Globe and Mail*, March 20, 2013, http://www.theglobeandmail.com/globe-debate/ufos-bigfoot-and-booze-this-is-national-geographic/article9968038.

7. Richard Brock, "What's Wrong With National Geographic?" *Wildlife Film News*, edited by Jason Peters, August 13, 2014.

8. Dereck Joubert, e-mail message to author, September 22, 2014.

9. "Discovery Communications; Leadership," accessed December 5, 2014, http://corporate.discovery.com/leadership/

10. Discovery, "Code of Ethics," Discovery Is a Responsible Corporate Citizen sec., accessed on November 25, 2014, http://ir.corporate.discovery.com/phoenix.zhtml?c=222412&p=irol-govconduct.

11. "October 1, 2014, Today in History," *Teleperformance Philippines*, accessed December 5, 2014, http://teleperformancephilippines.wordpress.com/2014/10/01/11928/

12. Peter M. Senge, *The Fifth Discipline: The Art & Practice of the Learning Organization* (New York: Doubleday Currency, 1990).

13. Paul Farhi, "National Geographic Explores New Frontiers with Gary Knell at the Helm," *Washington Post,* June 24, 2014, Style sec., http://www.washingtonpost.com/lifestyle/style/national-geographic-explores-new-frontiers-with-gary-knell-at-the-helm/2014/06/23/cc0edb30-f3ef-11e3-bf76-447a5df6411f_story.html.

14. Harish Manwani, "Profit's Not Always the Point." Filmed October 2013. TED video, 7:49. https://www.ted.com/talks/harish_manwani_profit_s_not_always_the_point?language=en

15. Edmund Lee, "Discovery CEO Stands to Make $110 Million in 2014 Pay," *Bloomberg,* January 3, 2014, http://www.bloomberg.com/news/2014-01-03/discovery-ceo-stands-to-make-110-million-in-2014-compensation.html.

16. Piers Warren, e-mail message to author, October 28, 2014.

17. Dennis Aig, e-mail message to author, October 25, 2014.

18. Patricia Kollappallil, e-mail message to author, October 22, 2014.

19. Tim Martin, e-mail message to author, September 16, 2014.

20. David Puttnam, "Does the Media Have a 'Duty to Care'?" Filmed June 2013 at TEDxHousesOfParliament talk. TED video, 10:39. https://www.ted.com/talks/david_puttnam_what_happens_when_the_media_s_priority_is_profit?language=en.

21. Neil Genzlinger, "Hunting the People Who Hunt the Whales," review of *Whale Wars* (Animal Planet), *New York Times,* November 9, 2008, http://www.nytimes.com/2008/11/07/arts/television/07whal.html.

22. Michael Parfit, e-mail message to author, October 20, 2014.

ACKNOWLEDGMENTS

MANY PEOPLE WERE INSTRUMENTAL in turning this book from an idea into reality, and their influence can be seen on every page. I especially want to thank (in alphabetical order) Roger DiSilvestro, Mike Harvey, Hardy Jones, Diane MacEachern, and Grant Thompson, as well as my three amazing daughters (Kimberly, Christina, and Jenny) and my wonderful wife Gail.

I also want to thank the wildlife filmmakers whose ethically-sound and extraordinary work has guided me throughout the years. These remarkable individuals include Peter Argentine, Richard Brock, Tom Campbell, Katie Carpenter, Dave Clark, Beth Davidow, Mark Deeble, Howard and Michele Hall, Jeff Hogan, Dereck and Beverly Joubert, Carl Kriegeskotte, Brian Leith, Cara Blessley Lowe, Tim Martin, Liam O'Brien, Kathryn Pasternak, Bob Poole, Adam Ravetch, Mark Shelley, Vicky Stone, Melissa Thompson, Tom Veltre, Piers Warren, and Rob Whitehair.

I have likewise profited from the wisdom and knowledge of Michael Cascio, Anna Cummins, Jim and Jamie Dutcher, Brock Evans, Stephanie Flack, Jeff Flocken, Melissa Groo, David Helvarg, Andrea Heydlauff,

Julian Keniry, David Kirby, Randy Olson, David Shiffman, Brian Switek, Bruce Weide, Mark Wexler, and Christie Wilcox.

I also want to thank the experts who helped me: Dr. Jonathan Balcombe, Dr. Marc Bekoff, Dr. Derek Bousé, Dr. Barbara King, Dr. Sterling Miller, Dr. Naomi Rose, Dr. Carl Safina, Dr. Ken Shapiro, and Dr. Greg Skomal.

A number of individuals provided comments and edits to improve early drafts of the book. I acknowledge with gratitude the time and effort of Dennis Aig, Casey Anderson, Gerry Bishop, John Burgess, Aaron Dorman, Erin Finicane, Sarah Gulick, John Heminway, Dan Mathews, Kevin McCarey, Kim McCoy, David Mizjewski, Roy O'Connor, Mike Parfit, Geoff Pepos, Lisa Samford, Rob SanGeorge, Wayne Schmidt, Vanessa Serrao, Lena Spadacene, Russell Sparkman, Mike Steinberg, Charlotte Vick, Adam Welz, James West, and Todd Wilkinson.

I want to thank my faculty colleagues at American University School of Communication and at the Center for Environmental Filmmaking, especially Dean Jeff Rutenbeck, Sandy Cannon-Brown, John Douglass, Larry Engel, Declan Fahy, Bill Gentile, Chris Lawrence, Brigid Maher, Sarah Menke-Fish, Chris Simpson, Maggie Burnette Stogner, and John Watson. I am also grateful to my colleagues on the AU and SOC staff, including Tia Sumler Milledge, Dani Rizzo, Ericka Floyd, and Gregg Sangillo.

I offer a big thanks also to my colleagues at MacGillivray Freeman Films and the One World One Ocean Foundation, particularly Greg and Barbara MacGillivray, Shaun MacGillivray, Kathy Almon, Mary Jane Dodge, Janna Emmel, Bob Harmon, Jeff Horst, Steve Judson, Harrison Smith, and Lori Rick.

My family is a continual source of joy and inspiration. I'm deeply grateful to my wife Gail, my three daughters (Kimberly, Christina, and Jenny),

my two sons-in-law (Sujay and CJ), my three grandchildren (Kareena, Neal, and Jackson), and my two brothers Tim and Jon.

Thanks also go to Joan Murray, Bill and Laurie Benenson, Leonard Berman, Angel Braestrup, Mark Butterworth, Colton Hoover Chase, Caroline Gabel, Wolcott Henry, Lacey Hoover, Elysabeth Kleinhans, Betsy Mead, Diana Mead, John McMurray, Caroline Ramsay Merriam, Gil Ordway, Amy Panek, Kristin Pauly, Lisa Peterfreund, Todd Robinson, Elizabeth Ruml, Rhett Turner, Ted Turner, Sheila and Bill Wasserman, and Lucy Waletzky.

I thank Suzanne and Bob Murray for their faith in this book and for working so hard on it with me. I'm also grateful for the exemplary copy-editing by Stefanie Lazer and Sarah McCarry, as well as fact-checking by Jeff Cantwell.

Last, but certainly not least, I thank all my students, including my dedicated Teaching Assistants Berna Elibuyuk, Jazmin Garcia, Alexander Gillies, Shannon Lawrence, Will Reid, Sam Sheline, and Jamey Warner.

INDEX

Index

Index

ABOUT THE AUTHOR

CHRIS PALMER is a professor, speaker, author, and environmental/wildlife film producer, who has swum with dolphins and whales, come face-to-face with sharks and Kodiak bears, camped with wolf packs, and waded hip-deep through Everglade swamps.

Over the past thirty years, he has spearheaded the production of more than 300 hours of original programming for prime time television and the giant screen IMAX film industry. His films have been broadcast on numerous channels, including the Disney Channel, TBS, Animal Planet, and PBS. His IMAX films include *Whales, Wolves, Dolphins, Bears, Coral Reef Adventure*, and *Grand Canyon Adventure*. He has worked with many celebrities, including Robert Redford, Paul Newman, Jane Fonda, Ted Turner, and Ted Danson.

Chris's career as a film producer began in 1983 when he founded the nonprofit organization National Audubon Society Productions, where he served as president and CEO for eleven years. In 1994, he founded another nonprofit film production company, National Wildlife Productions (part of the National Wildlife Federation, the largest conservation

organization in the United States), which he led as president and CEO for ten years.

Chris is currently president of One World One Ocean Foundation and the MacGillivray Freeman Films Educational Foundation, both of which produce and fund IMAX films on conservation. MacGillivray Freeman Films is the world's largest and most successful producer and distributor of IMAX films.

In 2004, Chris joined American University's full-time faculty as Distinguished Film Producer in Residence at the School of Communication. There he founded, and currently directs, the Center for Environmental Filmmaking, whose mission is to inspire a new generation of filmmakers and media experts whose commitment to environmental stewardship drives them to produce creative work that is informative, ethically sound, and entertaining—and that makes a positive difference.

His book, *Shooting in the Wild: An Insider's Account of Making Movies in the Animal Kingdom*, was published in 2010 by Sierra Club Books and described by Jane Goodall as "a very important and much-needed book." Now in its second printing, *Shooting in the Wild* (along with its film version for PBS with Alexandra Cousteau) pulls back the curtain on the dark side of wildlife filmmaking, revealing an industry undermined by sensationalism, fabrication, and sometimes even animal abuse.

Profiles about Chris have appeared in many publications, including the *Wall Street Journal* and *The Washington Post*. He has been interviewed on the *Today Show*, ABC Nightline, NPR, the Fox News Channel, and other networks. He publishes articles regularly (including a bimonthly column on "best practices" for *Realscreen Magazine*) and currently serves on the board of fourteen nonprofits.

Chris is a frequent keynote speaker at conferences and film festivals,

and he regularly gives workshops on a variety of topics, including how to radically improve one's success and productivity, how to raise money, how to give effective presentations, how to network effectively, and how to motivate and engage students.

Chris and his colleagues have won numerous awards, including two Emmys and an Oscar nomination. Chris has also been honored with the Frank G. Wells Award from the Environmental Media Association, and the Lifetime Achievement Award for Media at the 2009 International Wildlife Film Festival. In 2010 he was honored at the Green Globe Awards in Los Angeles with the award for Environmental Film Educator of the Decade. In 2011 he received the IWFF Wildlife Hero of the Year Award for his "determined campaign to reform the wildlife filmmaking industry," and in 2012 he was named the recipient of the Ronald B. Tobias Award for Achievement in Science and Natural History Filmmaking Education. He received the 2014 University Faculty Award for Outstanding Teaching at AU.

In his twenty years before becoming a film producer, Chris was a high school boxing champion, an officer in the Royal Navy, an engineer, a business consultant, an energy analyst, an environmental activist, chief energy advisor to a senior U.S. senator, and a political appointee in the Environmental Protection Agency under President Jimmy Carter. He has jumped out of helicopters and worked on an Israeli kibbutz.

Chris holds a B.S. with First Class Honors in Mechanical Engineering from University College London, an M.S. in Ocean Engineering and Naval Architecture also from University College London, and a master's degree in Public Administration from Harvard University where he was a Kennedy Scholar and received a Harkness Fellowship.

Born in Hong Kong, Chris grew up in England and immigrated to the

United States in 1972. He is married to Gail Shearer and is the father of three grown daughters (Kim, Christina, and Jenny). For five years he was a stand-up comedian and performed regularly in DC comedy clubs. He is currently writing a book about how to be an effective father to three daughters.

* * *

Chris can be reached at palmer@american.edu and at (202) 885-3408 at American University. His websites are www.ChrisPalmerOnline.com, which contains scores of free handouts, and www.environmentalfilm. org. He blogs at http://soc-palmer.blogs.american.edu/. Chris encourages you to write to him with questions, problems, or suggestions for the next edition.

Made in the USA
Charleston, SC
07 April 2015